KU-794-607

LEICESTER MUSEUM STUDIES
General Editor: Susan M. Pearce

Popular Collecting and the Everyday Self

LEEDS BECKETT UNIVERSITY
Leeds Metropolitan University

17 0430507 6

*To my parents Frank and Sylvia for instilling in me
a great sense of right and wrong, without which things
may well have turned out very differently*

Popular Collecting and the Everyday Self

The Reinvention of Museums?

Paul Martin

Leicester University Press
London and New York

LEEDS METROPOLITAN
UNIVERSITY
LIBRARY

1704305071
KV-D 5/5/05
CL- 60176
26-4-05
069.4 MAR

LEICESTER UNIVERSITY PRESS
A Cassell Imprint
Wellington House, 125 Strand, London WC2R 0BB
370 Lexington Avenue, New York, NY 10017–6550

First published 1999

© Paul Martin 1999

Apart from any fair dealing for the purposes of research or private study or criticism
or review, as permitted under the Copyright, Designs and Patents Act 1988, this
publication may not be reproduced, stored or transmitted, in any form or by any
means or process, without the prior permission in writing of the copyright holders or
their agents. Except for reproduction in accordance with the terms of licences issued
by the Copyright Licensing Agency, photocopying of the whole or part of this
publication without the prior written permission of the copyright holders or their
agents in single or multiple copies whether for gain or not is illegal and expressly
forbidden. Please direct all enquiries concerning copyright to the publishers.

British Library Cataloguing-in-Publication Data

A catalogue record for this book is available from the British Library.
ISBN 0-7185-0170-5

Library of Congress Cataloging-in-Publication Data

Martin, Paul, 1959–
 Popular collecting and the everyday self : the reinvention of museums?/ Paul Martin.
 p. cm. — (Leicester museum studies)
 Includes bibliographical references and index.
 ISBN 0-7185-0170-5 (hard)
 1. Collectors and collecting—Social aspects. 2. Popular culture—Collectors and
 collecting. 3. Museums—Philosophy. 4. Museum curators. I. Title. II. Series:
 Leicester museum studies series.
 AM231.M28 1998
 069'.4—dc21 98–17887
 CIP

Typeset by Ben Cracknell Studios
Printed and bound in Great Britain by TJ International Ltd, Padstow Cornwall

Contents

Plates

Figures

Tables

General preface to series

Museums are an international growth area. The number of museums in the world is now very large, embracing some 13,500 in Europe, of which 2,300 are in the UK: some 7,000 in North America; 2,800 in Australasia and Asia; and perhaps 2,000 in the rest of the world. The range of museum orientation is correspondingly varied and covers all aspects of the natural and the human heritage. Paralleling the growth in numbers, comes a major development in the opportunities open to museums to play an important part in shaping cultural perceptions within their communities, as people everywhere become more aware of themselves and their surroundings.

Accordingly, museums are now reviewing and rethinking their role as the storehouses of knowledge and as the presenters to people of their relationship to their own environment and past and to those of others. Traditional concepts of what a museum is, and how it should operate, are confronted by contemporary intellectual, social and political concerns which deal with questions like the validity of value judgements, bias in collecting and display, the demystifying of specialized knowledge, the protection of the environment, and the nature of our place in history.

These are all large and important areas and the debate is an international one. The series *Leicester Museum Studies* is designed to make a significant contribution to the development of new theory and practice across the broad range of the museum operation. Individual volumes in the series will consider in depth particular museum areas, defined either by disciplinary field or by function. Many strands of opinion will be represented, but the series as a whole will present a body of discussion and ideas which should help to redress both the present poverty of theory and the absence of a reference collection of substantial published material, which curators everywhere currently see as a fundamental lack. The community, quite rightly, is now asking more of its museums. More must be given, and to achieve this, new directions and new perspectives must be generated. In this project, *Leicester Museum Studies* is designed to play its part.

SUSAN M. PEARCE
Department of Museum Studies
University of Leicester

Preface

'I collect, therefore I am.' This paraphrase of Descartes (also the title of Chapter 4 of this book) seems as concise a way as any to summarize the intensely personal relationship people can have with objects. This is not to suggest that collecting is anti-intellectual (i.e. the opposite of Descartes' original assertion, 'I *think*, therefore I am'), but rather to proffer the idea that collecting is the material result of intense emotionally and culturally conditioned thought processes. Over the last two decades, the environments and agencies which promote collecting activity have increasingly pervaded our consciousness, and for many, their leisure time. The 'seriousness' (see Stebbins, 1982) with which such activity is sometimes undertaken often assumes the characteristics of a work ethic. This may include getting to the car-boot sale early on a Sunday (conventionally a leisure day); 'working' (haggling) towards acceptable prices with vendors; reconnoitring visited towns for suitable shops and markets, armed with 'wants lists'; networking by establishing contact and maintaining ongoing relationships with dealers and other collectors, etc. All of which suggests that collecting is an organic and important social practice. Behaviour of this kind does not happen in a vacuum and my thoughts were therefore to explore the possible causation for this phenomenon in a contemporary context.

Academic research has only recently been undertaken into contemporary popular collecting, and has only just begun to feature as a serious aspect of consumer behaviour and material culture studies. Likewise, some museums are cautiously beginning to acknowledge collecting behaviour. This book proposes the idea that it is perhaps a search for certainty and identity in an increasingly fluid, transient and ill-defined society that has largely spurred collecting activity in recent years. Nostalgia and marketing ploys as motivations for contemporary collecting are probably only the most visible tip of a more subliminal iceberg. What is collected, the way it is collected and the deep-seated meanings things have for people, suggest an intensity of identification with objects that corporate marketing only *eventually* taps into. Nostalgia can be seen as an undercurrent or backdrop, but is often a catch-all word too easily used to avoid deeper probing. It is a word which has historically had varying connotations (Starobinski, 1966) and which is today usually used only in a superficial sense.

Collecting activity, as I propose in the second half of this book, should be viewed as an opportunity by museums to redefine themselves. Although some recognition has been afforded to popular collecting museologically, it is little enough. The more I investigated contemporary collecting through popular literature, visiting car-boot sales and collectors' fairs, writing to clubs and talking to collectors themselves, the

more I began to compare it with museum attitudes and practice. It increasingly seemed that there existed two mutually exclusive worlds or environments in which collecting activity happened; one, professionalized and socially approved (museums); the other (popular collecting) completely without perimeters and regarded with caution or suspicion by the museum and antiquities establishments. It was therefore decided to make comparisons in attitude and activity between professional collecting institutions (museums) and their nearest comparable institutions in the emergent popular collecting sector, the collectors' clubs. This was done in order to seek any common ground between them which could be built on to mutual benefit. This was achieved initially through questionnaires and later through participant observation. Like public profanity or sex on television before it, popular collecting has aroused interest to the extent that it had become socially approved or even sometimes promoted by society more widely. No sooner had we accepted that the old toy cars or Barbie dolls we used to play with as children were now potentially worth hundreds of pounds, than newer, more deviant objects, more akin to rubbish than aesthetics, began to pick up a collecting fraternity (e.g. bubblegum wrappers or phone cards).

Sociologically and museologically, then, contemporary popular collecting can tell us a great deal about ourselves. It is explored here as a societal coping mechanism for dealing with fundamental social change, as employment practices and technological advances change the way we think, work, act and plan ahead. It is proposed that socioeconomic uncertainty undermines the confidence of the individual, which collecting seemingly helps to re-establish. This scenario, then, implies we are acting out our doubts and foreboding about the future through collecting that which we find offers us reassurance through what we see reflected in it. We stand on the threshold of a new epoch of digitized information technology. This offers us work and leisure environments distinctly less tactile than hitherto, and with an increasing 'virtuality' rather than 'actuality'. It may prove to be that the idea of such a future is partly responsible for the fascination with the everyday emissaries of the material world, but that is a story for another day.

PAUL MARTIN
Leicester, November 1997

Acknowledgements

In the course of writing this book, there have inevitably been a number of people who have encouraged me and offered helpful suggestions. Special mention must be made of the following: Ruskin College, Oxford, for affording me the opportunity as a mature student to develop my philosophy on life and history; in particular, the late Raphael Samuel, who was a mentor and inspiration to me; Susan Pearce, who helped me steer a steady course and whose belief in the project was never less than complete; Kevin Moore, who, on a number of occasions, acted as my sounding-board and whose positive attitude, comments on and enthusiasm for the project always infused me with renewed determination to complete the book; Gordon Fyfe and Flora Kaplin, whose comments and suggestions led to useful revisions; and an anonymous reviewer for a number of useful references. To Maria and Diago Mouliou, and Alex Bounia for their wonderful Greek hospitality and warmth of friendship. To Peter Reti for his interest in my progress and his supportive comments. Lastly, but always first to me, my partner Marie for lending moral and material support, without which this book may very well have not been written. To anyone else not mentioned, my thanks go to you also.

1 *The concept, the book*

Collecting is an activity which is much acknowledged but only beginning to be understood. Only in recent years has any concerted study been undertaken. It has been regarded variously as a child's activity which should be outgrown at puberty; a form of adult relaxation which encourages diversity of interest and calms an over-exerted mind; or, in extremity, an unhealthy obsession or fetishism which clearly signifies a surrogate for some character or personality defect. Recent research has explored the contingencies of collecting and has sought to fathom them more deeply (e.g. Elsner and Cardinal, 1994a; Belk, 1995; Pearce, 1995). The kind of collecting this book is concerned with is not the rarefied world of antiques or fine art, but those objects which are obtainable, affordable and appealing to the majority of people. Such 'popular' collecting is now so widespread that conventional wisdom is inadequate to explain it. This book is intended to complement the major recent works on collecting and to open avenues of serious new research for others.

The book proposes that contemporary popular collecting has grown as a result of an underlying societal anxiety. Collecting, it is proffered, acts as a means by which self-assurance and social equilibrium are reinforced when socio-economic forces threaten to destabilize them. This is implied by the female collector of 'Rupert Bear' memorabilia:

> I like him [Rupert] because he's happy, friendly, colourful and everything always goes right for him. He takes me out of this awful world and reminds me of the safety of my childhood. (Rush, 1997: 9)

This is not to assert that this is the only reason people collect now (or have in the past); collecting could be perceived quite conversely as an expression of renewed confidence in society and as a sign of affluence. Whilst not entirely discounting this view, one would expect in such a scenario that the material collected would be of widely acknowledged financial and/or artistic value (Mason, 1981). This obviously happens as it always has in terms of classical collecting, but in the modernist (and arguably) postmodernist sense, popular collecting often focuses on the inexpensive and the unconsidered (from old bus tickets or product packaging to phone cards and cereal premiums). It is proposed that accumulating what might in other circumstances be seen as the material detritus of consumer society is a now common way of reassuring oneself of one's relationship to society by what we choose to see reflected back at us in the collected material.

Framework

The book is based on the following proposition: objects are a language, collecting is a dialect of that language and like any language, it can be used to make many meanings. This I feel stands beyond metaphor, and is a concept which still invites further research. The study is concerned with two main themes. First, it is argued that contemporary collecting is a social dynamic given impetus by the sociopolitical and sociocultural changes of the last two decades. I have used the social theory of Guy Debord as a philosophical framework in this respect. Collecting is presented as the means by which the collector creates an alternative society or environment and thus justifies and makes sense of the world. This places collecting in a wider cultural context.

Second, the reality of and potential for museum–collector interaction is discussed. The nature of collecting at individual and institutional levels is considered by comparing, contrasting and contextualizing their relative merits, whilst positing the potential for inclusion of 'the popular' of the private collector in the professional world of the museum.

The aims of this book, therefore, are to explore the rise of and interest in contemporary popular collecting; to explain how objects (via the practice of collecting) are used to construct alternative identities as a means of coping with social change; to place collecting in a wider sociocultural context, thus ascribing to it the importance which it deserves both sociologically and museologically; and to argue convincingly for greater co-operation between museums and collectors in the best interests of the material. A wider knowledge-sharing nexus is argued for, as part of the continuing evolution of museums, and as the strongest possible cross-cultural base for the promotion of objects in a society which is becoming increasingly technocratic and exclusive rather than inclusive. For anyone who doubts the increase in popular collecting, it is worth noting that when a collector placed a small advertisement in a monthly magazine asking if anyone would be interested in joining a proposed club for collectors of McDonald's 'Happy Meal' toys (given away with children's meals), the collector received 3000 enquiries before the next issue of the magazine came out! (Richardson and Marshall-Jones, 1997: 64).

Methodology

The primary research for this study consists of correspondence, questionnaires, conversations, participant observations and the taped testimony of individual collectors (details are given in Appendix 2), and visits to various collectors' clubs and museums. Two clubs, the United Kingdom Spoon Collectors and the Leicestershire Collectors' Clubs were chosen as case studies. Four others, related to the collection of brewery ephemera, were also studied. In addition, the newsletters and magazines of approximately fifty different collecting organizations were used to make specific points, such as value judgements, notions of 'worth' and collecting vocabulary (see Chapter 6 and Appendix 3). Completed questionnaires were received from 128 collectors' clubs, 196 local authority and 126 independent museums. (The results are incorporated into Chapters 6 and 7.) The research methods are both quantitative and qualitative (see Appendix 1). The intention was to compare attitudes, knowledge and organization among the clubs, as well as their potential for greater mutual co-operation.

Because of the contemporary nature of the subject, secondary sources in addition to the usual academic texts have been used. The secondary sources fall into three main categories: popular literature such as large-format coffee-table books, collectors' manuals, price guides and the publications of collectors' clubs; television and radio programmes dealing with collecting and material culture – these serve to illustrate the public and commercial responses to the personal fascination with collecting; and newspaper and magazine articles. The diversity of the material helps locate collecting in its widest possible social context and thus provides a fuller contextualized view.

A note on postmodernism

This book is centred on the present whilst drawing on the recent past and positing the imminent future. It is modernist because it seeks to 'change individuals' perceptions . . . and strives to promote (and explain) social transformation' (Kellner, 1995: 160). It is also largely concerned with the here and now. 'Contemporary' (in the sense it is used throughout the book) can be equated with modernist, because many of the newly collected objects have acquired cultural and other values as a result of ongoing social transformation. It is argued that collecting is subconsciously used as a control mechanism to regulate the assimilation of change. It is equally postmodernist in that it is influenced by the cultural theories of Guy Debord and Jean Baudrillard, and is open to the widest possible interpretation. That is to say, the boundaries which might usually be held to define the scope of a subject (e.g. collecting as a clinical, psychological condition) have been removed in order to allow a full examination of other possibilities. This might be criticized as failing to define any boundaries or parameters at the outset, but it is employed as a democratic approach – the subject can be examined, like a glass prism, from every angle.

Whilst it is acknowledged that the term 'postmodern' has varying definitions, that proffered by Douglas Kellner offers a useful basic conception:

> The discourse of the postmodern is a cultural and theoretical construct, not a thing or a state of affairs. That is, there are no phenomena that are intrinsically 'postmodern' which the theorist can then describe. (Kellner, 1995: 47)

> Rather than taking postmodernity as a new cultural totality, I would thus argue that it makes more sense to interpret the many facets of the postmodern as an emergent cultural trend in contrast to residual traditional values and practices still operative and a dominant capitalist modernity defined as the project of the hegemony of capital whereby commodification, individualism, fragmentation, reification and consumer culture are still key constituents of the modern age. (Kellner, 1995: 256)

Overview

The museum versus heritage industry debate of the 1980s, with its attendant establishment infighting, has tended to obscure the wider public focus on collectable things. Importantly, these objects have proved to be largely *not* what museums have traditionally collected or displayed. They vary from beer cans to cartoon memorabilia; from airline sick bags to McDonald's give-away plastic toys; and from Christmas cracker novelties to the pulp fiction of the 1940s and 1950s. Since the 1980s, museums have been changing rapidly – they are no longer the sole providers and interpreters

of heritage culture. They are becoming only one in a range of entertainment and educational institutions which offer such a service. The heritage industry, and more recently organized collectors' groups, are becoming increasingly sophisticated, in some cases even eclipsing the work of museums.

If museum curators were asked twenty years ago to define their role and responsibilities, they would probably not have had to think too hard. Today, there would be a lot more scratching of heads and any such definition would very likely vary from curator to curator. Museums have traditionally been seen either as repositories for the rare, delicate and valuable or as a dumping ground for unwanted junk (Hewison, 1987; Lumley, 1988; Borg, 1991; Kenyon, 1992; Samuel, 1995). Today, collection policies and mission statements are periodically compiled to define the role of the museum in its community and to state the boundaries of its collecting focus (Davies, 1996: 38). In some cases, museums have almost stopped collecting. Acquisition is now viewed as a burden rather than an asset. How and why has this come about? What does it mean in a wider context? Also, if museums are far more reluctant to collect now, who is collecting and what is their position in relation to museums?

The great auction houses such as Sotheby's, Christie's and Phillips Son & Neale, now hold regular sales of collectables, pop memorabilia and lifestyle material which would have been anathema to them twenty-five years ago. The value (aesthetically and financially) of almost any seemingly innocuous and worthless piece of paper or plastic can now be found to have a collector or collectors' organization based on it. Why? Are 'People's Shows' (in which the collections of the individual are collectively displayed in the museum) a sufficient museum response? It can be argued, as many museums have done, that popular collecting represents nothing more than a fad which should be ignored. However, everything has a causation, and the context which gives rise to it should be explored, if for nothing else than to document the concerns and mind-sets of large sections of society at the end of an epoch.

2 *The story so far*

Collecting and the academics

The early literature on collecting was as concerned with children as with adults (e.g. Freyer-Burk, 1900; Whitely, 1929; Witty, 1931; Durost, 1932). These studies focus on conventional children's collectables such as toys, cigar bands, marbles, scraps and cuttings. What is striking in contemporary collecting is that children are collecting, and indeed dealing in, material on a similar basis to adults. One eleven-year-old boy has been collecting Rupert Bear ephemera since he was four. His collection is estimated to be worth over £4000 and includes a 1937 mint-condition Rupert annual which his mother bought at auction for £250. Even more striking is the thirteen-year-old collector of buttons. Her personal collection is estimated to be worth £8000. She has a Saturday stall in the Portobello Road Market in London, on which she regularly takes as much as £600 in a day selling duplicates, whilst trading and dealing with other seasoned adult stall holders (*The Antiques Show*, 1997). Since the 1980s money has become 'nothing to be ashamed of' and youth has ceased to be a barrier to wealth creation. The 'real' world intrudes on children's lives in ways unimaginable when the earlier studies on children's collecting were carried out and would still have been surprising as little as twenty years ago. This juvenile entrepreneurship usefully highlights the intensification of materialism and commodity value over the period under discussion. Bizarrely, as adults attempt to recapture childhood through collecting personally nostalgic material, children can reach for adulthood through engaging with it.

Research published on adult collecting has tended to focus on conventional subjects, e.g. autographs (Joline, 1902); books (Currie, 1931; Benjamin, 1982a; Brook, 1980; Paton, 1988) and coins and stamps (Christ, 1965; Bryant, 1989; Moskoff, 1990; Gelber, 1992). Art collecting has a longer and more established pedigree (Rheims, 1961; 1975; Cabanne, 1963; Baekeland, 1981; Alsop, 1982; Moulin, 1987; Marquis, 1991) but is confined largely to traditional conventions of 'high culture'. Some philosophical writing has sought to explore the history of popular collecting in an earlier age (Rigby and Rigby, 1944; Gelber, 1991) and one important book on the collecting aesthetics of the Enlightenment usefully informs our contemporary view (Pomian, 1990). Papers on contemporary popular collecting, however, have not been numerous, although one or two have sought to explore it by concentrating on single subjects (e.g. Dannefer, 1980; 1981 on old cars; Butsch, 1984 on model aeroplanes; Olmsted, 1988; 1989 on guns) and some others have sought to codify it (e.g. Danet and Katriel, 1989; 1994; Belk and Wallendorf, 1994). Equally, other studies have

focused on the environments in which collecting or more broadly second-hand object acquisition and human–object interaction take place (e.g. Maisel, 1974; Hermann and Soiffer, 1984; McCree, 1984; Gordon, 1986; Soiffer and Hermann, 1987; Glancy, 1988; Smith, 1989; Sherry, 1990; Gregson and Crewe, 1994; 1997; Gregson *et al.*, 1997). Still others have attempted to identify the attachment to objects that individuals feel. This has been attempted from a psychological angle (e.g. Belk, 1988a; Lancaster and Foddy, 1988; Dittmar, 1991) and through consumer studies perspectives, both historical (Greenhalgh, 1988; 1989; Briggs, 1990; Richards, 1991; Bennett, 1994) and contemporary (e.g. Csikszentmihalyi and Rochberg-Halton, 1981; Stoller, 1984; Appadurai, 1986a; Belk, 1987; 1988a; 1991b; Wallendorf and Arnould, 1988; Assendorf, 1993).

Whilst the above can broadly be grouped as psychological at root, the various strands of approach to collecting theory (if one accepts that such a 'discipline' now exists) show how cultural, social, economic and other factors condition or reinforce this. The present study draws on much of the above while seeking to isolate and expand on some of the sociocultural and socioeconomic factors which, it is proposed, 'draw out' the collecting instinct. In addition, the social theory of Guy Debord's *Society of the Spectacle* (1967/1983) is employed as an explanatory tool. This is discussed in more depth in Chapter 3. Here it suffices to say that for Debord, 'the spectacle' is society's image of itself as defined by corporate culture through marketing and the media, and the hegemony of economy. For Debord, the way we are sold things, concern with consumer preferences, sensitivity to nuances in changing and emerging tastes, and the projection of the hyper-real as factual, all serve to distort our sense of the actual. The Debordian thesis sees late capitalist society intensifying its imposition of commodity consumption. In 1990s Britain (at least), we live in an atomized and economic, rather than a social or civil society. The intensification that Debord articulated is now reaching critical mass. In so doing, it has intensified our fascination with and self-definition by objects and material goods. In this sense, much of the literature outlined above fits the Debordian model of society.

Over the last ten years in Britain, interest in contemporary collecting has been recognized by some museums. In 1990, the Walsall Museum and Art Gallery staged its first (of three) 'People's Shows'. A People's Show is essentially a collective display, in a museum environment, of a number of private collections ranging from pencil erasers to pulp fiction. This first initiative was rightly applauded (Suggitt, 1990b; Mullen, 1991). It was, though, the 'People's Show Festival' of 1994, involving over fifty museums nation-wide, which generated a literature of participant studies from the Leicester University Department of Museum Studies (Digger, 1995; Fardell, 1995; Lovatt, 1995), one of which (Lovatt, 1995) has now been published (Pearce, 1997: 196–254). Arising from this, museum relationships with the material culture of popular culture (as distinct from social history) have attracted greater attention (Moore, 1997). These studies are important, in that they represent the first attempts to acknowledge the marriage of contemporary popular collecting with museum practice. In so doing, they offer a precedent for a potential realignment of museological imperatives without cultural appropriation.

In 1984, Susan Stewart's *On Longing* was published, which, although addressing a wider cultural ambit, included what was perhaps the first postmodernist attempt to deconstruct collecting as a process of mediating experience. The importance of Stewart's work is reflected in the most recent papers on the coveting of commodities.

These attribute such desires to a romanticized, idealized or even collective sense of longing (Campbell, 1997; Veenis, 1997). It was only in the 1990s, however, that any substantive books on contemporary collecting theory were written, notably Pearce (1992; 1995); Elsner and Cardinal (1994b); Muensterberger (1994) and Belk (1995). These have come from four different disciplines: museology, aesthetics, psychoanalysis and consumer studies, whilst a further study (Chibnall, in preparation) addresses contemporary collecting from a highly theoretical postmodernist position. The approach adopted towards collecting is therefore necessarily conditioned by the parent disciplines. The research contained in this book draws from and builds upon this literature and attempts to tease out some of the causal paths which collecting takes.

Muensterberger is a practising psychoanalyst and adopts perhaps the most detached, even aloof position to the collecting question. Some of his observations are based on interviews with ex-patients who are collectors. From this perspective he offers some useful analysis. He concludes that collecting is very much about relieving anxiety and tension (Muensterberger, 1994: 253), which is asserted in different ways throughout his book. Being firmly anchored in the psychological field, however, he finds it difficult to follow anything other than the classic Freudian line that collecting in adults (at least beyond a certain point) is an anally retentive characteristic (Baddock, 1989: 68–86). He sees it as largely a reaction to childhood trauma (Muensterberger, 1994: 254, 255) and views collecting in adults as an ego defence mechanism.

He is not alone in toeing the Freudian line (now largely outdated). Baudrillard (1994), for instance, shares similar views, but many studies of collecting and consumer behaviour suggest a much stronger emphasis on social and cultural factors (Wallendorf and Arnould, 1988; Suggitt, 1990b; Dittmar, 1991; Olmsted, 1991; Pearce, 1992; 1995; Cardinal, 1994; Mullen, 1991; Digger, 1995; Lovatt, 1995). This serves to demonstrate that the complexity of material desire reaches beyond basic psychology. Collecting is not necessarily conditioned by living in a consumer society if a world view of the subject is taken, but the Western tradition clearly heightens the tendency to consume (Christ, 1965; Csikszentmihalyi and Rochberg-Halton, 1981; Mason, 1981; Hermann and Soiffer, 1984; Stoller, 1984; Miller, 1987; Nataraajan and Goff, 1991; Moeran and Skov, 1993; Belk, 1995). Muensterberger's interviewees are also largely art and antiquities collectors. While this of course does not invalidate his analysis of collecting motivations, it does follow on from previous psychological analysis of art collecting (Baekeland, 1981) and so places itself in the same narrow confines of the self-professed art connoisseur. This therefore omits any attention to the social and cultural context which opens a veritable panoply of collecting activity and behaviour on a wider social level. It also ignores the wider implications of popular collecting for museums which this book does address.

Belk considers collecting from a different angle, that of consumer research. Belk sees collecting as: 'consumption writ large' (Belk, 1995: 157). The Western propensity to conspicuously consume gathered interest throughout the 1980s (Mason, 1981; Miller, 1987), but not until Belk had collecting been examined as an aspect of it. Whilst Muensterberger uses the logic of his training to keep distanced from the subject, Belk objectifies aesthetics into consumables to paint collecting into the canvas of material commodities, maintaining the same rigidity of distance.

Belk argues that in regard to consumption, the museum's task is to 'make the familiar strange, so that we may see it freshly and critically' (Belk, 1995: 157). This

proposes a questioning rather than a celebrating of material culture. This is particularly salient in the museum context to the People's Show. Following from Belk's conclusions, however, I argue in Chapter 7 that People's Shows should not be seen as an end in themselves, but merely the first step in a closer museum working relationship with collectors, leading to a greater understanding and valuing of the phenomenon of popular collecting in Britain over the last twenty years. Further, I argue that the changing nature of consumption should attribute to collecting a far wider sociocultural significance.

Belk's most notable work prior to 1995 was the 'Consumer Behaviour Odyssey' (1991b). This was born out of his frustration with the narrow and conservative nature of consumer research in the 1980s. Part of his letter to his eventual co-authors outlined the nature of the investigation:

> In a nutshell the idea is for a small group of us to travel from coast to coast one summer in order to qualitatively document various buyer and consumer behaviours via videotaped in situ consumer interviews, largely unobtrusive still photos and impressionistic journals. The goal would be to approach people shopping, buying and consuming products and services in a largely unstructured way without a priori hypotheses or quantitative/structured measures and obtain an archive of records for whatever teaching/research/learning purposes we or others could (a posteriori) devise. (Belk, 1991b: 1)

From this project and in conjunction with others, a number of papers were published which sought to give previously functionalist processes wider implications, such as sacred notions of money (with Wallendorf, 1990); the mysteries of possessions (1991a); Christmas materialism (1993); gift giving as agapic love (with Coon, 1993) and importantly, gender and identity in collecting (with Wallendorf, 1994). Belk's work builds on the important 'Chicago Project' undertaken by Csikszentmihalyi and Rochberg-Halton (1981). This sought to elicit the attraction of possessions in people's homes to which they felt most attached. Together these two studies serve to widen the significance of acquisition behaviour from the purely economic to the socioeconomic.

Pearce adopts a far more poetic approach. For instance, Muensterberger (1994: 252) accurately concludes that: 'acquisitions act as both a palliative and a stimulant'. Pearce (1995: 173) more aesthetically captures the essence of the conclusion when she refers to collecting as 'the kiss of possession'. By this she means that there is a sweetness in the process or act of acquisition which gives pleasure, but like the kiss has to be repeated in order to recapture it. In common with Pomian (1990) and Stewart (1984), Pearce uses aesthetics as a levelling device with which to enter the collector's psyche as an objective companion, not as a means by which to prove or reinforce a pre-held condemnation of the practice, as Muensterberger does. Pearce (1995: 411) views objects as a material language and collecting as a narrative of the self utilizing that language. Whereas Muensterberger and Belk treat collecting as the bricks in a wall, Pearce analyses it as the cement which holds them together. She demonstrates the longevity and lineage of classical (as opposed to contemporary) collecting in the European tradition and sites it squarely in a cultural context, thus questioning the purely psychological analysis it has received from other quarters.

Pomian (1990: 1) recognizes that in the real world, to be taken seriously, a collection has to have a strong economic value, though he, like Pearce, is concerned with the aesthetics and cultural worth of things. What variously delights and disconcerts professionals and the public alike is the great variety of what would until recently

have been regarded as rubbish, but which now commands monetary value. Pomian (1990: 20–5) articulates the counter-value, that is the aesthetic value, by juxtaposing the economic worth of an object, the 'visible', with the aesthetic or priceless value, the 'invisible'. The invisible, the intangible, is the value which can only be accrued by an object once taken out of economic circulation, but it is a value which supersedes the monetary (visible) one, because it is unreachable and therefore indefinable, which is equated as priceless when reinterpreted in material terms. This applies as much to presumed rubbish as to works of art. It is the pursuit of the invisible that collectors engage in, the reason why more essential material needs are sacrificed or reduced in order to acquire the object that for the collector represents or harnesses that intangible 'worth'. In so doing, collectors are somehow grasping the ungraspable and creating (to them) a sounder equilibrium through its attainment than by husbanding a larger bank balance. In Debordian terms, collectors sense a hidden value, one which has eluded commodification and which they seek to capture and control. Ultimately these values are appropriated and commodified anew, imbibed with the collector's desire. Hence, for instance, the marketing ploy of the 'limited edition'.

This book, based in the same philosophy, seeks to widen the ambit of this approach by questioning the nature of collecting in an increasingly exclusive rather than inclusive society. Much of the writing on collecting attributes its instigation to serendipity. I argue that in the contemporary sense, societal anxieties contribute to its manifestation. I propose that contemporary popular collecting can be read as a covert signal. It comes very often from those who have traditionally felt themselves to be an integral part of society, but who have been increasingly disenfranchised or alienated from it. This may have taken the form of redundancy or home repossession, minor court summonses for non-payment of taxes, etc., and they are searching for a point of re-entry. It is also seen as a talisman against a perceived decline in the collector's social values. To collect that which is emblematic of a happier or more certain time acts as psychological protection from the uncertainties of the future. By collecting badges related to certain subjects of previous generations, Gregory (see Chapter 5) manifests, reinforces and illuminates his own values. Likewise another collector, Gloria, had a happy childhood during World War II and collects the memorabilia connected with the Home Front. This is not to assert that all collectors are thus motivated, but that the increase in popular collecting can only be properly understood by examining it in the context of the sociopolitical background from which it has come. Debord, writing thirty years ago, emphasized the links between consumer, image and object. Since then, this linkage has intensified to such an extent as to necessitate a redefinition of our sense of belonging to society, through re-codifying our relationship with objects and material culture generally.

The most recent findings on collection motivation are contained in Pearce's *Collecting in Contemporary Practice* (1998). Belk and Pearce, however, have already published collecting motivations which illustrate the various strands that contribute to it. Belk (1988a: 548–52) reached the following conclusions on collecting motivation: (1) collections seldom begin purposefully; (2) addictions and compulsions pervade collecting; (3) collecting legitimizes acquisitiveness as art or science; (4) profane-to-sacred conversions occur when items enter the collection; (5) collections serve as extensions of the self; (6) collections tend towards specialization; (7) post-mortem distribution problems are significant to collectors and their families; (8) there is a simultaneous desire for and fear of completing a collection.

Whilst the above are salient, some are oversimplified. Only now is private collecting being compared with public collecting, a major aspect of this book. If Belk's conclusions are compared with museum collecting, there seems to be more commonality than difference. For instance, Cardinal (1994: 86) writes: 'However worthless, human trash always secretes cultural meaning.' Whether something is legitimized (point 3) is surely determined by who is doing the legitimizing. Outside of the monetary worth or value of an object, the purpose or use of that object will define its cultural or aesthetic value to its owner. So the need for a collector to justify spending £60 on a rare football programme is no different to the Victoria and Albert Museum's justification for spending £7.6 million on Canova's *Three Graces*. There is cultural value in the football programme as much as in the sculpture. Equally there will be bafflement, from different quarters of society, at paying £60 for a football programme and paying such a large sum for a sculpture. Profanity-to-sacredness transfers occur not just in private collections (point 4), but also (and even especially) in museums. An object is taken out of circulation and context and given a glass case and a satin-covered plinth to rest on. This is simply institutional deification. As for specialization (point 6), museums also specialize. They place special emphasis on, and market, famous or well-regarded aspects of their collections, often to the point of acting as a national repository for their specialized material.

Pearce (1992: 69–88) lists no fewer than sixteen motivations for collecting: leisure; aesthetics; competition; risk; fantasy; a sense of community; prestige; domination; sensual gratification; sexual foreplay; desire to re-frame objects; the pleasing rhythm of sameness and difference; ambition to achieve perfection; extending the self; reaffirming the body; producing gender identity; achieving immortality. These sub-directories are repackaged into three basic codings: fetishes, souvenirs and systematics.

It would be hard to find any further categories into which collecting could be placed, though complementary to (if somewhat overlapping) Pearce, Danet and Katriel (1994: 36) define five sets of metaphors: collecting as hunting; as therapy; as passion and desire; as a disease and as supernatural experience. In a Debordian sense, popular collecting could also be said to exhibit certain anarchistic traits. The disregard for the authority of the object's original intention and the wilful re-coding of its meaning to suit oneself are expressive of this. Bal (1994: 112) however believes, unlike Pearce, that: 'motivation changes according to its place in the narrative'. In a society of such constant and profound change for people from all former classes and categories, the collector is barely able to keep pace with the narrative. In this sense, the amount of material deemed collectable and the rate at which it is collected, are so increased as to make objective limitations difficult. Whilst fully accepting the clear psychological implications of collecting, it is also shown to be socioculturally conditioned. I draw on all the above philosophies, because there is no single thread which leads exclusively to any single one.

One area from which collecting theory most heavily draws is archaeology. It was Hodder (1987b: 1) who clarified what has become known as 'the new material culture'. He attributes to objects the three dynamics of functionalism (effect through use), symbolism (coded meanings) and historicism (past associations). It was the Cambridge school, of which Hodder is a leading exponent, which in the 1970s and 1980s began interpreting ancient material culture in terms of contemporary theories. Beyond mere revisionism, it adopts a postmodernist approach to the very ancient past. The current study adopts a similar methodology towards material which is much

closer to us in time, indeed, is actually contemporary. This makes it at one and the same time easier, because current thinking can be more reasonably applied to current situations, but also harder, because the lack of historical distance allows no time to test the application.

Miller (1994: 15) made the remark that 'peoples, under terms such as cultures, became viewed principally as labels for groups of artefacts which are the immediate subjects of analysis'. Again, when the material remnants of the ancient past are examined, they were/are taken as 'being' the culture itself. In modern society the two are symbiotic: there is no historical distance which allows a view across the years, yet the relationship is the same and Hodder's 'three principles of the object' are as pertinent to a Phillips computer play-station of the 1990s as they are to the dice games of ancient Rome.

Tilley (1989: 192) puts forward a similar argument through the concept of polysemy, in which

> An object, any object has no ultimate or unitary meaning that can be held to exhaust it. Rather, any object has multiple and sometimes contradictory meanings.

Here again a postmodernist approach, where boundaries are removed to allow a less pre-structured interpretation of the subject, has been adopted. If this is valid for things from the ancient past, it must be even more so for things of the present, where their contexts are there to be seen, but which are largely ignored because they do not have the kudos of historical distance and the patina of time, or because their utilitarian nature still defines them as functional rather than aesthetic. Similarly, Shanks (1992: 167–70) decries middle-class crafts for their inversion of what were once working-class trades (functional and utilitarian) into art (aesthetics). Thus the mundanity of yesterday becomes the rarefied of today. Yesterday's rubbish is today's commodity. It is the principle that museums, auction houses, collectors' fairs and car-boot sales all work on. However, the commodity of today is sometimes hard to sell as such, with no history and little passing of time to legitimize its rise in esteem. This is mediated through the mini-industry of the limited edition – intended to create or inspire a desire for the immediately available but imminently unavailable, without the patina of time accruing to it before it becomes saleable. Such contemporary trends have yet to be attributed authority or validity by the arbiters of material cultural value (functional or aesthetic). Debord (1967: 154), however, did address these issues. Society promotes its commodities, Debord claims, as festivities. This festivity, though, can only last for the duration of the expenditure of the commodity. Therefore, the process has continually to be replayed in order to maintain momentum. This, essentially, is for society what Pearce's 'kiss of possession' is for the individual collector.

The influential volume of edited essays by Elsner and Cardinal, *The Cultures of Collecting* (1994), has much to offer in terms of an intellectual approach towards collecting. The volume is a mixture of the more traditional, classical topics (Freud's effigy collection, the Habsburg Treasury, Sir John Soane's house) and the popular (Robert Opie's packaging collection, Swatch watches, French postcards). The overall purpose of the book is to explore and interpret different paradigms in both classic and contemporary collecting. It further stands as the first collaboration of writers from diverse academic backgrounds bringing their experience and thoughts to bear on collecting studies. This highlights the multi-disciplinary nature of the material

that I draw upon and indicates the diversity and the rich mine of enlightenment that material culture studies has to offer. In conjunction with the major works previously discussed, the literature of culture studies comprises the backbone of the academic literature on contemporary collecting.

Collecting and the popular

The popular literature on collecting is both large and without boundaries. It can range from price guides for investment to glossy photographic coffee-table books. As a broad definition of popular literature, I have borrowed a phrase from Olmsted – 'non-scientific'. Olmsted (1991: 294) gives a more precise definition of the term, but here it is used to mean all those publications that can strictly be called non-academic.

The quality of the publications on popular collecting that emanate from outside the academic arena is highly variable. Many are little more than glossy photo books, but they none the less act as mirrors, reflecting our gaze as we search for deeper meaning in what we perceive. Others are deeply informative. Still others are check-lists – the completist's bible on the subject concerned. This literature is supportive of the objects collected and acts as a means of reference for the collector. It is also important to social and cultural historians as illustrative of the importance of material culture at any one time, the 'aestheticization of lowly, everyday objects' as Danet and Katriel (1994: 49) put it. This has long been recognized in America, where mail order catalogues (such as the Sears Roebuck) have been used as tools for social and cultural analysis for some years (Schroeder, 1981a: 76–83).

MacKenzie (1984; 1986) describes the vehicles of propaganda used by the establishment, manufacturers and others to imbue a healthy respect for, and sense of responsibility towards, the British Empire from the end of the nineteenth century. Images of popular icons of empire such as John Bull, Britannia, Tommy Atkins and Jack Tar, as well as the full coterie of royalist imagery, were employed on everything and anything from tins of treacle to cigarettes (Jubb, 1984; Opie, 1985; Constantine, 1986). Such material went hand-in-hand with the conservative nature of the popular music hall (Steadman-Jones, 1974; Senelick, 1975; Summerfield, 1986). Together with other grander activities such as imperial exhibitions (Greenhalgh, 1988; 1989; Briggs, 1990) which also created a vast souvenir/collectables industry in their own right, the images attempted to create meaning, or at least coerce emotions, regarding imperial Britain. My point is that imagery, the optical aspect, is the first cognitive step towards collecting, whether internally or externally perceived. The ideas created or suggested by the material surrounding us seemingly act as a stimulus to the collecting instinct.

The commercial literature of popular collecting is on the surface about monetary value or investment. This, in such a material society as our own, is a significant trigger in itself. However, it also reminds us that there are other reasons. The teapot, for instance, could be read as a vessel which harbours notions of extended family and community values. In today's society where time is such a commodity, the lengthy brew of a pot of tea is replaced with the immediacy of the tea bag dunked in the mug. To collect teapots, then, is to mourn the acceleration of life's pace, and stands as a substitute for a loss of contact or relaxation. Tea bags can represent time lost whilst teapots represent time regained. Old bubblegum cards have long been collected, but now the wrappers are more prized than the cards themselves, being even more

ephemeral. The cards were made to be collected, the wrappers to be discarded. That the wrappers have become more highly prized is a result of, in Debordian terms, passive situationism – to do the opposite of what is expected. On this basis, then, the popular literature (especially as it is so copiously illustrated) can be regarded, at least in the abstract sense, as manuals of passive subversion.

Vintage poster art became collectable in the 1960s, and from this grew an interest in the emblems and banners of the labour movement and many other areas. Old enamel advertising signs and similar commercial media also became fashionable to collect at this time, as did other popular material culture from the late Victorian and Edwardian eras, largely spurred on by fashionable frequenting of London markets, especially Portobello Road (for a detailed account see *All Mod Cons*, 1997). By the 1980s reference books on popular art and collectables were burgeoning (Mullen, 1979; Jubb, 1984; Sibley, 1985; Opie, 1985; 1987; 1988). The popular literature, and more often the imagery in it, has been selling the idea of collecting in Britain for the last twenty years or so. An early example aimed at children suggests simple objects such as badges. These are presented as inexpensive and fun things to collect (Newark and Gibson, 1976). By 1988 they have become serious collectables and are seen as antiques (Mellor, 1988). Enamel advertising signs became codified as 'street jewellery' by the 1970s (Baglee and Morley, 1988) and now there are guides (many of them American imports) to virtually everything, from scholarly catalogues on barbed wire (Clifton, 1970) to 'the fun thing', like vintage lunch boxes (Bruce, 1988). Millbank Books, based in Hertfordshire, provide a UK outlet for many of the American imports. A glance at their new publications for 1993 illustrates how diverse and desired some objects have become. Autumn 1993 releases included books on collecting handbags; plastic toys of the 1950s and 1960s; Pepsi-Cola memorabilia; Christmas bisque figures; the space race; and gambling memorabilia. Museums are also party to this phenomenon (e.g. Franklin, 1984).

Labour history illustrates the way in which the seemingly esoteric becomes established as received wisdom, operating in a similar way to the imperial propaganda images. A book on the membership emblems of craft unions (Leeson, 1971) was soon followed by one on union banners (Gorman, 1972), which has now become an orthodoxy of labour history. Others followed. First, on miners' banners (Moyes, 1974), then church banners (Lewery, 1986), women's banners (Campbell, 1989) and banners of the Co-operative Movement (Campbell and Wilson, 1994). The subject matter of the banner becomes ultimately less important than the banner itself, the object signifying more or other than its original intention (Hobsbawm, 1984b: 66–82). This has led to volumes on every other aspect of the labour movement's material heritage (Gorman, 1985; Achlen *et al.*, 1986; Durr, 1988). There is in addition an informal, privately published body of work originating from collectors and their own organizations (e.g. Seaton, 1986; Dodds, 1994; Hammond, 1995).

Objects can be objectified or rarefied. They are as semantic as words, if not more so. Their meaning depends on the internal rationale of the beholder and the socioeconomic context in which it arises. Golf is often perceived as a businessman's sport. It has a longer pedigree than other similar corporate sports such as squash. Its material history has become deified (Baddiel, 1989) and commands high prices from collectors. Even fine art, which arguably is more fetishized than any popular collectable given the pretensions that surround it, has aspects of popular collectables such as Art Nouveau postcards (Fanelli and Godolie, 1987). Vintage poster books

on airlines (Morris, 1989), railways (Cole and Durack, 1990; 1992) and the London Underground (Green, 1990), to name but a few, became very popular throughout the 1980s and 1990s. There are also handbooks and catalogues on subjects such as the badges of the nursing profession (Meglaughlin, 1990), trade unions (Hammond, 1995), football clubs (Wilkinson, 1990), Gollies (Dodds, 1994), bowls (Thornhill, 1994) and the Home Front in World War II (Mills, 1997). These publications are labours of love by the collectors. To this category should be added the regular newsletters and magazines published by and circulated within the collectors' clubs, as distinct from commercial publications (see Appendix 3). A body of knowledge is gradually built up as a result, which ultimately contributes towards a wider understanding of industrial and post-industrial society and our relationships with its material culture.

Conclusion

In Britain, it is only in the last decade of the twentieth century that contemporary popular collecting and material culture have received serious academic attention. This has been largely due to the tremendous upsurge in popular collecting activity and its reflection in the media. In America, it has become a staple element of social history. For instance, Orr and Ohno (1981) used the material culture of popular protest, such as badges, stickers and posters, to document the history of the anti-Vietnam-War movement, whilst Hurst (1981) incorporated similar material into a regional historical association. Mayo (1984) uses similar material to interpret aspects of presidential conventions and campaigns. In Britain, although there is a substantial body of work on the material culture of the labour movement and a thriving collectors' organization for its artefacts, it is still necessary to plead for more such material to be acquired by museums (see Moore, 1994: 142–73). A similar gap has been identified in the emergent sports museums (Mason, 1996: 21–3; Tyler, 1996: 26–7).

The symbiotic nature of academic and popular writing is evident. In 1981 Anderson and Swinglehurst produced their illustrated book *Train and Transport: A Collector's Guide*, which was a project of the Ephemera Society (est. 1975). A one-time president of the Ephemera Society was Asa Briggs, who used such printed ephemera to both research and illustrate his book *Victorian Things* (1988). Indeed, the Centre for Ephemera Studies was opened at Reading University in 1993 from the core collection of Maurice Rickards, the Ephemera Society's secretary (Roberts, 1993: 3). This demonstrates the seriousness with which 'rubbish' is taken and the stories that it has to tell.

Popular collecting can be read as an attempt by the individual to regain the status and value of civil hegemony. The communities and organizations (e.g. collectors' clubs), which have resulted from popular collecting, can be read as constituents in a postmodern or alternative civil society in the Gramscian sense (Bocock, 1986: 33–4). The psychological and aesthetic impulses to movement in such directions are implicit in Debord. Debord decries the society of the spectacle, precisely because he sees the encroachment and intensification of the economic over the civil and social elements of society. Debord's insistence on a subject–object relationship always allows an ultimate self-referential material grounding in reality. The material culture approaches to collecting of archaeology, museology and consumer studies sit well within this concept.

Museologically, People's Shows reveal how such relationships are reinterpreted and explored. They also fit into the pantheon of commodity spectacle. They are the Debordian festivities of commodities, returned to substitute for a lack of sociocultural cohesion. They can also be read as a rejection of the corporate insistence on the abandonment of the old and the adoption of the new. The worlds of collectors' clubs and manuals, car-boot sales and auctions, evolve their own language, codes and values. These encourage parallel environments and systems of judgement to come into existence, which can be read as a resistance movement to the dominant corporate media culture. They can also be read, as Gregson and Crewe (1997: 99–104) conclude in their study of car-boot sales, as arenas of accumulated knowledge and competitive individualism. In this sense, they mimic or parody the society of the spectacle, by seeking to enact in reality what corporate media culture imposes through the hyper-reality of advertising. The popular literature on collecting is replete with images and captions that exemplify this hypothesis.

3 *The society of the spectacle*

Introduction

Since about 1980 British society has displayed characteristics which distinguish it sharply from earlier decades. These changes not only are economic but are conditioned by profound shifts in the nature of social relationships between individuals. These shifts cause us to perceive that a new age – the postmodern – has arrived. Contemporary collecting is a part of this since collecting is about the objects which constitute the urban environment and condition our perceptions of reality. It is therefore fitting that the social theory applied to discussing contemporary collecting should be primarily Guy Debord's *La Société du spectacle* (*Society of the Spectacle*), published in 1967. Debord was not the first to express an opinion on consumer culture. Zola's classic novel *Au Bonheur des dames* (*The Ladies' Paradise*), published in 1883, was perhaps the first to consider the future of a society in which a dominant feature would be the large department stores such as Bon Marché in Paris (Miller, 1981) on which his novel was based. Later, Walter Benjamin's unfinished 'Arcades' project deconstructed the cultural phenomenon of the shopping arcade with poetic and sociological acumen (Buck-Morss, 1989). Debord, however, was perhaps the first to anticipate postmodernism in the sense of environmental and ecological relationships. The third and most recent English translation of his book was published in 1983 and is the edition used throughout this study.

Debord has been obscured by other thinkers who built on his theories in the following decades, notably Baudrillard (1975; 1981), with whom Debord was a contemporary. Indeed, the American Alvin Toffler, through his seminal book *Future Shock* first published in 1968, added the string of 'futurism' to the bow of sociology. He is now regarded in some quarters as a veritable messiah (Toffler, 1980; Grant, 1996).

Debord is perhaps best known as one of the founders of the International Situationist Movement, formed in 1957 (and which he abandoned soon after the 1968 Paris riots), and as the editor of its journal, *Internationale situationiste*, from 1957 to 1969. Situationism was a mixture of basic Marxism and the avant-garde of Dadaism. Situationists sought to alert the public to the passivity of consumerism and perceived technological repression by 'perpetuating situations conceived to pervert established codes and values'. Slogans such as: 'culture is the inversion of life', 'it is forbidden to forbid' and 'be reasonable, demand the impossible' were used as a spur to action (Rogan, 1988: 328). Debord committed suicide on 30 November 1994, largely it is believed from despair at the direction in which he perceived society to

be heading (Lajus, 1996: 59). His depression is heavily implied in *Comments on the Society of the Spectacle* (1979). He is also perhaps the most salient theorist of modern Britain, given his ecological concerns which in our small island have now become imperative. His thinking on representation, self-referentiality, and arguably hyper-reality in the 1960s, inspired Baudrillard in the 1970s.

Debord's social critique

In *Society of the Spectacle*, Debord sees society becoming increasingly conditioned by the mass media, especially television (on which he later refused to appear). These changes he felt were for the worse. For Debord, monopolization by the media of social perception becomes dominant, leading ultimately to the hegemony of the economy and the projection of society as mere image or spectacle. This is devoid of aesthetic or social concerns and is managed, reconstituted and repackaged to suit a corporate culture. Although the most obvious aspect of his book, Debord was reaching beyond this:

> More generally, it refers to the vast institutional and technical apparatus of late capitalism, to all the means and methods, power employs outside of direct force, to relegate subjects to the critical and creative margins of society and to obscure the nature of its distorting power. (Best, 1994: 47)

Throughout this study, 'the spectacle' takes on the meaning expressed in this quotation. Debord foresaw what was to become British government policy in the 1980s – market economics. The domination of economic over social life substitutes the economic *having* (i.e. individual ownership) for the social *being* (i.e. communal sharing). *Having* slides into *appearing* and image and presentation become paramount values (Debord, 1983: 17). It was Margaret Thatcher who asserted that there was no such thing as society. Getting and owning became the dominant concerns of a generation. It was the 1980s which saw the rise of popular collecting, as the naked materialism of the Conservative ethic both took hold of and affected all levels of society. The engine of economic necessity coupled with the carriages of cultural practice led to the popularization of car-boot sales, swap-meets and collecting in Britain.

Debord, as a neo-Marxist, holds to the idea of object–subject, which keeps the spectacle grounded in social relations and insists on the idea of society. Baudrillard, however, inhabits the simulacrum 'an abstract non-society devoid of cohesive relations, social meaning and collective representation' (Best, 1994: 51), which denies the concept of society. This, for Baudrillard, is where postmodernism takes over and everything is reduced to an exchange–sign status. (Recently Baudrillard has sought to distance himself from this concept, see Zurbrugg, 1997.)

While Baudrillard rejects all needs, Debord maintains a link with 'real' or 'authentic' needs (Best, 1994: 59). In contemporary collecting, Debord's thesis is the more relevant because his attachment to social relations means that there is a 'real' to be reclaimed from behind the mask of the spectacle. Thus anchored, we can see the subject (collector)–object (collected) relationship in societal terms, rooted in ruptures caused by social change. This does not, however, entirely rule out Baudrillard's thesis of the simulacrum.

Contemporary society, Best (1994: 54) believes, is 'best interpreted as an intensification of (capitalist) modernity, rather than a wholly new postmodernity'.

That is to say, capitalism in recession intensifies its normal codes of procedure (e.g. intensifying marketing, downsizing the workforce), which pushes people to the limit, but which doesn't mark anything distinctive in its behaviour from previous recessions. The process of social change can indeed seem like Baudrillard's simulacrum. When the world one has always known begins to disappear or change out of all proportion; when the skills that have taken a lifetime to learn and apply are overnight made obsolete; when cultural, social and economic practices and values that have seemingly always been intact are suddenly portrayed as worthless – then one can feel very much in the simulacrum. Objects, signs, sounds, images of all kinds, take on a heightened importance.

Best (1994: 57) believes that the most important aspect of Debord's work is in demonstrating that 'self-referentiality does not entail hyperreality'. In collecting terms, this is because – if based in a subject–object, rather than a sign–exchange relationship – there is always 'the real' to be salvaged. As Askegaard and Fuat Firat (1997: 129) note: 'Goods of all kinds are becoming consciously used as cultural markers or means of expression whose individual and social importance in any context goes far beyond their utility'. When, however, anxiety, concern or disruption recede (which, it is argued in Chapter 4, are the main imperatives of contemporary collecting), so does the intensity of emphasis placed on the collected object. Its meaning becomes recontextualized. It is like a piece of a jigsaw puzzle that recedes back into the completed whole, rather than standing proud from it. At this point, the collected object's self-referentiality is revealed. The underlying subject–object and social relationships are shown to have only been temporarily masked by the spectacle. However, for the period when the collected object is at its mystical height in relation to the collector's perception of it, it is indeed the vessel of hyper-reality. As Pomian (1990: 27) suggests:

> Two moments have special significance in the passage in time of each phenomenon: the moment of its appearance when it crosses over from the invisible to the visible, and that of its disappearance, when it moves from the visible to the invisible.

The analysis of self-referentialism in relation to hyper-reality is valid, but only in a rational and objective situation. Hyper-reality, after all, is the very apex of subjectivity. The experience and perception of social change, and the intensity with which objects take on new values or meanings to the individual, do then constitute hyper-reality. Only from the vantage point of the detached observer can we see the material (and Marxist) actuality, as Pomian (1990: 31) again demonstrates

> when one group sees something as a semiophore, another, or indeed the same group but at a different moment, sees it as a potential usage value. The more an object is attributed meaning, the less the interest which is taken in its usefulness.

It would, however, be false consciousness to believe that this is an end-game, because ultimately the new becomes the orthodox, and inevitably a new order or stability entails. This is the lesson of history that Baudrillard chooses to ignore, while Debord grounds his work in it.

Askegaard and Fuat Firat (1997: 132–6) have usefully outlined the nature of the hegemony of the economy in modern life, which they refer to as the 'unidimension-alization' of society. The conundrum is to find re-enchantment by establishing a 'multidimensionalisation' of society, in which all social goals are negotiated on an

equal basis. Objects in modern society take on the role of capital, they become perceived as cultural currency. In collecting, this tendency is heightened still further. The context in which they are seen adds another dimension to them. In this sense, at least, collecting can be interpreted as a means by which re-enchantment with society can be facilitated; it is an aspect of multidimensionalization. Debord recognized this when he discussed the change of the role of a commodity from use to value. He uses the example of the gadget. We may use any number of objects that might find their way into private or social history collections of museums. For example, the 'cult' of 'Mr Blobby', a pink-and-yellow Styrofoam creation of TV presenter Noel Edmunds, which regularly finds favour with audiences by embarrassing people on TV, or engaging in childlike playfulness. This gave rise to a mini-industry of 'Mr Blobby' merchandise and ultimately the opening (and closing) of Blobbyland in Morecambe, Lancashire, where any number of 'blobbyesque' scenarios could be encountered. Debord's (1983: 67) deconstruction of the gadget is equally applicable here when he says: 'just when the mass of commodities slides towards puerility, the puerile itself becomes a special commodity'. Perhaps we are not far away from an illustrated guide to the collectable Mr Blobby!

What is noticeable about contemporary collecting is its historical and cultural scale. Largely items from the nineteenth century to the present day are collected, and they are usually those items, such as beer cans, which hitherto have not had any importance attached to them. Pomian's (1990: 7) example is the old Polish lady who 'picks up orange, lemon and grapefruit wrappings'. These objects become celebrations of the contexts from which they are now divorced, like souvenir fragments of the Berlin Wall, deconstructed in substance but reconstructed in memory. The uncertainty pervading our society leads to anxiety and a need to grasp something more certain. This is often expressed through collecting, especially when an object related to the collector's childhood stands as a symbol of the certain, the safe, the known, the unchangeable past (a Meccano set, a Golly brooch or a copy of *Beano*).

Debord described what he called 'spectacular time'. This, he says, is when real time is replaced by advertised time, in effect hyper-reality. In this scenario, our sense of real time is circumvented by the spectacle as presented by the media, advertising, etc., whether an event (such as the celebrations of the 50th anniversary of VE day in May 1995) or an object which focuses on a specific theme or time slot. Museums do this all the time. Set against our own time, Debord's (1983: 154) words sound especially salient thirty years on:

> The epoch which displays its time to itself as essentially the sudden return of multiple festivities is also an epoch without festivals. What was in cyclical time, the moment of a community's participation in the luxurious expenditure of life is impossible for the society without community or luxury.

The celebration, he believed, is a deception 'always compensated by the promise of another deception' (Debord, 1983: 154). In the same way, collectors can be said to be deceiving themselves through the act of collecting, or perhaps more accurately, tricking time.

The collection is the realization of dream-time. This dream-time is what collectors have over museums, the indulgences of oneself in one's own specific collection, as opposed to the curators' need to rationalize and inform through the museums' many

collections. However, Debord says the world needs to get at the consciousness of the dream-time it already has. The consciousness is the object, which is realized through its existence and its recontextualization in, effectively, hyper-reality.

Debord writes of spectacular consumption. He was thinking largely of mass-produced consumer goods, but it is equally applicable to collectables. He writes of spectacular consumption preserving congealed past culture, which culturally becomes 'the communication of the incommunicable' (Debord, 1983: 192). The collection does exactly this and is very often beyond the collector's understanding or ability to explain. The collection can perhaps be understood in Debord's terms by what he claims the effect of the spectacle is:

> The spectacle obliterates the boundaries between self and world by crushing the self besieged by the presence–absence of the world and it obliterates the boundaries between true and false by driving all lived truth below the real presence of fraud ensured by the organisation of appearance. (Debord, 1983: 219)

In the 1990s we have entered the age of the digital revolution, which at one and the same time is claimed to be both a liberating development in humanity's system of communications (Gates, 1995: 1–2) and an ominous sign of potential global control by a technocratic elite (Gibson, 1984; Shwartau, 1994; Harrison, 1995; Lasch, 1995). These are Debord's thoughts written large, where the real and the surreal combine in cyberspace, offering a computer-generated third dimension. In Debord's terms the true becomes nothing more than a moment of the false (Debord, 1983: 9). Kellner (1995) argues, however, that the coming of the Internet and its boundaryless communication capability has enabled national and international political considerations to be rendered meaningless to those who actively engage with it, as reflected through the fiction genre of cyber-punk (Kellner, 1995: 297–314).

Debord felt a sense of loss which is reflected today in the outsider politics of anti-motorway groups, New-Age travellers and animal-rights protesters. These are in themselves a result of the commodification of society that Debord foresaw. This gives rise to social uncertainty which leads to collecting as a form of talismanic protection. He used the Marxist theory of false consciousness, which he refers to as 'the deceived gaze' (Debord, 1983: 3). *Society of the Spectacle*, by today's standards, can sometimes read rather quaintly in places, but is as relevant today as it was in 1967, if not more so. Debord writes about alienation as an inevitable corollary of an expanding economy (Debord, 1983: 32), which is perhaps greater now than at any other time in the past and which is a key factor in the practice of collecting. Society becomes dominated by the intangible as well as the tangible, which clearly prefaces hyper-reality and the coming of digital culture when he writes: 'the tangible world is replaced by a selection of images which exist above it, and which simultaneously impose themselves as the tangible par excellence' (Debord, 1983: 36). What is cyberspace if not intangible?

Debord foresaw the coming of niche marketing (a key issue for Toffler, see Grant, 1996) and what is now the virtual compartmentalization of society into target groups for advertisers and service provision which also plays an important role in collecting. He notes:

> one who collects the key chains which have been manufactured for collection, accumulates the 'indulgences of the commodity', a glorious sign of his presence amongst the faithful. (Debord, 1983: 65)

The religious wording is perhaps no accident. Materialism is indeed the most worshipped of gods.

Café society, once the life-blood of French intellectualism, can in Britain be seen as another example of compartmentalization. There is already the Hard Rock Café and Planet Hollywood restaurant in London, themed by rock music and American cinema. There is now a Sports Café, and most recently, a Fashion Café (Quinn, 1996: 4) to add to the burgeoning cyber-cafés. The brewery-owned theme pub and the museum-challenging theme parks of the 1980s are direct forerunners of these; the process seems to be accelerating.

The spectacle proclaims an unreal unity; what obliges the world's producers to construct the world is also what separates them from it (Debord, 1983: 72). Debord wrote: 'The world already possesses the dream of a time whose consciousness it must now possess in order to actually live it' (Debord, 1983: 164). The collector has the dream, the deceived gaze, in mind when collecting. The knowledge of the subject collected is the consciousness which allows them to live in that time. This applies as much to members of the Brontë Society as to collectors of early plastics. Debord asserts:

> Because history itself haunts modern society like a spectre, pseudo histories are constructed at every level of consumption of life in order to preserve the threatened equilibrium of present frozen time. (Debord, 1983: 200)

Figure 3.1 Binary opposites

Collections	Real life
Escapism	Entrapment
Fantasy	Factual
Familiar and comforting	Alien and harsh
Community (clubs)	Individualistic/atomized
Aesthetic currency	Fiscal restrictions
Real friends	Temporary acquaintances
Certainties	Doubts
Stable platform	Shifting sands
Controllable environment	Controlled by environment
Social cohesion	Social disintegration
Permanent	Transient
A known/safe past	Unknown/uncertain future
Soothing/reassuring	Anxious/undermining
Actively rewarding	Passively receptive

People have a false consciousness of the society in which they live because of the spectacle's commodification and management of it, like Muzak in shopping malls. Debord writes of the

> failure of the faculty of encounter and its replacement with a hallucinatory social fact . . . in a society where no-one can any longer be 'recognised' by others, every individual becomes unable to recognise his own reality. (Debord, 1983: 217)

For the collector then, a recognizable reality is built through the collection. It is both their reality and their dream-time, where stress can be eased by slipping effortlessly into a reassuring time capsule. Figure 3.1 illustrates how the parallel world of collecting relates to reality. Danet and Katriel also define the following binary opposites which are complementary to the above: decontextualization/recontextualization; concrete/imaginary; order/chaos; open-ended/highly directed; rationality/irrationality; controlling/being controlled; isolation/affiliation; energizing/relaxing (Danet and Katriel, 1994: 28–34).

Binary opposites and the masquerade of the sign

Binary opposites are those which enable us to distinguish between progress and regression; good and bad; right and wrong; pain and pleasure. They are the foundation stones of an ordered society – one is the twin of the other, like heaven and hell. Without our acceptance and understanding of these pairs of binary opposites, we would be literally living in Baudrillard's simulacrum, a world of chaos where everything loses its self-referential status, a virtual anarchy. What marketing does (as cultural engineering), in late capitalist society, is take pairs of binary opposites and subvert their relation to one another, with the end result that our reasoning of the contradictions that lie therein is rendered unreadable.

One way of illustrating how widespread binary opposites are, and thus to place collecting as one of them in a wider social context, is to look at sport. Consider an obese man smoking a cigarette, dressed in an Adidas® shell suit. Adidas® manufacture sportswear such as training shoes, shell suits and so on. Sportswear has been assimilated by popular street fashion and is as likely to be worn around town as comfortable leisure wear as it is as sportswear. The origins of the clothing as sportswear does not raise any sense of self-consciousness or irony, because the function of the clothing for its original purpose is completely overridden by its function as leisure wear. The design or fashion statement that it makes via its brand name makes it become 'other'. The binary opposites that this image represents are of course obvious; smoking and obesity equals a potential threat to health if not life itself, while sport equals health and life-enhancement. The two should be recognized as 'good' and 'bad', but they have been homogenized by marketing to make their original base values meaningless in the context in which they are being used.

Barthes (1972; 1979) in Kellner's words 'saw that advertising provided a repertoire of contemporary mythologies' (Kellner, 1995: 247). That is to say, the literal is reified to signify a multiplicity of referents, with boundless potential for expansion. Although the real world is not a simulacrum, the media world is, especially in televisual advertising (Kroker and Cook, 1986: 274). Cyberspace is even more so.

The sponsorship by tobacco companies of sporting activities such as the Benson and Hedges (cricket) Trophy, or motor sport by Marlboro and John Player, has long been criticized by medical and health groups. New legislation has only partially addressed the issue. When one thinks of cricket and the Benson and Hedges Trophy, the words seem synonymous with the sport itself (which of course is the desired effect), like 'green' and 'grass'. The words seem more compatible with Wisden's Almanac (the cricket bible) than with a cynical marketing ploy to link health risk (smoking) with health enhancement (sport). The same is true of Marlboro's sponsorship of Formula One racing, an attempt to glamorize a health hazard by

equating smoking with excitement. Again in this example, the binary opposites, health risk and health enhancement, are blurred into a symbiotic relationship of 'goodness'. That is to say, corporate sponsorship of sport equals the enhancement and popularization of sport so the negative aspect of who is sponsoring it appears sublime. Kellner concludes that 'the images of healthy nature [in Marlboro cigarette advertisements] are a Barthesian mythology which attempt to cover the image of the dangers to health from cigarette smoking' (Kellner, 1995: 250).

Thus, as is demonstrated through the example of sportswear, the simulacrum seeps out of the world of the ultra-commodity that is advertising and takes on certain material aspects. In this way the society of the spectacle is not only presented but enacted. Here, I would contend that the difference between collecting and consuming occurs. Collecting seems largely to be a practice used in self-defence *against* the society of the spectacle, whilst consuming, *per se*, is an act of engagement *with* it. In this sense, then, the binary pairs which we live by, although tacitly intact, are reified to suggest multi-referentiality to our environment and to objects both within and of it. These can be expanded, but rarely contracted, at any time marketing culture wishes to diversify the image referents to some other product.

Collecting as masquerade

Contemporary collecting works in much the same way. The theatrical symbols of the two masks of comedy and tragedy can be used to illustrate this. On a conscious level we have adopted the mask of comedy, believing that we aesthetically choose and like what we collect, helping the ever-elusive feel-good factor that politicians cherish so dearly. Subconsciously, the reason we collect is often otherwise. Collections act as a means by which we can exist in a state of denial. It is the mask of tragedy we really wear. Collections console us in our melancholia. We are in a state of mourning for the world of the familiar which is passing, as indeed Debord was. We gather round us objects and images which reassure us psycho-culturally that we still have an identity and worth in a society which seems to deny their existence, or at least their value. We touch them as though prodding a dead pet, unable to believe in its demise. We delude ourselves with objects. Collecting can therefore be read as symptomatic of our anxiety and insecurity. In postmodern culture, Baudrillard argues, the individual no longer experiences anxiety but rather an implosive hysteria, brought on by the bliss of multi-referentiality (Kellner, 1995: 233). However, that would be to deny the materially grounded basis for collecting in the first place, which is born out of concern for one's material future and security. Kellner concurs with Best (1994: 54) in believing that 'identities are . . . still relatively fixed and limited, though the boundaries of possible identities, of new identities, are continually expanding' (Kellner, 1995: 231).

In our own time, the digital revolution offers the most obvious gateway into playing with alternative identity, a wilful exploration of transforming oneself into a future of infinite possibilities. Collecting can also be used for this purpose, but is more often a means by which to reclaim or reassert a lost certainty of identity from the past. As Kellner contends:

> Once upon a time, it was who you were, what you did, what kind of a person you were – your moral, political and existential choices and commitments – which constituted individual identity. But today it is how you look, your image, your style and how you appear that constitutes identity. (Kellner, 1995: 259)

Thus in times past, one's self-definition was coded by a set of attitudes and behaviours which were seemingly perpetual. Today it has to shift with the requirements of the day, being what someone else wants, not what one is, and hence the fascination with objects and collecting. Objects 'are'. Their solidity is in itself reassuring. We, however, only 'might be' and can never quite know if or what we 'are'. We can only reify that which 'is' (the object) with what we want or value, and hence recover our psychocultural balance.

Collecting is in many ways a material means of expressing ourselves in the third person, a time-honoured literary device. For instance, James Fenimore-Cooper, author of *Last of the Mohicans*, used his novels to right perceived wrongs in his actual life. His father was a judge and property developer, on whose death an expected large inheritance was gobbled up in debts. In 1820, Cooper wrote his first novel, *Precaution*:

> In fiction he discovered a reassuring power to control characters and plot; a power that was especially intoxicating because he was so impotent in the real world. (Taylor, 1996: 22)

> In [his third novel] *The Pioneers* (1823), Cooper reaffirms his self-worth and reclaims his legacy by imagining and crafting an improved past where property and power flow from a well-meaning, but flawed father to his perfectly genteel heirs. (Taylor, 1996: 24)

The collection allows us to form our own vision of reality, in which the rough edges are smoothed over, just as Cooper did through writing.

Showing and hiding

Contemporary collecting is the anaesthetic masquerading as the aesthetic. It acts subconsciously as an anaesthetic in that it keeps anxiety and tension at bay. Consciously we take this to be indicative of the pleasure collecting gives us, but in reality, it is a sign, image or message conveyed by the collected that we use as a palliative for our fears for the future.

This exemplifies Debord's assertion that everything lived moves away into representation (Debord, 1983: 1). The length of linear time and the spatial depth of temporal time are compacted into the smallness of the 'now'. The collected object represents the compilation of the collector's 'greatest hits'. The collector packs his selected experiences and memories into the suitcase of the collected. Made manifest and portable, we feel we can always look to the collection to lift our spirits. This it may well do, and there is no doubt that collections are about *showing* what we are concerned about, or a way of demonstrating what ails us. However, as in the above scenario, they are also about *hiding* and denying those same things.

There is, then, a certain splicing of Debord's self-referentialism and Baudrillard's hyper-reality. Although Debord is right to hold to the subject–object analysis of society, and thereby anchor material relations in a social context, the spaces where the shifts in social change and emphasis occur (Pomian's visible–invisible/ invisible–visible moments) do, for periods of time, constitute hyper-reality. Sawchuck (1994: 97), discussing Baudrillard's *The Ecstasy of Communication*, writes of the

> realm where the packaging is indistinguishable from the product; a realm less concerned with the question of an adequate representation of the sign to the product-referent, than the types of associations being created in the minds of viewers and consumers.

Umberto Eco had previously asked 'who is the mass media?' He uses the example of the trendy polo shirt with a crocodile motif as the designer's label. Advertising initially makes the garment attractive, a generation eventually buys and wears it (Eco, 1987: 148–9). So the manufacturer not only makes profit from the buyer, the buyer, now wearer, is a free walking advertisement for the company. The consumer *becomes* the product referent. As Barthes writes: 'use never does anything but shelter meaning' (Barthes, 1979: 7).

Conclusion

Ultimately Debord's society of the spectacle, where 'every individual becomes unable to recognise his own reality' (Debord, 1983: 217) and therefore identity, is the basis for the burgeoning of popular collecting over the last two decades. Where Baudrillard denies individual identity, as the implosion of the mass becomes the only reality in the simulacrum, Debord recognizes the material and economic base of the loss of the self. However much reification or hyper-reality we perceive in our environment and its products, that grounding is always at the base. As Kellner (1995: 257) concludes:

> Rather than postmodernity constituting a break with capital and political economy as Baudrillard and others would have it, wherever one observes phenomena of postmodern culture, one can detect the logic of capital behind them.

This is the Debordian conception of cultural theory. It simply isn't possible to divorce the material world, as Baudrillard would have us do, from the associations and symbolism that we project upon it. Baudrillard's simulacrum lies squarely in the realm of marketing and advertising (Sawchuck, 1994: 89–119), where far from imploding into the simulacrum as if by some inevitable entropy, the simulacrum is imposed on us as viewers, by its originator – the visual media. Debord recognized this for what it was, a strengthening of the spectacle, or in other words, a sophisticated late-capitalist contrivance to bolster its position in what was to become a post-industrial world. The simulacrum leaks into the material world, as has been discussed, by reifying already obliquely obscured binary opposites, but this inevitably strengthens the Debordian argument by enriching the society of the spectacle.

4 'I collect, therefore I am': history and the social condition

Introduction

Debord's work describes the way in which the marketing of commodities both shows and hides meaning and intent. The response of the individual to this has been, it is proposed, the creation of a complex system of values based variously on functionalism, socioeconomics, aesthetics and sentiment. This chapter is intended to be a vehicle to float ideas resulting from this proposition, and thus act as a platform for further consideration. First, a hypothesis of the possible origins of popular collecting is put forward. British socioeconomic history of the last three decades as the backdrop against which the public expression of popular collecting has occurred is then sketched out. Second, the juxtaposition of everyday encounters with material culture is explored. This is done by using the example of the supermarket to illustrate the oneness that the individual shares with material culture, thus widening the rationality of collecting. Lastly, the notion of 'worth' is discussed, in terms of both financial and aesthetic value, in order to demonstrate the strength of feeling about some very ordinary things. This highlights the singular fascination we have with 'stuff' at the turn of the century.

The hidden history of popular collecting

Popular collecting has a hidden history. Although this study deals with contemporary collecting, it is useful to locate and contextualize the thread that links it to the past. The history of popular collecting deserves a full study in its own right. What follows is far from comprehensive, but at least presents a provisional overview with which to begin further research. The 'history from below' movement began in the 1950s and grew steadily throughout the 1960s (e.g. Pelling, 1963; Thompson, 1963; Hobsbawm, 1964; Lovell, 1969). This gave rise to the popularization of people's history and the disciplines of social history and cultural studies. Yet despite a substantial body of work on working-class leisure, popular collecting has not yet figured as part of it, this despite its prevalence in other areas of contemporary leisure such as popular music (e.g. Beckham, 1987: 88–95).

Collecting in one sense or another is probably as old as humanity itself. Popular souvenirs, in the sense we understand them today, can be traced back to at least the Middle Ages (see Geary, 1986: 161–91). Pilgrimage brooches, such as the one dedicated to Thomas à Becket in the shape of an ampulla and dating from around 1270, were commonplace (Tudor-Craig, 1996: 8–10), whilst further abroad:

In fourteenth century Jerusalem, there was a quarter, the Harat al-Turufiyya, which specialised in the production and sale of souvenirs. *The Saqati* were the specialist dealers in curiosities, mementoes and antiques. It was at this level, the sale of luxury goods, kitsch souvenirs and spurious relics, that the most substantial cultural interaction between Muslim and European Christian took place in the lands once occupied by the crusaders. (Irwin, 1997: 49)

In Britain, by the late eighteenth century, cheap commemorative and decorative pottery designed for popular consumption was commonly available and widely collected (Briggs, 1990: 148–51). It is especially noticeable in specific campaigns such as that pursued by the Anti-Corn-Law League in the 1840s (Briggs, 1990: 169). Political and trade tokens issued during copper shortages were also keenly collected (Rudkin, 1927: 90–4; Brunel and Jackson, 1966: 26–36). Danet and Katriel (1994: 25) also cite the Industrial Revolution as the crucible from which the popular impulse for collecting sprang:

> For one thing, it transformed and expanded the range of items treated as collectibles. The phenomenon of aestheticization of the obsolete was made possible by the Industrial Revolution, notably by the rise of a newly prosperous bourgeoisie, which led to a widespread new interest in objects for the home, and to the democratization of collecting, once the province of kings, princes and the Church.

It is with the improvements in mass-production technology from the mid-Victorian period onwards, however, that the rise of the souvenir industry, and hence popular collectables, is probably located (e.g. Thompson, 1979: 13–33 for his account of Stevengraphs; Briggs, 1990: 147, 152, 173–8 for the rise of popular interest in Baxterprints). John MacKenzie, in his pioneering work on the influence of imperialist propaganda on popular culture, describes how the advent of photography led to the middle-class hobby of collecting cartes-de-visites. These featured images of royalty, famous statesmen, soldiers and theatrical personalities. Yet it was the cheap mass production of the postcard from the 1890s onwards that achieved the 'democratisation of the visual image' (MacKenzie, 1984: 20–1). Cartes-de-visites are not widely collected today; postcards are. By Edwardian times, the collecting of postcards (in particular) and stamps ceased to be sneered at as the pastime of genteel young ladies, and became the 'serious hobbies' (i.e. commercially competed for) of men (Gelber, 1992: 745–51). These remained some of the chief collectables of the inter-war years. Other material such as cigarette cards (Briggs, 1990: 147) were the currency of and carried kudos for many a schoolboy at this time, and have persisted as adult pursuits. By contrast, in America during the 1930s, collecting, as part of a large 'hobbies' movement, was very popular. This movement was dominated by a loose caucus of journalists, academics and other educators who appointed themselves arbiters of 'worthy' pastimes (Gelber, 1991: 743). A need to define and encourage constructive pastimes was thought to be important in order to deflect the minds of unemployed men away from crime, riot or revolt.

Postcards and cigarette cards were as collectable as novelty items at the time of their original production as they are today as artefacts of popular culture. Postcards, indeed, have often been used to explore aspects of social history which would otherwise have evaded professional historians (e.g. MacDonald, 1989; 1994: 5–9; Tickner, 1987; Atkinson, 1992). Other less well-known items such as Goss crested china (a cheap form of china with coloured transfers of civic armorials and town crests, popular from the 1890s to the 1920s) have also enjoyed a sustained collecting interest

(Briggs, 1990: 156–7). Between 1900 and 1932, there existed a 'League of Goss Collectors' who published Goss postcards and a magazine *The Goss Record* for collectors (Howell, 1974: 138; Pine, 1986: 18). What soon becomes clear is that for one hundred years there has existed a popular collecting culture, which until its recent 'coming out' has remained hidden or been considered irrelevant.

There have always been working-class collectors. They are heard of in the mid-nineteenth century, very often as amateur botanists and lepidopterists, walking the hills of Cheshire and Lancashire, collecting specimens and using the Mechanics Institute library for reference sources. The popular movement, the Holiday Fellowship, was started by an Anglican priest in 1913, who discovered such popular interests amongst his congregation (Hardman, 1981: 1–20). We hear also of collectors like Will Sherwood, a veteran member of the National Union of General and Municipal Workers, who had by 1937 been collecting minerals and gems for forty years, and who had a 'practically complete collection of British trade union badges' (*Labour*, 1937: 19). One collector (Tony), discussed in Chapter 5, is now in his fifties. Both his parents, and grandparents on both sides of his family, were strong collectors of popular cultural material and so dates the tradition to at least the 1920s in one family.

The late nineteenth century witnessed the rise in popularity of seaside resorts such as Blackpool, Margate and Southend with working-class 'trippers', who were able to visit due to the advent of cheap day excursions facilitated by the ever-growing railway companies:

> There [were] . . . unrivalled opportunities for the entertainment industry and a veracious new demand for collectable items, which contributed to the taste for bric-a-brac so characteristic of all but the poorest homes. (MacKenzie, 1984: 16)

This is borne out in wider histories of the rise of the seaside holiday industry (Walton, 1983a; Walton, 1983c). Others too have noted that 'collecting was not perceived to be distinct from leisure until the second half of the nineteenth century' (Gelber, 1992: 743). Such end-of-the-pier souvenirs as Mauchlineware (Briggs, 1990: 146), Goss crested china, imitation jet jewellery (the real version of which is currently experiencing a renaissance, see Hetherington, 1997: 12), glass paperweights and the omnipresent postcard were, for the late Victorian and Edwardian working class, more than personal souvenirs. They could also potentially act as harbingers of stolen time from the daily drudge of the labour of necessity, a meditational object with which to free the mind from more pressing material needs. The late Victorian bric-a-brac industry, then, probably represents the starting-point of popular collecting in Britain, as the mass production of such items became widespread. For instance, the development of the drop-stamping machine, along with a tin alloy which vaguely resembled silver in appearance, led to the widespread dissemination of cheap souvenir medals from the end of the eighteenth century (Fearon, 1986: 3) and which took on monumental proportions from the mid-nineteenth century. By the time of Queen Victoria's golden jubilee in 1887, 'ten times as many popular medals were produced for the jubilee than for any previous occasion in history' (Briggs, 1990: 158). The population from the 1880s until at least the end of World War I were also being bombarded with imperial images on packaging and domestic items of all kinds in a bid by the establishment to instil a sense of pride in Empire and as a means of marketing various merchandise by lending royal kudos to their products. This was facilitated by the invention of offset colour lithography in the 1870s (Leeson, 1971; see also Jubb,

1984; MacKenzie, 1984; 1986; Opie, 1985 for examples). The widespread use of enamel advertising signs from the early to mid-twentieth century for the same purpose must have made the main streets of British towns a lot more colourful than the sepia and black-and-white images of them that remain would imply (see Baglee and Morley, 1988). Without falling into the trap of historical back-projection, it would not be unreasonable to suggest that this could have served as a visual stimulus for the population at large to cognitively engage with design, shape and colour.

The improvements in technology throughout the nineteenth century facilitated a correspondingly increased output of images and advertising. The novelty of material such as postage stamps, introduced in mid-century, had, by its end, become various and diverse enough to have inspired a significant body of collectors (Briggs, 1990; Gelber, 1992). There developed a Victorian characteristic of fascination with taxonomy. This is reflected in the numerous entomological, fossil, shell, botanical and taxidermic collections typical of Victorian museums and private collections. The Great Exhibition of 1851 introduced new and exotic commodities to a large new audience (Greenhalgh, 1988; Briggs, 1990; Richards, 1991; Bennett, 1994). The possibilities of consumer society were thus unfolded on a grand scale, and an entrancement with the spectacle was initiated. By the century's end, this fascination had fed through to more popular collectables such as the new postcards and crested china, which imitated the scientific approach of taxonomy, in the use of serialization as a collecting criterion. It is perhaps at this point that the society of the spectacle really develops. The following proposed scenario encapsulates this: Technology and ideology applied to an already developed taste for taxonomy (albeit a largely bourgeois one) begin to commodify that taste. The movement for rational recreation supports the trend, by encouraging museum-visiting and collecting as educational and self-improving pastimes in the 'respectable' working classes. As Hides notes: 'mass-produced goods became integrated into practices through which middle- and working-class identities were articulated' (Hides, 1997: 26). Popular collecting (of approved criteria) then becomes socially sanctioned, as a means of self-education (philately, as an aid to learning geography, is perhaps the most obvious example). Attitudes towards collecting behaviour change as the spectacle's products and innovations become more numerous and common. After World War I, collecting becomes frowned upon except in the very young, for whom it is seen as a means of initiation into consumer society, and the very old, for whom it is seen as a means of occupying empty time, and avoiding melancholia.

The sociopolitical landscape 1945–79

The following sections are intended as broad brush strokes with which to paint the canvas of social change since World War II. It is the scenery against which popular collecting behaviour has emerged. The years after World War II were characterized by the reinvigoration of traditional male-dominated industries and economic and social coherence born from the need to rebuild the country's infrastructure. These were the years in popular memory when 'people never had it so good', in Harold Macmillan's famous words. Jobs were easy to come by. Even the negative aspects of the period, such as continued rationing (until 1954) and conscription to national service (until 1960), can be looked upon as beneficial. Many adults have their childhood centred in the 1950s and 1960s. The toys and modern collectables that

command the highest prices at auctions are those which date from these years. Meccano sets, Matchbox and Dinky models, Robertson's Golly brooches, all have their aesthetic roots in this period (although some had been in production since the 1930s). These things were contemporary with the adult world's belief in Britain's future. This was defined in the popular mind as jobs for life, family stability, council provision of services and welfare under both Conservative and Labour governments – underpinned by a general sense of well-being and social cohesion. It was Edward Heath's government from 1970 to 1974 which marked a new departure.

Heath's manifesto was one of trade union reform and cut-backs in public expenditure. His 1971 Industrial Relations Act heralded the biggest labour movement protest since the 1926 General Strike. The Upper Clyde Shipyard occupation of 1971, the building workers' strike of 1972 (which saw arrest and imprisonment under the Industrial Relations Act), and ultimately the 1972 and 1974 miners' strikes, saw Conservative retreats at each stage. Compounded by the oil crisis of 1973, Heath went to the country in 1974 on the 'Who governs Britain?' question in the midst of power cuts and the three-day week. The election led to a narrow victory for Harold Wilson's Labour Party which would later, under James Callaghan, require Liberal support to maintain its majority.

The Labour Party's tenure of office both under Wilson (1974–76) and Callaghan (1976–79) was one of increasing discontent as unemployment increased. A militant 'right to work' campaign was launched, there was rioting in the streets as anti-fascists clashed with the National Front, whilst the Labour government seemed powerless or unwilling to act. Trade union dissatisfaction with public-sector pay led to the first national firemen's strike in 1977. Rubbish went uncollected in the streets and in total created a new folk-devil 'the winter of discontent'. The seemingly aimless and moribund Labour government was finally ousted by Margaret Thatcher's Conservative Party in the 1979 general election. She, even more than Heath, was determined to curb public expenditure and the perceived power of the unions. Former Chancellor Dennis Healey, going cap in hand to the International Monetary Fund, was invoked as proof of Labour's inability to control the nation's purse-strings.

The moribund nature of the government in the late 1970s was mirrored in youth culture by the advent of punk rock in 1976. This cult railed against the staleness of the prevalent rock culture, the sterility of politics and its lack of relevance to youth in general. Punk rock threw youth culture out of kilter, in that it invoked aspects of every previous youth culture in its dress codes (see Laing, 1985; Savage, 1992). Malcolm MacLaren, the colourful manager of the Sex Pistols, was an ex-art student and an avid situationist in the 1960s. Punk rock and the Sex Pistols provided him with a perfect situationist tool. In the months between late 1976 and mid-1977, MacLaren had 'infiltrated' the Sex Pistols into two mainstream record companies (EMI and A&M) eager to cash-in on a new 'fad'. They soon found they had bitten off more than they could chew, after the Pistols had, with MacLaren's encouragement, alarmed company executives with their outlandish behaviour. MacLaren then walked away with large cheques in settlement of truncated contracts. Musically, artistically, visually, punk was an inverted 'V sign' to the establishment, and propagated the idea of being in control of one's own destiny. Jamie Reid's cut-out newspaper lettering, used extensively for the Sex Pistols' graphics on posters and record sleeves, brought pop art back to street level. This owed much to Kurt Schwitters rubbish collages of

the 1930s (see Cardinal, 1994: 68–97) and to collectors of tram tickets and similar ephemera dating from the same period (e.g. *Guardian*, 1990: 4).

Indeed, the fashion culture made extensive use of rubbish in innovative ways, such as wearing plastic bin liners as miniskirts or T-shirts. Plastic in all its forms became a metaphor for the suffocation of the natural by the artificial, and was celebrated as such by punks as an expression of alienation and identity with rubbish, which they felt society treated them as. They saw themselves as products of a plastic society. Poly Styrene, of the band 'X-Ray Spex', made the most explicit statements of this during 1977, in her songs such as 'The day the world turned Day-Glo', 'Artificial' and 'Plastic bag'. The plastic bin liner, and the safety pin even more so, took on reified meanings, surpassing their utilitarian purposes and becoming statements of identity (or loss of it) as an assertion of otherness (Tilley, 1989: 191; Pearce, 1992: 37). Such otherness has international meaning (e.g. Bar-Haim, 1987; 1988) and such identity exchanges occur on many levels (e.g. Campbell, 1996: 93–105).

Punks mixed musical styles, raided charity shops and turned what would once have been termed 'kitsch' objects like plastic sandals and sunglasses into subversive statements. The intrinsic worthlessness of the appendages and the materials from which they were made stood for the felt worthlessness of the wearer to society, but, in asserting this worthlessness, made the object culturally valuable for the very same reason (see Laing, 1985; Savage, 1992). The punk-rock movement sparked the imaginations of many creative people, promoting the idea that anyone could make a statement of value without having to be an art-school graduate. Much of the creative thrust that has emerged since 1977 has punk to thank as its mainspring. Debord's notion of the puerile as the ultimate commodity (Debord, 1983: 67) found a vivid expression in punk culture.

Punk, culturally, responded most strikingly against the spectacle. Its most puerile commodities were adopted as icons of disaffection, its shortcomings were reflected back at it. Punk, read as a situationist response to the spectacle, was arguably more influential than the Paris riots of 1968, in that although it was inevitably absorbed and recommodified as 'safe' (as 'new wave', 'power pop', etc.) by the spectacle, the influence of punk on popular culture and attitudes has been profound. In using the useless, valuing the valueless, punk challenged notions of worth and made it a part of an overt and outward identity. These same notions can be seen in much of what is currently collected, as will be seen later. The 1970s represented the first dislocation of the post-war consensus of what Britain was about and the direction in which it was heading, the first indication of the undermining of national confidence.

The contemporary social context of popular collecting

It is against the backdrop of the Conservative governments of the 1980s and 1990s, and of 'Thatcherism' in particular, that the growth in popular collecting occurred. Thatcher's declared aims of cutting public spending, curbing trade unions and closing 'obsolete' industries, whilst giving a free reign to the private sector, has led inevitably to uncertainty and insecurity, which I propose considerably conditioned contemporary collecting. The phenomenon of the 'selfish Eighties', in which the few profited at the expense of the many through speculation and privatization, endorses the perception of disappearing values such as communal and civic belonging. Collecting then offers

a surrogate community, which exemplifies or restores in some way to the individual these lost values.

We are now presented with two opposing aesthetics. The first is functionalist, in which people seek to use the new order of things to establish themselves in a perceived advancing wave of innovation and progress. This is most often materialized through advanced familiarity with information technology and streamlined business practices. The second is the antithesis of the first. It is nostalgic and fearful of the future and is facilitated through relationships with material culture, especially collecting (see Belk, 1995). This is reflected through the media via a multiplicity of programmes, of which there are two types. First, there are those which address collecting in various ways such as *The Antiques Roadshow, The Antiques Show, The Exchange, For Love or Money, Collectors' Lot, Mad About Machines* (which included collectors of lawnmowers and sewing machines) and *The Antiques Inspectors*. Second, there are those which take a more sociological look at services, roles and place in society, such as the three-part series, *I'll Just See If He's In*, BBC2's historical survey of the secretary, and the popular sociology of the *Modern Times* series. Others have included a nostalgic look back at the first motorways of the 1950s and a portrait of the electric milk float.

The former aesthetic is a child of the Thatcher/Reagan years which sees its environment in strictly utilitarian terms – the Internet. The new technology of the 1980s became the digital revolution of the 1990s, where global communication becomes accessible from a laptop computer. The never-never land of cyberspace provides a digital alternative environment for the individual while collecting offers a tactile one. The digital environment, though, is also the negation of material culture, by its intangible nature, and so posits itself in opposition to collecting behaviour. Conversely, it is used by collectors to advertise themselves and make new contacts internationally. In the first UK edition of the net surfer's magazine *Wired* (April 1995), the front cover and central article are devoted to Thomas Paine, the eighteenth-century revolutionary and his relevance to the digital revolution. Thus the past is invoked by the futurists which they are otherwise anxious to disown (Katz, 1995: 64–9).

The museological context of this is also relevant. Museums, if nothing else, are a reminder of how things have changed technologically and socially. The visitor can most commonly perceive this in two ways. First as a record of progress, or second, as the world we have lost. Collecting is often about reverting to the safety of the past (be it recent or distant, personal or general), whilst the digital revolution is identified with progress. In this case, no objectified psychological aid (like collecting) is needed to give reassurance. This is because what the future holds is always what is being striven for and therefore has no material culture attendant to it, whereas in the former scenario, what the future holds is what is feared and thus guarded against. This protection often takes the talismanic form of a collection, of emissaries from the past. One collector (Gregory, discussed in Chapter 5) collects badges. He is dismissive of modern pieces, but highly enthusiastic about older issues dating from the 1890s up until the time of his own youth in the 1950s. Here, the anti-spectacle aspect of collecting as a defence of identity is vividly juxtaposed with the spectacle's requirement for us to jettison the old and adopt the new, in the form of digital culture.

Hoole's Guide to British Collecting Clubs (1992) gives details of 108 collecting clubs in Great Britain. Of these 54 have been formed since 1980, and a further 16 were formed between 1975 and 1979. The material which members of these clubs collect

is diverse (see Appendix 3; a comprehensive list of collected material exhibited at People's Shows in 1994 can be found in Lovatt, 1995). Not all the material is contemporary. Older items are often collected, but nonetheless have only become collectable in recent years, and can therefore be said to be contemporary in this sense.

Britain is not the only society in which this phenomenon is occurring. As Dittmar has concluded:

> It may be tentatively argued that the Anglo-American Western world including Canada is characterised by similar systems of gender and economic stratification as well as broadly similar forms of material symbolism. (Dittmar, 1991: 183)

This would also have to include Japan. Japan is as consumer-orientated as (perhaps even more so than) America. Certainly judging by its marketing of Christmas, little is left to be exploited (see Moeran and Skov, 1993: 324–38) and yet even here there is a developing hunger for its own cultural relics. Shinto temples now regularly host enormous collectables fairs, large ones in Tokyo attracting upwards of 30,000 people. There is even a Japanese Antiques Roadshow called 'Family Treasure Assessors' (Takayama, 1996: 39). As Pearce put it, 'the modern world came to define itself both communally and individually, largely in terms of ownership of goods . . .' (Pearce, 1992: 3).

In Britain, the luxury of car and home ownership have become virtual necessities, both of which could be regarded as fetishes. They are not so regarded because of their almost universal appeal. This is reflected in television series such as, first, *Signs of the Times, Home Front, Our House, Changing Rooms, House Style, The House Detectives, Hot Property* and *Moving People*, which look at people's sense of self-definition in terms of their ideas of home (see Williamson, 1997: 6). Second, *A to B: Tales of Modern Motoring, The Car's the Star, Perpetual Motion, Classic Cars* and *Reduce Speed Now*, explore car culture. The torrent of car advertising on television (see Moore and Tucker, 1994: 22) reinforces this. The peoples of northern Europe and Japan are not especially demonstrative in their emotions towards each other and perhaps such tendencies are therefore invested or channelled into their prized possessions, be they collectables, houses or cars. In this sense we use objects to 'speak' for us by proxy when we feel unable to articulate our emotions in a spoken language, even to the extent of becoming cultural megaphones. The intensity of value placed on such life-defining commodities has increased concomitantly with the decline and dismantling of the welfare state and the post-war structures of the caring society. Even the terminology has changed; 'council housing' has been redefined as 'social housing', in order to wean us off the idea of welfarism. Government ceases to operate through 'departments', thus implying responsibility, which become 'agencies', implying that accountability lies elsewhere. The perception of rising crime and the inefficiency in dealing with it, and the media's regular reports of various war atrocities from around the world, all serve to undermine our confidence in human nature.

The second aesthetic is the dark side of the first. For those people whose confidence has been badly shaken by such change and perceptions, the desire for material goods, I believe, increases as a means of re-staking their claim in society. Their belonging is defined for them by material abundance. Anxiety is tempered and depression ameliorated by shopping or treating themselves. Transposed to collecting, the relative decline in many people's living standards in the boom-and-bust economy translates into new phenomena such as car-boot sales, collectors' fairs and markets, where new

cultures emerge and new relationships with objects are formed. Dealers and pitch-holders at such venues deal in collectable stuff which enables people to gain a purchase on their psychological selves. In so doing it may invoke mood swings which feed through to the adoption of collecting, the surrender to a sudden compulsion or the revelation of a means of salvation.

As a means of asserting or defining identity, a television programme (in Channel 4's *Fascism* series) on Tomi Ungerer, a collector of Nazi ephemera, gives a good example of the dark side of collecting. Ungerer lives in Strasbourg, France. He says: 'I've no way of describing myself'. He regards himself as an Alsatian, neither French nor German. He was 12 at the time of the Nazi occupation of Alsace in 1940 and was a member of the Hitler Youth. He detests the Nazis, but regards his time in Nazi schools as 'some of the best years of my life'. He tries to make sense of his childhood and his split identity through collecting the ephemera of the occupation. He says:

> I've been collecting all my life. The Alsatians are collectors, manic collectors. People collect out of insecurity. It's like a cancer, collecting is like a cancer, it grows on you.

He describes Strasbourg as being 'an island between two countries'. He believes that identity is a form of self-defence. His collecting is an assertion both of self-exploration and justification as well as self-defence. As a young schoolboy he enjoyed the camaraderie of the Hitler Youth, but hated what it stood for. He was always drawing and at school was made to draw Nazi propaganda, whilst at home he drew anti-Nazi cartoons. He published a book some while back of all his childhood cartoons, utilizing the ephemera he had kept from the war years. As a consequence, many readers began donating similar material to him, which he says was 'when this collection really started to become a collection'. He describes his motivations in collecting:

> You see it was like opening an abscess or something, it's a matter of demystification. It's a forbidden fruit, Nazi propaganda is a forbidden fruit. It's quite a dilemma, do you put it in the open or hush it up? This makes it very attractive.

Clearly there is an identity crisis in that he was raised to speak French, German, English and Alsatian (an old German dialect). His national identity quandary was compounded by his sentimental affection for his school years under the Nazis and his simultaneous hatred of what they stood for and did. He tries to externalize this through his collecting. He displays two propaganda posters for the camera. The first is a Nazi occupation poster which forbids the use of French. The second is a French poster issued after the war, which encourages the use of French. He also uses old photographs of Nazi soldiers, rationalizing the innocence of one private, who looked as though he was an unwilling conscript, compared to the cruelty in the eyes of an SS officer: 'this bastard' he retorts. Therefore, collecting can be seen as a therapy, a means of exorcizing personal demons. This is also seen in another collector (John) described in Chapter 5. Certainly Ungever is most enthusiastic about the finds his book dealer (therapist?) has made for him of Alsatian occupation material, commenting on its importance as he sifts through it. This dark side of collecting illustrates the depth of meaning it can have for the individual. Ungever may be wrestling with personal demons from half a century ago, but his method of doing so is contemporary. Until recently, such sensitive material would not have been openly

traded as it currently is, and certainly Ungever would have found it more difficult to go public about it.

The Freudian concept of collecting in adults as being anally retentive (see Chapter 2) is expressed in modern society by referring to someone as an 'anorak'. The anorak is a widely recognized signifier of bird-watchers, train-spotters and grown men who never left their parental home and is worthy of a wider semiotic study in itself. In Channel 4's 'Big Breakfast Show', an 'Anorak of the Week' award is made for what is deemed to be the most demonstrative form of this behaviour (Digger, 1995: 17), while the Radio 4 play *Anorak of Fire* (1994) concerns the obsessions of a train-spotter. The Talk Radio host, Steve Wright, invited collectors to ring in with their collecting habits. One caller collected anything to do with Noel Edmunds, a radio and TV host. The following was the response:

S. W.: Are you married?
Caller: No.
S. W.: Do you have a girlfriend?
Caller: I'm looking for one.
(Riotous laughter from studio technicians *et al.*)

The clear insinuation was that sex is a replacement for collecting, people replace things in importance and should do so in adolescence. The message conveyed is 'get a life!' By contrast another caller admitted to being obsessed with Frank Sinatra and collecting anything he could find on him. He admitted to buying duplicate copies of records because the covers were different, and of spending lavishly on boxed sets of CDs, even though he already had all the songs on them. In this instance the caller was given sympathy and his behaviour excused on the grounds that 'Sinatra is undoubtedly one of the greats'. This exemplifies the subjective attitudes that collecting elicits in others. Collecting itself is not frowned upon so much as what it is that is actually collected and whether it has a legitimacy for those who view it or come to hear of it. This is also consistent with the historical proposition that some collecting was socially sanctioned, where it was deemed to be self-improving, and otherwise condemned. This could also be read as a process of categorizing 'worth', a struggle to discriminate between worthy and unworthy objects, in a world which is increasingly full of them. Museums adopt this process as professional practice; on a more routine and daily basis we all engage in it.

We live in a consumer society that provides and services our every requirement. Through collecting we express a need for self-determination. Collecting demonstrates personal control over a material environment of our own making, our ability to determine the outcome. The collection represents the power of creation, and can in its extremity become a reality. This is exemplified by a collector of souvenir spoons (see Chapter 5) who has created an alternative reality through spoon collecting. Also, the world of Breweryana collecting (see Chapter 6) is contrived to create an alternative environment in which the world of beer can be 'lived'. This is not, though, to suggest that such a scenario has not happened before. The American phenomenon of the hobby movement of the 1930s, previously mentioned, was sustained, on the one hand, by society's elite as a means of maintaining social order at a time of mass unemployment and social discontent, and by the unemployed, on the other hand, who by undertaking a hobby, vested their work ethic in it. In so doing, they kept that work ethic alive and fit, ready to reapply it to employment once the economy picked

up. As Gelber put it, 'Hobbies served to confirm the legitimacy of a world view that favoured more work over more leisure by turning leisure into work' (Gelber, 1991: 742).

The difference between then and now is that the economy of the 1930s depended on the same industries and trades (e.g. steel, shipbuilding, mines and factories) as it had in the 1830s. It was expected to continue doing so, and in fact did so as a result of war needs after 1939. In contemporary society, those industries have been massively truncated or have disappeared altogether. It was found in 1930s America that many hobbyists adopted their work occupation, or aspects of it, as their hobby on becoming unemployed (Gelber, 1991: 757–8). This can be seen as a retrenchment exercise in anticipation of re-entering the work force in the same occupation, possibly with a wider or greater understanding of that subject, through the enforced leisure time given over to its study. In collecting we often seem to project a work ethic onto objects and material by collecting them, thus giving it physical presence. There are distinct differences between the two eras, however. In the former, hobbies can be viewed as a holding operation or a temporary work-like alternative to conventional work as Gelber implies:

> Rather than an offspring of either work or play, it is more accurate to view hobbies as an offspring of both; a child of two fathers. (Gelber, 1991: 744)

> Neither work nor play, they [hobbies] combined elements of both and served to legitimise each to the other. (Gelber, 1991: 751)

In contemporary society, the end of mass, centralized employment and the ensuing social ruptures, mean hobbies can potentially assume a much higher profile of fixity and permanence as new technology has eradicated the old. Second, the social phenomenon of the affluent teenager and the existence of a distinct youth culture, was a product of a recovering economy from the 1950s. This has by now created a significant memory of and longing for its material culture. The sociocultural diversity that we have undergone since 1945, the liberalizing of values, shrinkage of the world and general quickening of pace in change of all kinds, has concomitantly left us with a half-century legacy of popular folk memory, encapsulated in its material culture. In this climate much of our contemporary material culture becomes, or is actually marketed as, collectable (or in a larger form necessary to preserve). This is again distinct from pre-war years when apart from minority cult collectables such as jazz records, or well-established ones such as coins or stamps, most contemporary material was functional or decorative, any potential post-utilitarian existence (such as in a museum) was by accident or good fortune rather than design. Gelber asserts, then, that we tinker or play with, study or otherwise engage with stuff, as a kind of halfway stage between work and play. In Debordian terms, hobbies are a kind of way station, or pit-stop in which we may either develop anti-spectacle traits such as collecting old, innocuous and inexpensive things or, conversely, re-engage with the spectacle by accepting the utilitarian worthiness of new commodities over the acquired taste for old ones.

What links collecting in the two eras is that they are both serious leisure. Stebbins notes that a tendency of serious leisure is that it requires perseverance and that often it becomes a career:

Careers in serious leisure frequently rest on a third quality, namely, significant, personal effort based on special knowledge, training or skill, and sometimes all three. (Stebbins, 1982: 256)

Other research has concluded that 'the borderline between realms of work and leisure in our postmodern world is experienced as increasingly blurred' (Danet and Katriel, 1994: 51). By taking their leisure activities seriously, collectors have become more refined and sophisticated in their knowledge. Unemployment and under-employment have allowed them the time to study more deeply their chosen field of collection. It is, at least in part, from such fundamental social and cultural shifts in values and perceptions that extra-museum collecting has developed at such a volume and speed in recent years. With the decline or absence of industries and trades in which to become employed, the idea of one's hobby becoming a means of self-employment takes on heightened potential. Hence one reason for the voracious market for dealing in and collecting 'stuff'. The specialist knowledge necessary to become literate in one's chosen 'leisure profession', as it might be termed, is nearer to hand than in the 1930s. Television teems with programmes on collectables and their values; price guides and collectors' reference books cram the shelves of bookshops; collectors' fairs and car-boot sales are held every week. Into such an environment, the focus, energy and acumen of the work ethic can be concentrated, resulting in a frenzy of supply and demand for objects ranging from the mundane to the magnificent (see *Collect It!* magazine, June–December 1997 for examples). Stebbins defines 'serious' collections as those from which can be developed: 'a technical knowledge of the commercial, social, and physical circumstances in which their fancied items are acquired' (Stebbins, 1982: 260–1). He cites conventional items such as stamps, rare books, butterflies, violins, minerals or paintings as examples of such collectables, whilst citing the 'casual collecting' of matchbooks, beer bottles and travel pennants as:

> at best a marginal instance of hobbyism (to coin a new word). Here, there is no equivalent complex of commercial, social and physical circumstances to learn about; no substantial aesthetic or technical appreciation possible; no comparable level of understanding of their production to be developed. (Stebbins, 1982: 261)

Whilst there should be no quarrel with the former, the latter is in contemporary collecting just as serious. It could equally be argued that a casual approach could be adopted towards stamps or coins, etc. The dismissal of such items as beer bottles as materially unimportant is what has kept a considerable body of social history hidden from museums and revealed to private collectors.

For those with a regular income, urban/suburban lifestyles provide life's necessities without much effort in their obtaining (e.g. the advertising slogan 'Argos superstores take care of it'). Hence that aspect of human nature which tends to become frustrated or lacklustre without the proposition of a challenge is socialized and codified through collecting. The hunt for the addition to the collection, the research on our chosen subject's history (preservation of the object through knowledge of its use and origins) are all symptomatic of our need to be recognized as mortal and individual, not simply placid recipients of a service-provision environment. This can thus be seen as a form of resistance. We save money for economic and material security, we save objects for cultural and aesthetic security and psychological sanctuary. Whether money or material culture, it is felt to have a value which is intrinsic to our own preservation. Collecting feeds a need to make a material statement about the human condition and the

homogeneous nature of modern Western society. Our individuality is built externally through the collection, the unusual decor of one's home, etc. The making of something as one's own is the essential manifestation of the need for self-determination and ultimate control of one's own environment. This is perhaps illustrated by collectors of such items as fluffy toys and animal ornaments, who distribute them throughout the house. The objects are held to 'live' in certain places and may even be used functionally (e.g. owl-shaped teapots, etc.) as they are by one collector of camel images (see Chapter 5).

The collecting of badges and memorabilia of Butlin's holiday camps, especially of the 1950s, is widespread. Those who were regular attenders at the camps in their heyday incorporate their collections into their living space to act as touchstones for remembrance and subconsciously perhaps as talismans to combat the bad news of modern society, in which sense they are weapons of self-defence. Many other people collect Butlin's memorabilia, who have never set foot in a camp, but to whom the iconography of its souvenir and advertising material represent something that is perceived to have been lost, a sentiment of popular value no longer present in society (e.g. communal leisure, sharing, simple pleasures, etc.). In fact Butlin's (now owned by Rank) have initiated their own museum, thus demonstrating the appeal of its imagery (*Butlin's Loyalty Club Newsletter*, 1994: 15).

Collecting as a means of resistance is subconscious, but as a nation renowned for its conservative attitude towards change of any kind, Britain exemplifies the often complex and multifarious levels of engagement with objects as coping mechanisms. Contemporary collecting should, I believe, be seen in the context of transition to a post-industrial society. As in most other spheres of modern life, boundaries dissolve, old certainties become meaningless and everything is up for grabs. What for the last two decades in Britain has been sold as 'opportunity' for the entrepreneur is, for many, nothing more than the encroachment of poverty and doubt about the future. As others have observed, 'instead of the economy being in the service of the consumer, the consumer is often present in circumstances that enable the economy (that is the activity of entities that yield economic value) to be healthy' (Askegaard and Fuat Firat, 1997: 132). Debord would probably recognize this as 'the deceived gaze', the hegemony of the economy, disguised as the freedom of choice and expression. It is further noted that 'The interesting thing is that we conceptualise and signify our intervention in the market through the use of our wealth or incomes as non-intervention, as the "natural" flow of things' (Askegaard and Fuat Firat, 1997: 134). For Debord, this would probably not be surprising. It simply illustrates the strength of the spectacle's (late capitalism's) illusion.

Fin-de-siècle anxiety

The uneasiness felt by many, it could be argued, is no more than a cyclical repetition of social fears that accompany the end of every century. A postmodernist interpretation of them, it could be argued, is little more than fatalism or faddism. Certainly major themes of concern can be located at the end of centuries past (Briggs and Snowman, 1997). The early nineteenth century witnessed serious reactions against the new industrialism, and in the early twentieth century fears about the falling birth rate amongst the middle classes and the poor condition of working-class health gave rise to premonitions of racial extinction. The bogeyman for the twenty-first century is

the disappearance of that which has been railed against during the previous two hundred years – industry. However cyclical *fin-de-siècle* anxiety may be, it does not invalidate the examination of the contexts which gave rise to it and the implications it holds for the future.

In a post-industrial society, devoid of the architecture and material culture which determined one's sense of purpose and self-dignity, we now look on the years of mass production and urbanization as a golden age. Yesterday's mass produce becomes today's rarity. Its commonality enhances our awe as we gaze in wonder at the assumed simplicity of the times it seems to reflect and in which it was used. We nostalgically lament yesterday's mass produce because of the abundance and certainty which its unlimited nature represented. We sigh at the paucity of our own times, our lack of confidence and its use as a cipher for rarity and necessary acquisition. The concept of the limited edition (Plate 4.1) has now been used as a marketing tool for everything from chocolate bars to cars (see also Walker, 1997: 260). 'Just in time' provision of staff as well as commodities has replaced job security and the abundantly overfilled shelving space of warehouses. Manufacturing qualms about market share, and public tendencies to save rather than spend, lead to minimal runs of any manufactured good. This is then marketed as a limited edition. Just as our publicly owned national

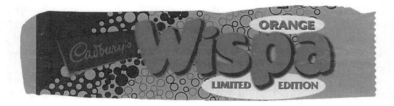

A

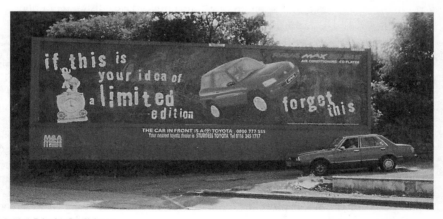

B

Plate 4.1 Limited editions
A. Sweet wrappers. Cadbury's Orange Wispa limited edition chocolate bar wrapper. Reproduced by permission of Cadbury Ltd.
B. The car. Limited edition car poster. Photographed by the author.

assets have been privatized and sold back to us as shoddy goods, lack of inward investment reflected in the trend towards niche marketing leads therefore to much smaller quantities of manufactured goods. This is marketed as a special opportunity not to be missed when in fact it is only a lack of confidence in manufacturing industry, leading to restricted output.

Arguably we increasingly perceive ourselves as moving towards a society where cyberspace and information (intangibles) are the centre of people's lives rather than places or things (tangibles). As our children grow up with digital technology, in all its sophistication, as normal a tool for them as a ball-point pen, we worry about being left behind and becoming redundant. We disguise this by celebrating the fact through humour. The 10-year-old boy who has to teach his otherwise self-reliant father how to use a computer was a favourite of the early 1990s. Behind the façade, however, the discomfort is often real. Clearly people cannot live every minute of their lives in a permanent state of worry, but in so far as it colours our decisions and thoughts about our futures, it needs a palliative, a salve. Collecting acts like a material aspirin. It gives relief to the intensity of our tensions by allowing us to enter a fantasy world. The same effect was noticed more obviously in the inter-war years when cinema visiting was at its height.

In contemplating things there develops an awareness or conviction that anything which is currently familiar, but not recent in origin, could at any time be phased out, and this lends an urgency to its preservation through collecting in one form or another. Consider the door, for instance. As we move towards a sleeker, more efficient architecture, it may well come to pass that doors will only be accessed by use of a number pad or a swipe card, as many commercial ones already are. This then makes handles redundant. It is perfectly feasible that British television will then initiate a series on 'classic door knobs', or a 'door-knob collectors' club' will take root. Already there is a 'Society for the Protection of Electromagnetic Species' which seeks to preserve the test-card transmissions of the days before 24-hour television. Another society exists to preserve the 'Muzac' that was played over them, and a recent CD compilation, *Test Card Classics*, was a best-seller amongst the nouveau easy-listening public.

Displacement and reassimilation

Communications and technology are advancing at a heady rate. The house-owning democracy of the 1980s turned into a negative-equity nightmare in the 1990s. The decentralization of work patterns plus part-time and self-employment account for an increasing proportion of people's income. The concept of the job, certainly of a permanent one, is fast becoming anachronistic, even to those who have been professionals all their lives (Pilkington, 1996: 23). Consequently the nature and shape of communities and living spaces are in flux. As older residents of a community die off or move into communal homes, they are replaced with an increasingly transient and restless population, whose roots are more likely to be in cyberspace than in any specific geographical area as they search for temporary contract work around the country or abroad. This inspires little confidence or investment in permanent roots (see Pilkington, 1996: 23). In times past when such economic and social upheaval has occurred, resort to violent opposition has been the reaction (e.g. Luddites in the 1810s against power looms and Captain Swing in 1830 against agricultural threshing machines). The advent of the single-issue campaign on issues such as poll tax, live

animal exports, vivisection, nuclear disarmament and motorway extensions, all carry on this tradition and reflect the alienation felt by many from conventional politics. This alienation is emphasized every time a politician refers to 'the taxpayer' (as they invariably do) when talking about 'the nation'. They thereby exclude the unemployed, pensioners and other non-taxpayers, who are rendered non-citizens by definition. This also serves to re-codify belonging with economic rather than social values. More subtle resistance, however, can be reflected in other ways.

Since the 1970s, 'retro-chic' in dress, house decor, etc. has become less a matter of eccentricity than one of style, hence Alex Woolliams, 'the man who lives in the Thirties' (*Best of British*, 1995: 8–9), does not seem at all out of the ordinary when he is pictured sitting in his 1930s-decorated living room. The BBC2 interior decoration series *Home Front* contained an episode on retro living (1996). This featured a man who decorated his house in the style of William Morris (he even wore a similar moustache to Morris), a young couple of nouveau mods, who decorated in authentic early-1960s decor and a French woman who did the same with the late 1960s and psychedelia. Also featured was Christie's first-ever 1960s design auction in which a 1967 inflatable plastic armchair sold for £230. Such themed living space, although not the norm, is increasingly popular. British Television's light drama reflects the appetite for nostalgia, with series like *Heartbeat* (Carlton TV) portraying the lot of a young rural policeman in the 1960s, or more recently *And the Beat Goes On* (Channel 4), which serves up familiar soap opera fare, but set in 1960 with the moral attributions characteristic of the age and echoing John Major's 'back to basics'. Although such tendencies clearly have nostalgic foundations, this is too convenient a dismissal. The word 'nostalgia' is derived from the Latin words for *return* and *sorrow* and was considered originally to be a medical condition (Starobinski, 1966: 84–5). It is therefore a state of lament. People born in the 1960s and 1970s cannot in the strictest sense yearn for a historical period they have never known, but the 'aura' (see Benjamin, 1982b) of its historical mystique offers a cosier and more certain environment. Physically, in older material, it is often a certain element of style or method of production or care and attention to quality of detail that attracts us to objects of the past. When they were contemporary to their period, they were not necessarily seen as anything out of the ordinary. In this sense a conscious mourning for the passing of the values of an age disguises the subconscious rejection of the seemingly soulless present, which seeks to skimp on quality and pay only a passing care to style. In so doing, the growth of the reproduction market has been encouraged.

The burgeoning of postmodern collecting is a boom industry. The material-(object-)centred society, however, can be perceived as being superseded by a non-material one. For instance we are often told that with the advent of the smart card, we are heading towards a cashless society, and the Internet implies a new focus of value away from material objects and onto information as the new fiscal and cultural currency in the marketplace of cyberspace. There is a growing body of work which might usefully be called 'anxiety literature'. This warns of the disappearance of the job, the vulnerability of personal and corporate computer records and information and the imperative of keeping up with new developments, which you fail to do at the risk of losing your job or even your career. These writings have an echo of the German invasion scare stories of the early 1900s, only this time the enemy is more insidious, intangible and even invisible (e.g. Campen, 1992; Shwartau, 1994; Bridges, 1995; Hutton, 1995; Lasch, 1995). Programmes such as BBC2's *The I Bomb* and *Visions*

of Heaven and Hell, dealing with the apocalyptic nature of new technology as much as the potential benefits, contribute to the overall sense of unease at what we are told is not just around the corner, but already here.

A film of the early 1990s, *The Net*, starring Sandra Bullock, tells the story of a software repairer who inadvertently stumbles on a computer security system with a built-in flaw designed to extract any confidential information required from the systems it is supposedly protecting. When discovered, her identity is erased via the Internet on all public and corporate records. To all intents and purposes she does not exist, she has been murdered in cyberspace. This may sound like typical Hollywood fantasy, but there are factual cases that suggest how seriously the Internet is taken in this respect. One John Goyden sued for divorce, on the grounds that his wife committed adultery in cyberspace via their computer, with a man she'd never met who lived on the other side of America (Katz, 1996: 3). Microchips that can steal your mobile phone number out of the air, or discover your bank account PIN code from an ATM (automated teller machine) after it has been used, are common fear factors amongst some groups in today's society.

Since the 1980s financial institutions have referred to their services as 'products', as though they were something tangible, reluctant perhaps to abandon the nation's manufacturing past by shipping in old value-loaded terminology which is ultimately empty of substance. The ultimate non-product – information sent as net transmissions – will no doubt be ascribed the same corporate labels to imbibe them with the familiarity of ownable substance. In an uncertain world, people look for that which offers them psychological sanctuary and material confidence, and many have found this in collecting. Collecting, I propose, is a cleaving to the mass-produced at a time when production is ceasing to be mass. Where once mass production was derided for its easy vulgarity of style, it is now remembered with affection as a symbol of abundance in our current age of paucity and lack of political will and vision. Graham, a member of the Leicester Collectors' Club (see Chapter 6), collects vintage electrical appliances, especially from the 1920s and 1930s. He states that

> There's very little research been done on the history of popular manufactured goods. It's not fine art, decorative art, it's industrial produce. Short of company histories there's very little research been done.

So like the Wrangler Jeans advertisement which proclaims: 'every pair tells a story' (bus shelter advertisement, Leicester, 1996), the uniformly mass-produced can now be invested with its own character. That which was the same can now be viewed as individual. This is even more the case in such mass-produced items as early plastics, which are widely collected. In early production runs, colours and shades were unstable and so infinite variety can be found. Thus the all-embracing standardized product can be imbued with its own personality.

Those with the concerns that Bill Gates, the billionaire owner of Microsoft, sketches below are just some of those who wish things were otherwise, despite Gates's optimism:

> Change of this magnitude makes people nervous. Everyday people ask about the implications of the network. What will happen to our jobs? Will people withdraw from the physical world and live vicariously through their computers? Will the gulf between the haves and have-nots widen? I've thought about the difficulties and on balance, I'm optimistic. I'm thrilled by the feeling that I'm squinting into the future and catching the first revealing hint of revolutionary possibilities. (Gates, 1995: 1)

Disconnection from the orderly: the supermarket

Debord had a fear of the homogenization of culture in which the individual components of society would be isolated and re-marketed as part of a bland and all-embracing whole. Fosse Park Shopping Centre in Leicestershire personifies this. The spectacle of the parked cars gives the impression of cattle in a corral. The signposts which indicate the businesses located in the park look like urban totem poles, depicting or invoking the spirits of mammon to be worshipped.

Debord despaired of the passivity of consumerism and the spread of 'enormous shopping centres built on the bare ground of parking lots' and 'the dictatorship of the automobile' (Debord, 1983: 174). Such concerns would have been scoffed at just a few years ago, but are now universally recognized as important. The supermarket in Britain seems to realize Debord's fears especially well. In many ways it acts as a museum, only of removable, ownable and consumable objects. It acts as a community centre with babycare facilities for mothers. It provides assistants who will push around trolleys for the elderly. It is a cathedral of worship. 'Singles nights' are organized at some ASDA supermarkets, thus acting like a dating agency. We immerse ourselves in the offerings of the supermarket and hide behind the pretence of our control in our choices, as the collector hides behind the collection and acts out control through the environment's manipulation. The checkout operator is our therapist as we reveal ourselves to them via our purchases; family, single, or microwave ready. Their prescribed smile and greeting (supermarkets advertise for 'greeters' as a job position) are supposed to enhance our feel-good factor on entry and exit. Both Sainsbury's and Tesco had plans to introduce high street shops which were simply to be called 'shop'. The various loyalty schemes, utilizing 'bonus points' with every purchase, seek to identify the consumer's every requirement and service it. The corporate supermarket wars are an expression of the recognition of a consumer-driven market force which is probably more salient and relevant to people's everyday lives than governmental pronouncements.

The midland supermarket chain, Morrisons, advertise the merits of their establishments: 'Take a walk down "market street" in Morrisons. Fresh food prepared daily in store' (Channel 4, 5 May 1996). The idea of the high street shop is here appropriated wholesale and reconstituted within the confines of the supermarket. The shops are suggested rather than stated, a styling rather than a reproduction, but the concept of a shopping theme park is clearly implied. This increases the disassociation of the shop as a binary part of life as it becomes an indifferent necessity. As part of the territory wars between supermarkets, model vehicles utilizing the corporate liveries are sold or used as purchase incentives (see *Model Collector*, 1995: 21–9), probably as much for adults as for children, thus tying shopping even closer to collecting behaviour. Here, the spectacle's appropriation of a method of resistance to it, and its recommodification, are evident.

In an even wider context, supermarkets, especially the larger out-of-town variety, allow us to play out material indulgences. The supermarket is a palace of variety. As the museum once brought exotic objects for us to wonder at, so now the supermarket offers exotic foods. The supermarket can in a sense be seen as an educator by the introduction of 'new lines'. The buying of that unwanted yet irresistible item, to which we all succumb, is like buying an obligatory souvenir of a visit to prove that we've been there. The staff who obligingly direct you to the

correct aisle for shortbread are the tourist guides of a heritage industry yet to come. They will be as romantically missed and mourned as the small shop with its personal touch was missed when supermarkets forced them out of business. The author of an article extolling the virtues of covered, out-of-town shopping centres was already looking forward to the 'first listed shopping mall' (Barker, 1996: 3). First coal mines ceased to be workplaces and became tourist attractions as the service sector was proclaimed to be Britain's future. Supermarkets could be the first service sector casualty, as mines were the first industrial one, to be turned into a heritage park – they are in transition as computerized home shopping begins to be introduced (H.D., 1995: 3).

In a more sentimental way, we associate toy shops with the idea of childhood and want to be wooed and treated as adult children when we enter the shop's environment, which we wish to be receptive and sensitive to our sentiments. Toys R Us, in Leicester's Fosse Park, reveals the naked domination of the economic *having* over the social *being* as Debord notes (Debord, 1983: 17). Fluffy toys are stuffed in rows of metal racks in a warehouse environment. They give the impression of being battery hens. One is not encouraged to find that special item for a loved one, but is offered a shopping basket on entry as though in a supermarket. A tape looped voice over the Tannoy constantly and distastefully announces the range of credit cards accepted by the shop. The whole experience contrives to strip bare all sentimental pretence and presents as indifferent that which we had sought to imbue with something more than the stasis of an inanimate object. Fosse Park, in common with all our large out-of-town shopping centres, bears the unmistakable imprint of man, but lacks any humanity. It makes no pretence of endearing us to the commodities for sale, it is a bare economic statement: take it or leave it. Collecting is as much about re-establishing the magic of objects as anything else, in an age that advertises paucity as rarity and therefore desirable. When the economic imperative of the spectacle's new commodities are revealed as such, it seems often to be a moment in which they are rejected, and older material becomes collectable. Such trends have grown over the last two decades, as society has become increasingly economically defined. Collecting, I propose, is often about re-balancing the civil aspect of society with the economic and state aspects in hegemony.

The supermarket, then, plays with the need to relate to material culture, collecting instincts ('buy two, get one free') and social interaction, subsuming those roles that traditional institutions such as museums would normally provide. The supermarket replaces the familiar and safe (e.g. Jones Brothers, The High Street) with the grid references of the Ordnance Survey Map (e.g. Meadowhall, Junction 34 off the M1). It is also undermined by the replacement of the known with the unknown. Jones Brothers may still have the name plaque on the shop which has actually been sold to Mr and Mrs Williams, and is no longer just a newsagent as the board outside indicates, but also an off licence. This is even more the case when what appears on the outside to still be an Anglican church of the late nineteenth century has actually been internally converted into units for a small business centre. This disorientates the sense of the expected and makes collecting the known that much more essential, as the perception of loss, or at least change, and therefore the imperative of preservation, becomes heightened.

The 'worth' of things

The world being as it is, full of stuff, results in an endless cycle of commodification and recommodification. It is stated that the entire gift industry in Britain is worth around £5 billion a year of which around £375 million is represented by heritage gifts. Servicing the desire for heritage and nostalgia is a business sector estimated at £100 million a year (Atkinson, 1996: 11). These figures are believed to draw in every conceivable souvenir, but almost certainly do not include the informal markets of the undeclared earnings of dealers in collectables on markets and car-boot fairs all over the country (see Maisel, 1974; Stoller, 1984; Morgan, 1993). It would probably also exclude the material which, though not 'heritage' by intent (e.g. destined for sale through acknowledged outlets such as National Trust shops and Past Times chain stores), casts an eye on that particular market and incorporates elements of it into new and everyday items. Such retrospective material can range from Ronson lighters to the 'traditional' design and packaging of ice lollies (Duckers, 1991: 14; Landesman, 1995). As Atkinson points out, it becomes harder on the fringes of the heritage industry to separate nostalgia products from mainstream commodities. In this sense, then, a seamless web of yesteryear is insidiously woven around us and confronts us in all the forms of our everyday environment. The subtlety (and often crassness) of such market-driven social engineering is reflected in the media via such programmes as *The Antiques Roadshow* and numerous other programmes which deal with collecting, material culture and hyper-commodification.

We live in an age of niche marketing in which we are constantly encouraged to consume or even actively to 'collect' a given product. Desire and profit are strong motives for acquisition, and at a street level, the 1990s have seen the mushrooming of demand. In 1992, the posters used by Sony to advertise their Walkman cassette players proved very popular. They pictured shoes made up to look like human faces, some based allegedly on actual personalities. So popular were these posters that students began stealing them from poster sites on the sides of bus shelters for their bedroom walls (*Independent on Sunday*, 1992: 8). In Brighton, children as young as five began rifling the colourful and free piles of leaflets advertising rave parties from local record shops and selling them for up to five pounds each in the school playground (Heron, 1992).

It may cause some of us to draw breath to hear that a 1930s Dinky toy sold for £12,650 at auction (*Guardian*, 1994: 5), but what makes 200,000 Germans and 60,000 Britons collect telephone cards? Furthermore, what makes some of them worth between £30 and £500 each? (Coren, 1994: 16). To collect that which most people would regard as disposable is a form of humorously subversive activity. It places value in the worthless and revels in the esoteric nature of the deep knowledge of the material collected. In this scenario, it is an act of passive resistance to the spectacle. If such material becomes recognized belatedly as being of social, historical or cultural significance by museums, then it loses its attraction for those collectors who are only interested in the material's subversive or novelty value. Others, though, usually with large collections of the material, become fêted as cultural custodians (such as Robert Opie, see Chapter 5). If the material has the added bonus of being financially valuable, then admiration and wisdom are attributed to the collector. In so doing, such collectors are being applauded for their insight, and their collections socially validated as statements of educational enlightenment (thus conforming to

the rational recreation model). The subversive element can be seen in the way in which comics (especially American ones) have such a fascination and command such a high price compared to the more erudite world of first-edition book collecting. The first edition of D.C. Comics in which Batman appeared can be worth from £30,000 to £100,000 (Connolly, 1994a: 10; Daneff, 1994: 4). Max Decharne had 10,000 comics by the age of ten, he now has five times as many. He is selling his 13 rarest comics, which he confidently expects to reach £100,000 at auction, in order to buy a house for his family (Connolly, 1994a: 10). If one considers this in terms of a straight exchange, thirteen comics for a £100,000 house, it turns conventional notions of 'value' on their head, and yet why should a first-edition Batman comic not be worth as much as a painting by a post-impressionist? It says more about the social changes going on around us than any intrinsic nature of the object itself.

On a less financially impressive scale, but highly subversive, is Steve Chibnall's collection of American pulp fiction. These cheap paperbacks arrived in Britain as ballast on American merchant ships from the 1940s onwards. Everything about them says trash, and that's the appeal. Chibnall says:

> Some books have got what I call drop-jaw titles like 'Me and My Ghoul' . . . I love the outrageousness of it all, there's this element of liking the despised. (Jarvis, 1995: 10)

In general, before the advent of punk rock in the late 1970s, it was decidedly un-hip to pay visual reference to previous fashions or the past at all. By the 1980s it was common practice to mix up styles both of previous youth cultures and of pre-youth culture fashions. Now even vintage denim has a growing collectors' market, with prices ranging up to thousands of pounds. For the first time, Miller's *Collectables Price Guide* is to include sections on denim, training shoes, kettles 'and other domestic appliances' (Miller, 1997: 5). In the 1990s the accelerated pace of life is reflected in fashion in two ways. First, by reaffirming early-1980s 'new romantic chic', by looking even further back in time to create an identity, invoking fashion sentiments of (e.g.) the eighteenth century. Second, by viewing the female power-dressing style (padded shoulders, etc.) that emerged in the 1980s as already retro (Laybourne, 1994: 15). In short this reads as 'new is old, old is new'. One can choose to go with the flow in living in speedup where the pace of work in a professional role can be so accelerated that time seems to accelerate and leave far behind that which is only recently new. Such people live in nanoseconds as though they were aeons. This is 'new as old'. 'Old as new' occurs when people recognize that a concomitant dose of 'slow down' is necessary to cope with the frantic pace that society operates at today. In which case, one may look as far backwards in time for tranquillity as one may be rushing forwards to a work-centred future. Style guru Peter York's series *The Eighties* (BBC2) confronted us with the 'me too' attitude of the period as though it had existed at least twenty rather than seven years ago, but for those who suffered hardship and unemployment in the 1980s (who York signally does not address), the legacy is still with us as though it had never been otherwise.

The traits that express themselves are not peculiar to our own age, they are peculiar to human nature, but at the end of the twentieth century with all of its uncertainty, we are indulging in an orgy of material expression as though fumbling with worry beads. Objects and collections are psychic batteries, stored with powerful emotional psychological and cultural meaning for us. Jean Rhys understood this. In her story

Illusion, the main character, a British woman, Miss Bruce, lived and painted in Paris. She is described thus:

> she always wore a neat serge dress in the summer and a neat tweed costume in the winter, brown shoes with low heels and cotton stockings. (Rhys, 1970: 30)

She outwardly disapproved of showiness. One day she falls ill and asks her friend with whom she often dines to go to her flat to collect some things for her while she's in hospital. On opening a solemn-looking wardrobe expecting to find drab and dowdy clothes, her friend finds 'a riot of soft silks . . . everything that one did not expect'. Having described some of the opulent and colourful costumes, she anthropomorphizes the dresses, imagining them calling her:

> 'Wear me, give me life' it would seem to say to her 'and I'll do my damnedest for you' . . . I went back to lock the wardrobe doors and felt a sudden, irrational pity for the beautiful things inside. I imagined them shrugging their silken shoulders, rustling, whispering about the 'anglaise' who had dared to buy them in order to condemn them to a life in the dark . . . And I opened the doors again. The yellow dress appeared malevolent, slouching on its hanger; the black ones were mournful and the little chintz frock smiled gaily, waiting for the supple body and limbs that should breathe life into it. (Rhys, 1970: 34–5)

Miss Bruce professes to be a collector of pretty dresses, but adds she would never make such a fool of herself as to wear them. In a similar way a 37-year-old Action Man (GI Joe) collector would not dream of playing with his 'toys', he just likes collecting them (Jarvis, 1994: 9).

Conclusion

The foregoing has been necessarily wide-ranging in order to exemplify some aspects of social transformation which I propose have conditioned contemporary collecting. A rich variegation of pressures, some subtle (like linguistic nuances that suggest a distancing from collective cohesion), others cataclysmic (such as redundancy), are brought to bear on the social fabric we have come to take for granted. In so doing, our easy assumptions about security get bent out of shape. By extension we begin to question everything else. The example of the supermarket, for instance, illustrates the material expression of the line between modernism and postmodernism, the functional and the postfunctional and is reified through such TV series as *Off Your Trolley* and *Shop 'Til You Drop*. The social changes we sense, feel and often exaggerate help bring the collecting instinct to fruition. The desirability of objects identified with our personal past, or in which we perceive our own values expressed or reflected, have usually been attributed to nostalgia or sentiment (Stewart, 1984; Gordon, 1986; Pearce, 1995). In the scenarios given here, this is only a starting-point. The collected object ceases to have a pleasant or fun element and takes on the darker role of identity-definition, a rock to cling to, or a means of making sense of change.

5 *From rubbish to representation: individuals and collecting*

Introduction

The social conditioning for collecting the seemingly trivial is not always a reaction to living in a consumer society, it is also a statement or assertion of identity which does not necessitate an urban or consumer context to manifest itself. This chapter examines how the traits of collecting behaviour are exhibited in our everyday lives. First, this can be found in the rural past where encounters with material culture were arguably most rudimentary. The urban present is then examined, in which we unconsciously act out collecting behaviour in numerous ways. Second, it is sought to demonstrate how, as such behaviour enters our consciousness as collecting activity, we refine it to instil it with a new cogency which represents the full fruition of such behaviour. This is examined in a series of narratives based on individual collectors.

The historical, rural aspects are demonstrated in two examples from earlier in the twentieth century, in which meaning and statement were made from natural and man-made rubbish in rural France. Two edifices constructed from stones and discarded broken plates and bottles remind us that our encounters and relationships with material culture can be very basic. If collecting behaviour is inherent even at this level, where the spectacle's influence is minimal, then anything which follows must represent a refinement and adaptation of this behaviour in more sophisticated or developed surroundings. This applies as much to the impositions of the spectacle as to the recipients' response, or resistance to them.

Following from this hypothesis, I have used the more contemporary example of Tupperware to place the process in a modern suburban context and to show how covert collecting behaviour can be. We often 'accumulate' loose change in large containers for the fun of counting and bagging it up when full. Similarly, we 'decant' food from its packaging into glass storage jars and plastic air-sealed containers. In so doing, we are exhibiting collecting behaviour at its most unconscious and basic level. This illustrates how we can all be said to be passive collectors. This is also put into the context of museum collecting, which is often passive but which is accepted as more worthy.

Third, on a more conscious level, two television programmes which examine base-level human–object relations are discussed. One deals with the long-term storage problems of people's possessions, whilst the other demonstrates the reluctance to waste anything, by the recycling of worn-out material. This seems to demonstrate the apparently integral nature of our relationship with objects, which is accentuated by consumer society rather than originating in it.

In Debordian terms, then, the spectacle is aggressive. It exploits the acquisitive element of human nature which in its widest sense is sublime or subconscious in most of us. Once it is aroused, however, most obviously in consumer society, it cannot be wholly dominated by the spectacle. Not only does the spectacle act on it, but it is used as a defence mechanism against the spectacle by reconfiguring the intentions of, and reading deeper meanings into, things.

Finally, a series of narratives on individual collectors is used as a way of illustrating collecting behaviour in full bloom. In these narratives, apart from making points of connection they, in common with the two French examples earlier, are allowed to continue uninterrupted by comment. This is in order to facilitate a certain flow, allowing a stream of consciousness to ensue, which lends the factual a certain literary expression. It is also used as a means by which the reader can engage on a subliminal level with the narrative and thereby enter the collector's psyche. This then helps to convey the collecting experience as essentially a process of self-definition. The information from individual collectors cited in the second part of the chapter has been gained from reportage, interview, conversation, taped testimony, correspondence and participant observation. A detailed account is given in Appendix 2. Individual cases have been included in order to illustrate and contrast the varying motivations, sometimes complimentary, sometimes oppositional, to collecting. Collectors have been assigned pseudonyms where they are not already cited in the public domain.

The collecting instinct

Robert Owen (1771–1858), the pioneer of the co-operative movement, first stated that man's character was formed *for* rather than *by* him. That is to say, we are the product of our environment. Our culture and environment acts upon us, long before we are able to have any bearing upon it. Being born into a consumer society is therefore bound to act upon us in a way that encourages us to acquire, hoard, collect or generally consume. However susceptible we may be to the power of advertising, we are not unthinking, and therefore acquisitive behaviour is not solely engendered by a material society. The necessity of disposable income in order to behave in this way is often overlooked. If one is poor, however, other ways can be found to assert individuality above the pedestrian, or to state one's presence in the world. The following historical examples demonstrate this.

The case of Ferdinand Cheval

Ferdinand Cheval (1836–1924) worked as a postman in Hauterives in Drome in rural south-east France. At the age of 40, he is said to have tripped over a stone while on his postal round: 'What the apple was to Newton, or the kettle to James Watt, this stone was to the postman' (Boston, 1995: 34). He was intrigued by the shape of this stone and began to seek out other strange-shaped stones, shells and fossils, eroded by time and the elements. At first he put them in his pockets, then took to collecting them in bags, and at last used a wheelbarrow, which was all the help he ever had. His thoughts seem to have been: 'These stones have curious shapes, they were made by nature. If nature can make curious shapes, then so can Ferdinand Cheval' (Boston, 1995: 34). He began, in 1879, to build a grand edifice, a tribute seemingly to his own powers of perseverance and endeavour, which he called Le Palais Idéal (Plate 5.1).

He did a 20-mile postal round each day and then worked on Le Palais Idéal for eight or more hours a day. The final stones were laid in 1912. He said:

> I was the first to agree with those who called me insane. I was no builder, I had never even handled a brick layer's trowel. I wasn't a sculptor, I'd never even used a chisel. I know nothing about architecture. (Boston, 1995: 34)

There are nuggets of wisdom carved on the walls:

> The weak and the strong are equal in the face of death

> In the minutes of leisure my work has allowed me, I have built this palace of one thousand and one nights and carved out my memory

> Winter and Summer, night and day, I have walked, I have roamed the plains, the hillsides and the rivers, to bring back hard stones, chiselled by nature. My back has paid for it. I have risked everything, even death. (Boston, 1995: 35)

There is a constant emphasis on equality, even with his wheelbarrow. He built a grotto to enshrine the faithful wheelbarrow, saw and trowels. He anthropomorphizes the wheelbarrow, enabling it to speak on behalf of the other tools:

> I am the faithful companion of the intelligent worker who every day fetched from the countryside what he needed. Now his work is finished, he is at rest from his labour, and I, his humble friend, have the place of honour.

> We (tools) say to future generations that you alone built this temple of marvels. The purpose was to show what could be done by sheer will power, the possibility of overcoming mental and material obstacles. (Boston, 1995: 35)

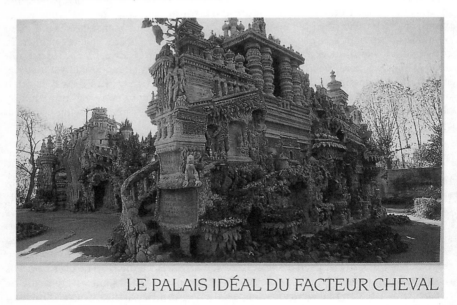

LE PALAIS IDÉAL DU FACTEUR CHEVAL

Plate 5.1 Postcard
Reproduced by permission of Hautrives City Council.

Cheval's endeavours seem to have resulted from some slight that he felt about his social position, or his capabilities, which Le Palais Idéal was supposed to put right. This monument to, and of, the self was created from a random selection of stones, the creating of something seemingly out of nothing. Popular collecting can also be fuelled by the same impulses. A second example also comes from France.

The case of Raymond Isadore

Raymond Isadore (1900–1964) was, for most of his working life, a cemetery cleaner in the town of Chartres near Paris. He built a house on a scrap of land in 1928 for his wife and three children. He was very poor, and like Cheval had only his wheelbarrow for aid. He scavenged for building materials using whatever he could find, recycle or get cheap. He wrote that

> we are not living in a very good century, I'd like to live amongst flowers and in beauty, I'm looking for a way to get people out of misery. (Boston, 1995: 36)

He bought an adjoining parcel of land and did more building. He built a chapel (he was very religious), a workshop, a privy, walls, walkways and arches. He collected like a jackdaw throughout this time; broken bottles, pieces of flint, old clocks, porcelain, broken plates, cups and saucers, anything durable and preferably brightly coloured or patterned. He just piled the fragments in heaps without any apparent end in view (Boston, 1995: 36). In 1938, he had an idea:

> I had gone for a walk in the fields, when by chance I saw little bits of broken glass, fragments of china, broken crockery. I gathered them together, without any precise intention, for their colours and their sparkle. I picked out the good stuff and threw away the bad. I piled them in the corner of my garden, and then the idea came to me to make a mosaic of them to decorate the house. To start with I thought I would just decorate part of the walls. I often walked miles to find my material; the broken plates, bottoms of perfume bottles, medicine bottles, things that people don't want and throw away in quarries and rubbish dumps, but that are still useful. I took the things that other people threw away. So many things are thrown away that could be used to give life happiness. (Boston, 1995: 36)

He said of his employment as a cemetery cleaner that

> it was as though I had been thrown on the rubbish dump of the dead when I was capable of doing other things, as I have proved. (Boston, 1995: 36)

He decorated every conceivable surface of his house and its interior with the coloured glass and pottery fragments (Plate 5.2). Clearly his frustration with his menial job was ameliorated by the excessive decoration of his house. Collecting operates in the same way (as set out in Figure 3.1). He devoted, by his own estimation, 29,000 hours of work in the decoration, dying from exhaustion in 1964 (Boston, 1995: 37). Isadore was endeavouring to create an alternative environment, to alleviate the drudgery of the everyday environment of his job. Working all day with the dead, the dark colours associated with this (black and grey) created a necessity to enliven his life. This he did by creating his own refuge from such work, in bright 'living' colours.

In contemporary terms the need to assert identity over uniformity can still take bizarre forms, such as 'roof furniture'. Derek Glass of Deeside mounted a car, a Riley Elf, on his roof because, he said, it was easier to work on. In 1986 the owner of a

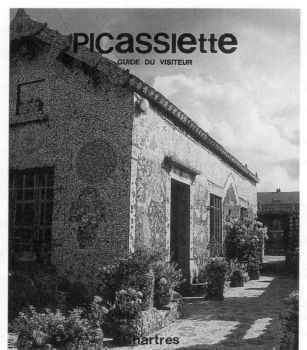

Plate 5.2 La Maison Picassiette
A. Cover of guide book Reproduced by permission of La Musée des Beaux Arts de Chartres.
B. Le Petit Salon Reproduced by permission of La Musée des Beaux Arts de Chartres.

A

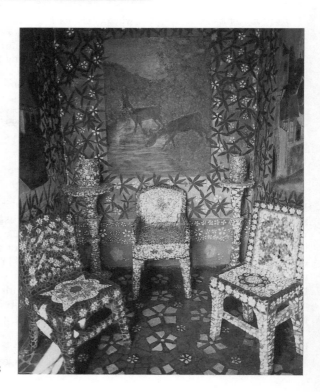

B

cinema in Oxford mounted a 25-foot fibreglass shark through the roof of his terraced house as 'an artistic statement'. John Gladden of Croydon mounted a 789lb fibreglass Marlin (fish) on his roof and was promptly taken to court for not having planning permission (Rayner, 1993). This can be read as a plea for acknowledgement, a statement of one's existence of which collecting is also a part. Once again, in Debordian terms, it can be seen as an act of resistance to the spectacle, by making an (albeit surreal) aesthetic statement. Debord believed that the corporate – media – advertising axis, the hegemony of the economy, denies the truth of lived experience, by the fraudulent 'organization of appearance' (Debord, 1983: 219). In the examples above, fraudulent images (sharks do not literally crash into roofs) are made manifest. In so doing, the owners are mimicking the spectacle's visual impositions, but with knowing and sarcasm. Materially, this equates to the appropriation of a pejorative term, such as 'queer', by the gay community, and its use as a term of pride, thus disempowering its pejorative inference.

The collecting impulse is often covert and would not be recognized as such by most people. For instance, the removal of our everyday foods from their packaging (profane) and their 'decanting' into more pleasing (sacred) containers is a ritual most people engage in. Biscuits go in tins, loaves of bread in bread bins, pasta into storage jars, etc. This in itself indicates that we harbour a sense of everything having its place, its symmetry or aesthetic in our domestic environment. Collecting is the full blossoming of this sense. As Cheval and Isadore gathered the flotsam and jetsam of nature to define themselves in labours of love, so the same instinct can be transferred in a consumer society through everyday material. Such is the case of Tupperware. In this instance the importance of the material in a museum context can also be seen.

Tupperware

These plastic containers become desirable partly because Tupperware has never been sold through shops, only through 'party plans' (a display/sales meeting in the home of a 'hostess') and therefore involves a social gathering, and a ritual of viewing and purchasing with the resultant interaction. One Tupperware saleswoman exalted the merits of decanting foods from their original packaging into specially made Tupperware boxes. At the conclusion of this, one of the party participants, Lucinda,

> was already writing a large cheque. 'I'm buying some square Space Savers and a Spice Saver Centre' she confessed. 'I just love storing things.' (Wolff, 1993: 4)

This can be read as an unconscious act of collecting (Figure 5.1, Level 1). As such the Tupperware is likely to drop out of the collecting equation, having served its time as a functional object, but may well end up being recycled via a car-boot sale, where it may be 'salvaged' by an active collector and thus re-enter the equation. The collector has then re-obtained the recycled object (Figure 5.1, Level 3) via the shortest route between function (the object's original use) and icon (the object's post-functional status). Should there develop a perceived market for vintage Tupperware, some may end up in museums, as indeed it has in London's Design Museum, which ran an exhibition in 1995 called *It's Plastic*.

Museums are the highest social medium through which cultural material is publicly exhibited, often encoding it intentionally or otherwise with an aesthetic value which it never originally possessed (Thompson, 1979; Appadurai, 1986a). Tupperware, for

Figure 5.1 The levels of collecting

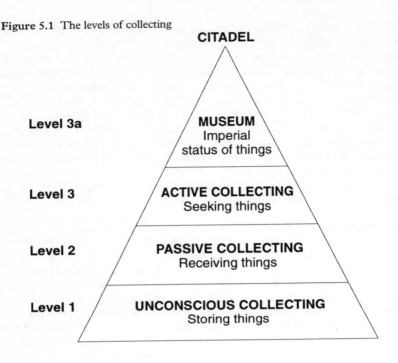

instance, may be used in a social history display as an example of the growth of consumer society and its casual reliance on the mass-produced. An exhibition at the Design Museum or Victoria and Albert Museum's Twentieth Century Gallery, however, is more likely to present Tupperware as an art form. This allows it (the mundane) to be elevated to the position of icon, placed outside its original context, and endows it (the disposable) with a status of permanence beyond the realm of function (Figure 5.1, Level 3a). This, however, is achieved via a more circuitous route because of its reliance on passive collecting to get there (Figure 5.1, Level 2). This, though, is not to negate the possibility of it having been actively sought by a museum for a temporary exhibition. None the less, in both cases, the Tupperware has achieved 'citadel status' (Figure 5.1). A useful next step would be to facilitate a greater level of involvement between collectors and museums. This may lead to the establishing of a wider constituency for consultation when considering sources, cost and availability of specific items or services. It would also help to shorten the procedural distance that such material has to travel between becoming available and arriving in the museum. This is fully discussed in Chapter 7.

Marking and salvaging

There are those who cannot bear to throw anything away, even if they do not use what they keep. Classically, this is termed as hoarding and some of it no doubt is. There are also, however, other reasons for keeping hold of the seemingly pointless.

First, sentimentality plays a great part in a reluctance to get rid of things that are otherwise simply taking up room. Second, a profound utilitarianism about material culture can lead to endless recycling of old clothes or engine parts in the belief that everything always has a use. Two Channel 4 programmes *Memories in Store* and *Scrimpers* deal with each of these in turn.

Gordon (1986: 140–3) lists five categories of souvenir, the fourth of which she describes as 'markers'. The marker is an object which acts as a memory cue, a compacted signifier which can trigger a leisurely unpacking of all its symbolism and memories. *Memories in Store* illustrates the marker. The programme followed people who had possessions in storage at Bishop's Move warehouse in Chichester, West Sussex. Amongst them was a widow whose husband could not bear to throw anything away (see also Belk and Wallendorf, 1994; Belk, 1995). He packed all extraneous belongings into 52 crates when they moved into a smaller house and consigned them to a warehouse, where they have been for 15 years (the husband having since died). She feels that to keep the crates intact is a sacred trust. She is afraid of what she will find in them, as her husband packed them. She has the idea that others will unpack it all unkindly, perhaps laugh at what they'll find. She fears the contents will be looked upon as collateral or material not aesthetic objects, detached from their meaning in life, which she sees as the biggest spur of all to keep the crates in storage. She finally goes through some of the things, and it's not as bad as she expected: 'It's like being told you haven't got cancer after all.' Conversely, a retired major just leaves his stuff in storage. He admits that it is probably not worth the cost, but he can't be bothered to sort it out. One thing, though, his military boots are in the crates and he would like to wear them again. He declares: 'I got blown up in those boots!'

These two examples illuminate other aspects of our relationship with material culture. Fear of confrontation by it, because of what we believe it harnesses, psychologically and emotionally, and reluctance to dispose of part of our lives as represented through it. These are strong motivators, which periodically, at least, focus our minds on objects. In so doing, we begin to read more into them, and collecting behaviour is further drawn out.

The series *Scrimpers* intended to give hints on how to recycle worn-out clothes and other durables at the end of their original utilitarian cycle. The first programme (broadcast 3 October 1994) dealt with car-boot sales. A Brighton (East Sussex) woman takes a discarded door from a skip to replace her back door. It is not clear whether her back door needed replacing, or whether the urge to reclaim what was perceived as wasted was greater than her need. She has cabinets full of old crockery and vases from local car-boot sales. She says she will sell them one day and is waiting for them to appreciate in value; she buys nothing new. A man has components of electric fires in boxes in his shed. He sells and recycles 'bits', more for being surrounded by them than the income it generates. In this instance the parts represent closure, the shed is the universe in which it takes place. The psychological and cultural need to relate meaningfully to familiar objects is part of what binds us to commodities, a way of knowing we have a small space in which we belong in the world. In media terms *Scrimpers* can make such people look eccentric or mean, whereas programmes such as the Channel 4 series *For Love or Money* and BBC2's *Antiques Show* deal with high art collecting and the enormous prices that such objects can command. Because collecting at this level is more of an investment, it is re-codified as a legitimate business activity.

Whether at its most basic level, or its grandest, the economic worth of things can be read as Debordian. Desire for the opulent is expressed through antique collecting. Antiques are the top end of the collecting market. As such, they represent the economic apex of a parallel value system. Antiques are old goods par excellence, having accrued financial worth equivalent to, or often surpassing, the spectacle's new goods. In this sense there is a certain parity of esteem. Conversely, scrimping and recycling are at the bottom end of this value system. This can be read as resistance to the spectacle's insistence on the abandoning of the old and spending on the new. This, of course, is in specific reference to such behaviour where it occurs outside of economic necessity. Recycling signifies an understanding in the individual, that there is a residual or alternative worth in the recycled object. The spectacle promotes the culture of the disposable. Keeping that which the dominant economic culture would have us discard can again be read as part of a counterculture of resistance to it. Having been dismissed by the spectacle, the object is thus valued because of its rejection of it.

Some collectors and their collecting characteristics

The following case studies are used to demonstrate the material backgrounds from which the collecting instinct has manifested itself. This exemplifies its diversity and seemingly random appearance. In terms of collectors of popular cultural material, Robert Opie is perhaps one of the more well known. His Museum of Packaging, The Pack-Age in Gloucester, in the West of England, has attracted considerable publicity and attention in recent years, as has his seemingly irresistible compulsion to collect contemporary packaging. Opie is referred to both because of his reputation and because of his similarity to at least one of the other collectors (Tony) discussed here, which clearly demonstrates that Opie is not one of a kind or the 'eccentric's eccentric', which is how he has been portrayed in the past.

Robert Opie

Opie comes from a collecting background. His parents, Peter and Iona Opie, collected and collated an enormous and prestigious library of children's books and other literature, folk-tales, etc., which now resides in the Bodleian Library, Oxford. As Opie himself tells it, he discovered his propensity for collecting packaging when on one rainy Sunday in Inverness, at the age of 16, he returned to the hotel where he was staying with his parents, having bought a packet of Munchies (chocolate-coated sweets). The thought occurred to him on discarding the wrapper that: 'if I throw this away, I will never see it again, and yet here is a whole wealth of history . . . that packet was going to change and develop into other things . . . yet I was going to throw it away, damage it' (Elsner and Cardinal, 1994: 33).

Opie refers to this sudden realization as 'the munchies' (Elsner and Cardinal, 1994: 32–3). Quintessentially this is not so much a case of matter becoming stronger than mind, but of matter becoming mind. There are people whose sensory perceptions are inexplicably cross-wired at birth, a condition known as synaesthesia. They can often relate taste to hearing, sounds to colours and so on. In this instance collectors think 'thing'. We admire artists for realizing their visions in oil and canvas, yet we often find unsettling those individuals who realize their vision through collecting.

Opie fully realizes that his collecting is obsessive and dominates his life (Elsner and Cardinal, 1994: 43, 46–7) even in relationships:

> You get very fond of a woman, and of course you want to spend more time with her. Then she wants 'more' time, and I just can't do it because if I lose just one week, it's impossible to catch up. That's the only time I panic a bit – when I feel I'm falling behind. (Connolly, 1994: 28)

In this extremity, collecting becomes umbilical. As autistic individuals withdraw into themselves, disposing of any external and material expressions of their feelings, so collectors externalize and express their feelings and values through collecting, almost turning themselves inside-out. The collection becomes a passionate love, a defenceless child and therefore a responsibility, it needs constantly to be fed (added to). Opie is a collector who has crossed the sacred line into 'museumness' with his Gloucester-based museum. As such, his collecting is accepted in one form or another, because he has allowed the public to gaze upon it.

Chris

The same cannot be said of Chris, a 37-year-old collector of Action Man (GI Joe in the USA). When he was 12, his mother decided he was too old for toys and burned them all on a bonfire, having uncharacteristically given her son some money to go and buy a comic, to get him out of the house. Needless to say he was devastated. The only toys to escape the inferno were his Action Man and accessories, which were kept elsewhere. Even so, when he was 15, he came home from school to find that his mother had given his Action Man away. He now has a room full of Action Man models and equipment. He is an expert on the history of the materials made for Action Man and all the myriad variations in the model since it was first introduced in the mid-1960s. He says:

> I want to stress that I never, ever play with the toys, some of these figures haven't moved in a couple of years, I just enjoy collecting them and all the equipment . . . It's like a time machine. It's why people keep letters. It's why toys are a lot more personal than antiques. (Jarvis, 1994)

Clearly there is an element of defiance, of revenge on mother for her misdeeds, to prove that he will never be too old for Action Man. This suggests a number of things. The doll symbolizes for him defiance and an assertion of choice and affirmative action, a manifestation of control when he was so helpless against his mother's actions. It also acts as reassurance of certainty. He 'knows' his collection because he created it; he didn't 'know' his mother would act the way she did. Here a single-subject collection has arisen, at least partially, as a means of asserting an apartness or divorce from one's past and also acts as the manifested guardian of that time divide. It simultaneously represents a compacting of the 'then' and the 'now', becoming the thin blue line that keeps past and present distinct. In the following example, multiple collections seem to act as a means of enabling the collector to bring the past forward and thereby remain in it.

Tony

Tony is in his mid-fifties and has collected all his life. The subjects of his current collections are stamps, coins, matchbox labels and matchbooks, cigar bands, cheese labels, bank notes, beer mats, beer labels, Triang railway sets, records, record players, cigarette and tea cards, poster stamps, record needle boxes, badges. Things he used to collect but no longer does are domestic packaging, chocolate and cigar tins, advertising mugs, newspapers, New Zealand leg of lamb tickets, beer memorabilia, Edgar Rice Burroughs books.

He began collecting when he was five: 'I cultivated taste through my grandfather who collected stamps.' Tony filtered his collection for the most interesting and best-conditioned examples. Both his parents and grandparents were also collectors and he inherited most of what they had amassed: 'I started a lot of my collections simply knowing people and never giving up . . . I never stopped collecting anything.' Perhaps the subliminal compulsion here was to collect as a sacred trust, which had been passed down to him by relatives and friends; the collections came to represent the people who had given them to him (as practised in ancestor worship, where a dead relative's belongings are treated as if they are actually the person themselves).

He tries to get bank notes of most countries, especially of those such as Greenland, whose currencies are hard to get. He writes to the philatelic [sic] bureau and asks to buy examples of their smallest denominational notes and especially likes the colours. There was an African state in the 1960s, Katanga, which lasted only three years, whose currency he had been trying to get for years, managing finally to find a note in a South African junk shop. He also brought back 30 bank notes from (Communist) Albania, which are hard to get. This idea of 'hard-to-getness', rarity or exclusivity seems to lend a sense of self-elevation, through the acquisition of the esoteric, which read as exotic gives dignity, rather like an SAS member, whose self-knowledge of his membership gives the necessary pride, without having to boast of it in public.

He feels the commercialization of beer mats, like stamps, is lessening his interest in them. Breweries issue mats in sets aimed at the collector, which is not the same as acquiring those made for the trade only. Clearly, to be spoon-fed a collectable removes the hunting and capturing aspect of the process, and is derided accordingly, like an antelope that would give itself up to the hunter's spear rather than try to avoid it. His record collection dates from 1909 to the present and consists of some 500–600 78rpm records, 3000 seven-inch singles, 500–600 CDs, 12 ten-inch singles, 300–400 twelve-inch singles and a few three- and five-inch records. He has collected records since the 1960s including early Beatles' albums, now worth a lot of money. He records older and rarer records onto tape to listen to, so as to better preserve the records. Here the record as object is as important as the music it contains, objectifying the already objectified, as the painter who paints a picture of himself painting. As another record collector, Kevin, said: 'Even if I tape a whole album, I never feel I "own" it, unless I actually have the actual CD or LP itself', i.e. the 'real thing'. Tony frequents record fairs and likes to get in early with the dealers, prior to the public being given access. He has managed this a few times: 'The anticipation of getting in first before the masses is a good feeling.' Here clearly there is a game being played. The little man is infiltrating the privileges of the higher-ups, the cuckoo in the nest is going to deprive the 'benefactors' of some of their valued commodity. It's a commando raid on enemy territory.

The record needles he relates to his mother and grandparents, who were avid collectors of these, and the nostalgia motivation is clear. With badges he will only collect those that cannot be bought in a shop: 'for me they have to be something I can send off for'. He gave his collection of domestic packaging to Robert Opie, which filled a Luton Bedford van, two Sherpa vans and Opie's car three times over! Although a non-smoker, he collected cigarettes (one of each brand). He bought them individually and was going to put them in individual glass cases as he knew a supplier of these. He decided to store them airtight inside a Tupperware box and then inside a shoe box. The idea of hiding, of preserving for ever, the preventing of change, like mummification, perhaps has its psychological roots in recapturing childhood with all its attendant reassurances and bittersweet memories. He says that as a child he always wanted something his friends hadn't got, he had a desire for different things. This perhaps stems from a confusion over the amount of material around him from his collecting relatives from an early age. It seems, though, that the desire for difference at a young age is an early attempt at self-definition and independence of expression. As a young female collector of tea cards states: 'Collecting "tea cards" was not like the usual hobbies of people of my age, it was something that only I did' (Bowman, 1993: 4950).

Tony's parents and friends would save bags full of packaging and other things he wanted on his behalf, which he found 'quite strange'. Perhaps his compulsions were triggered by fascination with control, being able to get people to save these things for him, lending a feeling of aggrandisement, as though being paid tribute or forfeit. He recognized that his collecting, like Opie's, was 'becoming an obsession, I wouldn't let anything go', but also that 'some of my hobbies are more obsessional than others'.

If the preservation of cigarettes was symbolic of arresting time, then there is also evidence that dealing with adulthood through collecting came next:

> I smuggled out some East German coins back in 1974. I came from Sweden via mini-van and I came out through East Germany, and I went a route I shouldn't have gone, took pictures where I shouldn't have been and I drove to West Berlin and I smuggled some coins in. I was supposed to give them all up what I had, but I smuggled those in, just you know, 'cause I wanted coins from East Germany.

He also went to the ANC headquarters when in South Africa, before independence, just after a bomb had been set off there. He went to ask for some badges, flags, etc. for his collection: 'without wishing to sound flash, I suppose if you want something, you go and do it'. Here, the notion of the exotic has expanded into notions of risk-taking and daring. The object once salvaged in this way becomes that much more prized. Tony becomes the explorer, the hunter, the adventurer. As he says: 'it's a strange feeling to want something to the point where you'd do almost anything for it. You get the idea in your mind of a fixed goal'. He echoes Opie when talking about being dominated by his possessions:

> I don't know where the desire comes from. Mine probably comes from what my parents had. Of course there's the possibility that the more possessions you have, the more you're trapped by your possessions and it's running a fine line and because the more you're trapped by your possessions, the more you concentrate on those things and your mind doesn't go on other things.

He also remembers how old he was on each occasion a collection was started. He was five when his grandfather introduced him to philately; his father gave him the collection of matchbox labels in 1949/50; he collected chocolate wrappers between the ages of seven and twelve and had two hundred; his great-aunt gave his sister a record player in 1960, and he was 20 when he was given 300 cigar bands; the cheese labels were given to him when he was six and the Triang railway set was a present for his eleventh birthday, from which time he has constantly added to it. Dates and ages are clear markers. The material collected then is seen perhaps as a way of preserving these times.

Tony is adamant and proud that he has never thrown anything away and has never stopped or discontinued a collection from childhood until the present, except for a few he grew tired of. He recognized that the packaging was getting too vast to contain; the advertising mugs and beer mats he decided were now too commercial (i.e. too easily obtained), whilst some other material was too esoteric to obtain. In general, though, he sees disposal as sacrilegious. While Tony was surrounded by a large family with friends who all collected or donated to his collecting, another collector of a similar age spent his childhood bereft of material possessions.

Gregory

Gregory is in his mid-fifties. His parents were Austrian Jewish immigrants to Britain, escaping Hitler. His father was a doctor who failed to take his final exams, which prevented him from gaining well-paid medical employment. His mother, who was trained as a concert pianist, gave up her career to look after the children. Leaving everything behind in Austria, they came to England, living much of the time in real poverty. Gregory's childhood was hard, his mother made ends meet by learning to make do and mend. He has a strong memory of finding an old Dinky toy in a local park which had a wheel missing, but which he cherished. This is a definite marker for him.

He and his brothers and sister never had much; if they had a bar of chocolate they had a square each rather than a bar. By the age of eleven, he had begun to collect fossils and stamps. As a young adult he developed an interest in Goss crested china and other ceramics, which he bought and sold in the 1960s. He became an assistant in an antiques shop in King's Road. The shop owner taught him a lot about silverware, which he started to buy and collect. His father (by this time quite poor and divorced from Gregory's mother) accumulated (as opposed to collected) seemingly worthless bits of silver and old bits and pieces which everyone chided him for. In 1969 he died intestate and Gregory became responsible for selling it all off. It realized over £9,000 in auction, which surprised everyone very much.

The money went to his mother, but she was so imbued with a make-do-and-mend mentality that she never used the money. The number of individual items in his father's flat reached four figures and represented a considerable period of time in the acquiring. His mother used to keep food way past its sell-by date and would eat partially mouldy food because she couldn't bear waste. Gregory used to worry about her poisoning herself.

Gregory now collects badges. It wasn't until he was out of university that he began to earn good money, but even then was reluctant to spend much of it. He gained an unfair reputation for meanness, which was really a legacy of impoverishment and a

heightened sense of the value of money. Gregory's father collected what he could afford to buy cheaply, probably for the same psychological purchase on material worth as Gregory. It could be argued that Gregory's propensity for collecting was based on his childhood impoverishment and subconscious need for material security. The badges he collects cover various subjects such as trade unions, speedway and civilian wartime badges. He has a network of contacts whom he rings whenever he makes a purchase, to seek advice on whether he's paid too much for it, and for any contextual background on the subject the badge relates to. This clearly indicates a lingering concern with value for money and perhaps guilt in spending it in the first place. This contrasts sharply with Tony, who buys whatever he sees if he likes it. This shows that the taste for collecting can be manifested either from a background which is overindulgent in objects and thus serves as an apprenticeship, or from one largely devoid of objects and thus leading to a finer appreciation of them later on. There is also a third context, as the following example demonstrates.

John

John is a retired maritime inspector. He began collecting souvenir teaspoons in 1982 as something to do when he retired (in 1985). It was also, as he puts it, 'to keep him out of mischief'. He started with display cases throughout his house, but they only displayed 3000 spoons. So he built a special extension onto his house to keep it in one place.

> The room is forty five feet by fifteen feet and air conditioned to house my display of 30,000 spoons, and is now too small to display all my collection. The spoons are in glass cabinets ranging from three hundred to one thousand in each display case . . . For exhibitions, display cabinets are velvet lined.

He belongs to spoon clubs around the world and speaks and judges at conventions. He is in regular contact with at least 180 other collectors on an individual basis. He is recognized by the *Guinness Book of Records* as having the largest spoon collection in the world, but they have not published it.

It seems important to John that he excel in his collecting. Having the biggest collection is clearly important to him. He had by his own admission a potential drink problem and his doctor recommended he take up a hobby as a substitute. Spoon collecting became his passion. To have the largest collection can be read as an attestation of his ability to impose his will over himself, using it as a means to exorcize personal demons. He also uses it to make a material statement about himself, by creating an environment over which he is entirely in control. He has had spoons made picturing himself on the finial (the end of the handle) in his gallery. Here Baudrillard's assertion that the collector is the ultimate object of inclusion in the collection seems vividly demonstrated (Baudrillard, 1994: 24, see also Plate 5.3). Thus collecting as a hobby in later life can equally take on exaggerated proportions, even when there is no personal history of it. Tony and Gregory, conversely, had always been disposed, from opposite positions, towards it. Gender is no barrier either, as the next case demonstrates.

Plate 5.3. Self-incorporation. Artist Julian Walker exemplifies Baudrillard's assertion that collecting is a discourse directed towards oneself, by incorporating himself into a series of cigarette cards of British military regiments, known as the 'artists rifles'. Reproduced by permission of Julian Walker.

Anita

Anita is in her seventies and has collected various objects since childhood. In adulthood she has collected stamps, Goss china, Staffordshire figures and badges. She admits: 'Each of my collections has been sold off to subsidise the next.' Her mother bought a collection of Goss and crested china at an auction and it stayed in the loft for years until Joyce read an article on it which reminded her about it and she joined the Goss Collectors' Club and collected it until 1975. She sold it at a profit, in order to start collecting Staffordshire figures, which she found 'less boring'. But the prices increased dramatically and so she sold this collection in 1981 when she retired from teaching. Her youngest son had a number of badges with which he had won a second prize in a school display. Joyce had

> saved my Teddy Tails and Coco Cub badges from my youth. Gordon [her husband] had been half-heartedly collecting silver watch fobs and medallions and it gave me something to look out for at fairs, etc.

A particular badge of a newspaper children's club (as were the above), which she obtained cheaply at a fair, led her to the Colindale Newspaper Library to research it. This began a long interest in badges, especially of children's organizations. Once she had visited Colindale, she spent most of her free time there researching on children's clubs from old newspapers and magazines. She got to the stage of writing a book on the subject and was twice accepted for publication, but for the cost of colour reproduction of the illustrations. This demonstrates the process by which enthusiasms and new knowledge and information are brought to light by collectors. A badge book was eventually published by another collector (Setchfield, 1986), but was more general in tone, not a scholarly work as Anita's was to have been.

She has recently started to sell her badges in order to finance her latest enthusiasm, family history. She placed a collection of Victorian portrait badges, early political and royalty commemorative badges with the British Museum because she 'could not bear to break them up'. She has offered the children's club badges to a few museums, but has not had any enthusiastic response. She had a collection of Robertson's Golly brooches which she sold easily for £2000, which indicates the financial value of such 'trinkets'. As she says: 'I would willingly give some sections of my collection to a good home, but not if they are just put in a drawer and forgotten.' These would include a collection of 300 badges issued by regional libraries to encourage children to read. Museum professionals will be familiar with the unwanted public donation and provisos for permanent display. This is clearly impractical, but with a collectors' register, a welcome home could probably be found. A favour done for a collector may result in one done for the museum. Interestingly, one of Anita's daughters collects pencils from stately homes (which currently stand at 400), whilst the other one is obsessive about not accruing too many things. Clearly a distinct interest in context and provenance are expressed in Anita's collecting, demonstrating the wealth of enthusiasm and knowledge going untapped. There was certainly nothing frivolous about Joyce's collecting and the same is true of another female collector, Gloria.

Gloria

Gloria is unusual in that she collects in what might be thought a male collecting area. She is interested in military history, but does not have a familial background in the military. Her speciality is badges of the Home Front of World War I and World War II (such as Fire Watchers, Air Raid Precautions, etc.). The badges are only a composite part of her interest:

> Some people accumulate objects, but do not take the matter much further. The collecting is just the beginning as far as I'm concerned. Although I do not have a large collection, I take the matter quite seriously. From the beginning I have kept an acquisition book, giving each item a reference number, i.e: year/initials, identifying source/actual number, brief description/payment-exchange-donation, etc.

The accessioning system is not dissimilar to the museum index-card procedure. Clearly context and provenance are important to her and gives the lie to the assumption that collectors do not care for this. She also has the objective of holding a 'war on the Home Front' badge seminar comprising other collectors from a badge collectors' club. Indeed, a book on Home Front badges has recently been published (Mills, 1997). This has generated, for the first time, an insight into domestic organization and its symbolic representation during two world wars. That this has emanated from a popular collector demonstrates both the gaps left by academic historians and the way in which collecting can bring new knowledge to a wider public. Both Anita and Gloria demonstrate a real commitment to their collecting, as much as any typical male collector. Such female collectors no doubt always existed, but were not taken seriously (see Chapter 6). Often a male spouse will take over a collection and rigorously reassemble it. Not all private collecting is active, often it has a passive origin, as in the next case.

Jenny

Jenny collects model camels and images of camels. Or as she says: 'camels collected me'. At 16 she was given a pair of baseball boots with camel images on them, and at the same time a T-shirt with a camel on it. People then started giving her other camel-imaged material in the assumption she collected it, a classic case of passive collecting. She likes camels because of: 'the bizarre nature and aloofness of the beast . . . they're proud animals and can't be dominated, like cats. I'd love to have a real one!' The objects are variously cushion covers, camel tiles, ornamental Christmas cards and earrings. Some of her camels have names, but not all, as 'a name doesn't always spring to mind' and she introduces them to each other, anthropomorphically. She thinks provenance is important and that 'it's a shame that they can't all be dated or the maker traced'. She has coats and hats with camel brooches on, 'because that's where they live, it's not a conscious thing, they're just there'. She has camel-shaped teapots and other functional items, which she uses as they were intended, thereby contradicting the idea of exclusion from use as the criteria for sacredness. This demonstrates the more conventional wisdom, that women's collected items are incorporated into wider domestic decor (Pearce, 1993: 25–7). It further shows that in order to be an extension of the self (Belk, 1988b; Lancaster and Foddy, 1988; Dittmar, 1991), they have to join in with the owner's

functional life. The passive or accidental collecting scenario is also demonstrated in male collectors, as Mark shows.

Mark

Mark collects model vehicles (mainly cars and vans) made by the company 'Lledo'. He doesn't even drive himself (similar to the collector of Butlin's badges who had never set foot in a Butlin's holiday camp). He started collecting due to a promotional campaign for Walker's crisps. They offered some promotional models made by Lledo in exchange for crisp bags and he soon found himself swapping spares and collecting more. He managed to get photographs of them into an article which was published, and he now gets sent pre-production models for review and so started collecting accidentally. He dismissively waves his hand over a colour chart picturing currently available models, saying 'I've got all those'. The rare ones could be as little as three years old and sell for £400, but they generally retail at £4–£5. The attraction is that they 'look good together as a focal point and are cheap to buy'. Seemingly, in both Jenny's and Mark's cases, once by whatever means, the suggestion of an image or object is considered as above or beyond the ordinary, it carries on under its own momentum, like a voyage of discovery. There is clearly no organic motivation for either of them in what they collect, but the collections appear like revelations out of nowhere. The next case, however, exemplifies the object as a souvenir of the self.

Don

Don collects old light switches and electrical fittings. He worked as an electrician for the gas board in Leicester until a serious accident caused him to retire. He has been collecting for twenty years. His son visited the Science Museum, where he saw displays of such fittings. This made Don think that local people wouldn't know what the old fittings were like now. He began keeping all the old fittings he removed for replacement. He has 450 items in 11 glass display cabinets and they are all mounted on display boards with labels. He only collects older stuff and is proud to have an example of nearly every two-pin plug that was made. This is probably related to his time as an electrician, especially when training in his younger days. Therefore, the collection acts as a touchstone or a tangible testament of the occupation he was engaged in. He admits that his collecting helped him through the period of his accident. It could also represent a simpler time and certainty, with the memories that are packaged in the items. Organically, the objects can be read as symbolic of the sociocultural background from which they and he come; perhaps also as a reminder of now undermined or forgotten values or of areas of Leicester in which he worked, or of the people he got them from. Similar traits are expressed in the final case.

Helga

Helga collects handbells. She keeps them on narrow shelves at home, and takes about four hours to clean them all. She has a silver baby's bell on a ring, which is her oldest bell, and was hers as a baby (she is now 65). She has an Indonesian bell which was her parents', and a small plastic bell from her wedding cake (at which time she was not a bell collector). She also has a brass doorbell from her childhood house and

wants to get the wiring from the current owner of the house. She can't remember why she started collecting bells, but got the first one in 1974. All her bells have personal memories and stories attached to them, like souvenirs of the self. All her bells are brass bar one, which was given to her by a friend. She *didn't* want it, because it wasn't brass, but *did* want it because it was from a friend. She keeps it separate from the others. This implies a duality of sacredness and profanity and a dichotomy over which should prevail. Like Don, Helga's collection acts as much as a vessel for the containment of memory and sentiment. To lose or damage one would be to lose or damage a part of one's self, hence they are extensions of the self, emotions made physical.

Conclusion

In this chapter I have attempted to show that collecting, be it broken pottery or model camels, is intrinsic to our sense of self. How we arrange what we collect enables us to partially or fully construct an identity. Objects and material thus used can be said to constitute a kind of material language. The narrative they relate depends on what we want them to say to us and/or to others, in which sense the collector herself or himself becomes the centre of the collection. This, though, does not prevent these visual narratives from standing as testimony, wonder or curiosity to the uninitiated, as Cheval and Isadore illustrate. Individual collectors can be highly differentiated, as has been shown here and elsewhere (Elsner and Cardinal, 1994a) in their motives. Debord was convinced of the self-referential nature of our perceptions of material culture. Clearly, much of the material collected by those in the above narratives is highly self-referential. Sociologically and psychologically, such material is looked upon comparatively, with the spectacle's insistence on the new, and in the context of social change of which this is a part. In so doing, the collected material assumes the role of a shield or talisman, and ultimately a coping mechanism. What happens when collectors organize into clubs and societies, however, has not been widely studied (although Dannefer, 1981; Danet and Katriel, 1989; 1994; and Merriman, 1991 touch on them).

6 One big happy family? gender and collectors' clubs

Introduction

Having examined some traits of collecting and the gradual rise in consciousness of the full collecting sensibility, it is now time to explore the developed formalization of collecting as represented by collectors' clubs. Miller's call for more intrusive study of consumption in action (Miller, 1995a: 51) is facilitated by the inclusion of three studies based on participant observation. The chapter opens with a historical discussion of gender in collecting. This is salient, first, because it is an aspect of collecting only now being given serious consideration and second, because two of the clubs chosen for study are, to a high degree, gender specific (with a further mixed-gender club for contrast). The largely hidden gender history in collecting is therefore teased out to some extent, in order to make a comparison with the club studies.

The collectors' club, I propose, represents an alternative environment or society in which various behavioural patterns, such as acquisitiveness, are permitted and supported. They are also forums in which object-specific knowledge and information can be shared and valued, which in other social groupings would be seen as unfathomable or inappropriate. The potential for museums and social historians is therefore self-evident. In the study of male collectors' clubs centred on the material culture of breweries and pubs, the clubs provide an arena of friendly competition. This codifies collecting as the material culture of male bonding through rite of passage. The female club centred on souvenir spoons acts as a friendship network and enhances a sense of community, nurturing and sharing. Collectors' clubs generally, I submit, reinforce and promote values perceived to have disappeared in society at large and act as forums in which those values can be reconstructed and enacted via collecting. These values may include notions of the loss of neighbourliness for women or the disappearance of labour-intensive and skilled work for men. For men, therefore, competitive collecting represents effort, skill and determination; for women it represents a friendship network and a sharing environment. As such, collectors' clubs can be read as cells of resistance to the spectacle.

The full methodology for the field research appears as Appendix 2. This chapter explores the world of the collectors' club, using field research and correspondence relating to a number of organizations. The findings of a questionnaire received from 128 collectors' clubs are set out in the form of tables. Of 314 collectors' organizations contacted, 128 (40 per cent) responded. The 'old faithfuls' of stamps and coins were largely avoided, although some were included for balance and context. The main reason for canvassing their opinions was to explore any similarities or

differences between collectors' organizations and museums. It was also intended to discover the self-perceived levels and types of knowledge or expertise within clubs as comparable to museum knowledge. This would thus expose the potential richness of the collectors' contribution to a pooled knowledge of contemporary popular material culture (for further expansion on the scale and components of popular collecting in general, see Pearce, 1998). What became immediately clear was that the organizations see themselves differently in relation to collecting. Many objected to being called 'a club' and insisted they were 'a society'. They saw themselves often as organizations for learning and study, not solely for 'acquisition'. Knowledge of context is clearly important for them, which museums often accuse collectors of not having or wanting. Another reason for the canvass was to deduce the make-up of the clubs, not least in terms of gender, which is the area with which this chapter begins.

Gender and collecting

Popular collecting is a gender issue. Only recently has the extent of and differences in women's collecting started to be revealed (e.g. Dittmar, 1991; Pearce, 1993; 1995; Belk and Wallendorf, 1994; Wilkinson, 1997b). Whilst historical evidence for women's collecting is comparatively patchy, Gelber offers some insight in relation to the origins of stamp collecting (Gelber, 1992). In fact both stamp and postcard collecting originated with women. Being activities that took place in the home, middle-class women in particular were well placed to develop them. Stamps held an aesthetic attraction to women, who used to advertise for them to decorate furniture with (Gelber, 1992: 746). Ultimately, philately came to be dominated by men, when the commodity value of old and rare stamps was recognized and they were vested with the values and rituals of the male domain of the stockmarket. As Gelber notes: 'by the turn of the century, however, the idea of using stamps as decorative devices had become so absurd that philatelic journals made jokes about stamp wallpaper' (Gelber, 1992: 746). This is not to suggest that there were not serious or scientific female philatelists, but rather that in a male-dominated society, serious collecting was defined by men as were other social spheres and activities. Stamps lent themselves to systematic collecting (Gelber, 1992: 747). The attraction of collecting in sets and filling missing gaps has significantly contributed to the hobby's longevity and popularity. By contrast women also collected chromlithograph trade cards,

> but unlike the commercially produced trade cards however, the officially produced stamps came to be regarded as important. (Gelber, 1992: 747)

> Unlike the chromo scrapbook, the stamp album was both a catalog and a repository of wealth. Thus, even in their collecting hobbies, men produced and women consumed. (Gelber, 1992: 748)

There were calls by women for female philatelic clubs in an effort to redress the imbalance and to demonstrate that the hobby was being taken seriously by women, but they seem to have come to nought. Some female philatelists complained about sexism in the selection of club officers. Many male collectors believed that theirs was a scientific and structured approach, whilst women's was merely aesthetic and so invalid (Gelber, 1992: 749).

In contemporary collecting some organizations, such as the Badge Collectors' Circle, with over one thousand members, have a very good representation of women and junior members (those aged under 16). There are also a number of organizations which are almost entirely single-gender. The examples of a male club, the British Beer Mat Collectors' Club, and a female club, the United Kingdom Spoon Collectors' Club, are discussed later in the chapter. Women's possessions were more often seen as part of the overall decor of the house. They became part of the house contents rather than something apart from it. Even the periodic fads of the Victorian middle classes imply this. The fad for collecting blue china in the 1870s had a strong following in Liverpool. Blue china was being imported in quantity to Europe from China and Korea by the nineteenth century. A manual on art in the home by a Mrs Orrinsmith spoke of it thus:

> Surely there are not to be found more lovely bits of ornament for a drawing-room than rare old china – of course they should always be placed where they can be perfectly seen, without being touched; for would not one rather fracture a limb than break a friend's old Persian or Nankin? (*Museum Piece*, 1971: 1)

There was even a 'ballade of Blue China' written in 1885 by Andrew Lang, which claims:

> There's a joy without canker or cork,
> There's a pleasure eternally new,
> 'Tis to gaze on the glaze and the mark
> Of china that's ancient and blue.
> (Hillier, 1981: 81)

The china would probably have more than simply decorative value. It would possibly serve a social function as a conversation piece, or signifier for the lady of ambition for her husband's social elevation. The Victorians were eminently clubable, no-one formed more organizations for every conceivable purpose than they. There does not seem, however, to have ever been a formal blue china collectors' organization. The evidence, such as it is, as in the above verse, suggests that it was seen as a gentlewoman's pastime which would be tolerated, even endorsed, by their husbands or fathers. Although some blue china resides in Liverpool Museum, it does not do so in the form of collective bequests as it might have done had it been a male pursuit. This supports Pearce's assertion that it was not valorized as a legitimate collection (Pearce, 1993: 26). Had it been a male pursuit, there would no doubt be weighty tomes and catalogues extant relating to its scientific and taxonomic classification. Belk and Wallendorf cite Rémy Saisellin:

> Women bought to decorate and for the sheer joy of buying, but men had a vision for their collections, and viewed their collections as an ensemble with a philosophy behind it. (Belk and Wallendorf, 1994: 241)

This general assumption is perhaps also borne out by other material specifically female, of which there seems to be a dearth. In the aftermath of women's suffrage in Britain on the same terms as men (in 1929), the Suffrage Fellowship (an organization of ex-suffragettes) made an effort to collect and collate the material artefacts from papers to badges and banners, of former suffragettes, as did the Fawcett Library in London. Beyond this, however, very little suffrage material seems to have survived. This is interesting when it is considered how much material was generated utilizing

the Women's Social and Political Union's (WSPU) colours of purple, white and green. Both vested and commercial interests turned out thousands of badges, postcards, even clothes in the WSPU colours and were marketed as such in shops and catalogues (see Tickner, 1987; Atkinson, 1992). The same mind-set and fate presumably befell such material as the blue china. Seen as women's things with little relevance or inherent fiscal value, it was probably unceremoniously dumped. As the organizers of the Women's Pavilion at the 1893 Chicago Exposition asserted, women were the origin- ators of all industrial arts; once these were seen to be lucrative they were 'appropriated by men and women pushed aside' (Briggs, 1990: 95).

The most recent research into the question of gender in contemporary collecting and object attachment, however, is that of Dittmar (1991); Belk and Wallendorf (1994: 240–53) and Pearce (1995: 197–222). Dittmar's comparative study of collecting by gender and social class found that:

> With respect to gender identity-related meanings of possessions, men were mainly concerned with the self-referent, activity-related and instrumental aspects of their possessions. In comparison, women stressed both the symbolic and other-oriented features of possessions by emphasising relatedness to others and emotional attachment. (Dittmar, 1991: 182)

Thus, notions of use are male concerns whilst women erred towards aesthetics and emotional connection and decoration. These are the same criteria that ousted women from the mainstream of older hobbies as mentioned in Chapter 4. The artistic, aesthetic and sentimental connections to stamps and postcards, for example, that women initially made, could be dismissed as fads or crazes by men who then organized such collecting on a systematic basis by publishing guides and other information which allowed them to be collected scientifically and taxonomically. Belk and Wallendorf concluded that

> gender is reflected in both the activities involved in collecting and the objects that are collected. Gender is constructed through the uses to which the collections are put. (Belk and Wallendorf, 1994: 251)

Having found that two comparative studies in children's collecting from the 1930s (Witty, 1931; Durost, 1932) showed that the material boys collected differed from girls, they surveyed 192 adult collectors in 1993 and found much the same results (Belk and Wallendorf, 1994: 243). They found that women tended to collect self- referential and decorative material, whilst male collecting was geared more by control and domination (Belk and Wallendorf, 1994: 251). They concluded that collecting had societal functions such as the gendering of achievement worlds, pattern maintenance in economic spheres and a way of making gender culture visible. Whilst men's collections were about control or domination, women's collections were believed to 'represent achievement in the world of connection to other people – achievement of sentiment' (Belk and Wallendorf, 1994: 251).

Whilst the above conclusions are seemingly true, their drive lies more perhaps with the nature of the conscious and the subconscious. Men's collecting is indeed often consciously competitive, functional and driven by a need for control. It therefore assumes a rigid focus or tunnel vision. Subconsciously, however, there is often greater meaning and depth to their collecting, whilst women's collecting is more often consciously self-referential. This is perhaps because women are more open to, and capable of, exploring emotions and feelings than men. Traditionally, in a consumer society, women have been made into image-conscious media targets, hence leading

to a greater array of potential identities than men. This, on a wider social basis, is born out by the recent trend towards greater employment of women as traditional male jobs and industries disappear. This has led to an identity crisis in many men, whilst the change for women has been seemingly less problematic. Women more often confront, cope, explore and accept, whilst men are more likely to deny, control or reject emotions. All of which, in the context of material relations, offers scope for further investigation.

Pearce fills this out somewhat. She finds that women are 'faced with self-images which present them as whores, madonnas, little girls or house holding adults' (Pearce, 1995: 201) and that they tend to 'gather' material which supports such self-definitions (e.g. 'whore' becomes 'vamp' via the collection of 1930s clothes, Hollywood material, etc.). Men construct ideas of womanhood in their collections, usually as whores or madonnas, but seldom as mothers or normal girls (Pearce, 1995: 220). This is probably because men objectify women (Belk and Coon, 1993; Edgar, 1997). Again, socially constructed and oppositional gender roles for women create a dichotomy; young, hedonistic sexual entity versus mature, responsible and familial nurturing entity. Although oppositional, all roles are tried on for size and explored by women through collecting (and, by extension, through creation of domestic environment), from whatever quarter they may originate:

> When women are seeing themselves in the role of nurturing adults, they do indeed collect relationally and in an unemphatic style which so merges with their broader lives that its emergence as a true collection tends to be written out of the story. But when they are seeing themselves as vamps or child brides, the style of their collections is in a male mode, intense, specific, separate and serious (although of course the content of the collection is usually feminine material) and its emotional resonance is self-loving, narcissistic and absorbed. (Pearce, 1995: 210)

> Women construct themselves as little girls or whores but not much as madonnas. Women seldom construct men in their collections, either as wish fulfilment for themselves or as a means of projecting a male relationship which they find exciting. (Pearce, 1995: 219)

This latter point may well be because women do not objectify men in the same way as men do women. Women often look for something more meaningful and with greater depth in men than men themselves are prepared to readily project. Lisa Tickner's book on the banners and emblems of the women's suffrage movement is aptly titled *The Spectacle of Women*. Women suffragists did indeed present themselves as spectacle incorporating all the arts in which they were trained to further the cause (most notably Sylvia Pankhurst). As Briggs notes: 'much of the nineteenth century, culminating in Paris 1900, had the sense of a "great spectacle", particularly for the curious and entranced eye' (Briggs, 1990: 104). The women's movement at this time, it could be argued, can be seen as allied to the rise of the museum, department store and classic collecting as a panoply of material vistas all broadly celebratory of worthiness and greatness.

The way men and women perceive and use domestic space is also a consideration in this context (see Tognoli, 1980). Pearce is seemingly right in her assertion that men tend to need support structures such as display cabinets, to clearly objectify their things as collections (Pearce, 1993: 25–7). It would though seem, in the contemporary sense at least, increasingly a female trait as well. The Royal Worcester enamelled thimble collection advertisement in a colour supplement offers a free display cabinet to subscribers. The advertisement is clearly aimed at women.

Naomi Schor takes Baudrillard (in particular) to task for his sexual (and sexist) interpretation of collecting, whilst Walter Benjamin's collecting is analysed as a feminine construct (Schor, 1994: 253–4). Writing about her own collecting of Parisian postcards, she asserts:

> Collecting is generally theorised as a masculine activity, the postcard constitutes an interesting exception to these laws of gendering: it is the very example of the feminine collectable. (Schor, 1994: 262)

It would probably depend on the content of the card, as Hammond describes the trade in 'French' (i.e. pin-up) postcards:

> the trade in French cards and similar pin-up kinds was a way of shattering the virtual monopoly women held on the world of cartophilia and the opening up of postcard collecting to men. (Hammond, 1988: 10)

Belk found that there were gender differences in what is collected. Somewhat surprisingly, 49 per cent of American stamp collectors and 41 per cent of coin collectors were women, hobbies usually almost exclusively related in adulthood to men. Collectors of 'instant collectables' such as the china models and plates, etc. manufactured by Bradford Exchange and Franklin Mint are, he feels, all women (Belk, 1995: 97). Indeed, John Walter's comedy film *Serial Mom* (1994) revolves around a series a murders committed by the mother (Kathleen Turner) of a swap-meet obsessed daughter. One of the mother's middle-aged female friends is a Bradford Exchange and Franklin Mint devotee. However, given that a number of such items are commemorative of war events (especially the 50th anniversary of the Battle of Britain, etc.) and other traditional male-centred themes, it is possible that there are a good number of men collecting the output of these manufacturers, albeit on a smaller scale. It might, though, be argued that these seemingly male-themed wares are being targeted at middle-aged women as presents for their husbands.

The existence of collecting couples is one that has not yet been explored, though others have noted it (Danet and Katriel, 1994: 33). The dedicated book collectors Peter and Iona Opie have left an invaluable legacy of early children's literature, now housed in the Bodleian Library in Oxford. This certainly seems to have influenced their son Robert's collecting instincts, although he himself is unsure (Elsner and Cardinal, 1994a: 26). The labour movement would be significantly impoverished if it were not for the collections of Ruth and Eddie Frow in Manchester. Who, if either, in such pairings assumes a dominant collecting role remains to be examined. One comparable model has been Brian Harrison's study of feminist couples from the women's suffrage era (see Banks, 1985; Harrison, 1987). More pertinently, Gregson and Crewe's fieldwork on car-boot sales includes married couples working together as vendors (Gregson and Crewe, 1997: 101). Collecting is perhaps an underestimated aspect of feminist history and is deserving of a study in its own right. Popular collecting is here rendered invisible by default, as indeed women's history in general once was.

The composition of collectors' clubs

When collectors' clubs were asked about the construction of their membership by gender, only 20 (15 per cent) estimated female membership above 51 per cent and

these were largely female-dominated clubs such as spoon and teddy bear collectors. No specific conclusion can be drawn from this, but it does indicate that certain objects have a collecting gender attached to them, as Belk and Wallendorf's research (1994: 251) suggests.

Table 6.1 What is the female percentage of your club?

Response	Frequency	%
0–25%	66	51
26–50%	25	19
51% plus	20	15
Unanswered or unknown	17	13
	128	98

Similarly, 114 (89 per cent) of respondents reported that their junior membership (i.e. under 16) was less than 10 per cent. This seems to indicate that collectors' clubs are an adult institution (unless otherwise designated), where material is collected seriously. Exceptions lie in the older collectables such as stamps and coins, where junior clubs are long-established. The only large club of modern collectables, dominated by junior members, is British Telecom's Telephone Card Collectors' Club.

Table 6.2 What is the junior (under 16) percentage of your club?

Response	Frequency	%
0–10%	114	89
11–25%	1	0
26–50%	0	0
51% plus	1	0
Unanswered or unknown	12	9
	128	98

The number of dual memberships of club members was not readily quantifiable by respondents, with 56 (43 per cent) reporting it as 'unknown'. However, 30 (23 per cent) 'guestimated' that up to 25 per cent of their members were also members of other clubs. These were sometimes of similar or related themes to the respondent's club, at other times they were of entirely unrelated material.

Table 6.3 What percentage of your members are also members of other clubs?

Response	Frequency	%
0–25%	30	23
26–50%	12	9
51% plus	30	23
Unanswered or unknown	56	43
	128	98

Bonding in clubs

The collecting world has its own vocabulary and it in turn is used to weave spells around collectors. Collectors of Lilliput Lane, a range of miniature cottages made from painted plaster, were advised in Debenhams department store that a number of the currently available models were soon to be 'retired' (i.e. deleted) from the range. The term 'retired' is used in the same way as someone might speak of a relative having passed away rather than having died. It implies that it would be too brutal to refer to the object as deleted. Equally when collectors of any object organize in clubs, there seems to be an almost immediate need to legitimize the collective and their activities. One expression of this is finding a name, usually a Latin derivation, to describe themselves. The oldest in this lineage are of course *philatelists* (stamp collectors), *numismatists* (coin collectors) and *cartophiliasts* (trade card collectors). But there are also now *telegerists* (collectors of telephone cards), *pocilovists* (egg-cup collectors) and *tegestologists* (beer mat collectors), to name but a few. Another expression of legitimacy is the knowledge of, and meetings between, like-minded individuals, as one young cigarette card collector put it: 'Being part of the Cartophilic Society seemed to make it official that I was a collector' (Bowman, 1993: 4950). In this way, individual meaning is created out of the material that 'the spectacle' seeks to inculcate for its own profit. Dannefer concluded that 'Interpersonal relations are to a significant extent supplanted by mass media as the bearer of the content that is to be internalized' (Dannefer, 1981: 409). Collectors' clubs often work against this phenomenon by re-inculcating a new personal value into the material collected and focusing it through the collective. Debord's remark on collecting that it was 'a glorious sign of [one's] presence amongst the faithful' (Debord, 1983: 65) is appropriate here. The 'faithful', though, are committed to reinterpreting meaning, not accepting that of the spectacle's to which Debord was referring.

The material link that gives club members a continual sense of 'community' is the club magazine or newsletter (Plate 6.1). In the club survey, a few clubs stated that they were a postal organization only and did not publish a newsletter, but the overwhelming majority did so (see Appendix 3). These varied in quality and content, but nearly all of them had addresses and information on where to acquire the latest additions for the collection. This suggests that the collector needs the potential for diversity and rearrangement within the collection (thus emphasizing the play element suggested by Danet and Katriel, 1989) rather than closure through completion. However, closure through completion is just as big an issue in collecting as 'want ads' in collectors' magazines testify. As one American collector put it:

> A collector is a person who gets many things they resent getting but he has to get them to complete his collection. A collector always has to have something coming. (Tuchman, 1994: 40–2)

Although Pearce indicates that as many women collect as men (Pearce, 1998), *what* they collect seems to be more gender specific. The examples below deal with the all-male environment of 'breweryana' and the almost entirely female hobby of spoon collecting. It should be said that none of the organizations concerned ban one sex or the other from membership, it is just that the hobby concerned seemingly attracts one gender only. Lastly, an example of a general collectors' club which is equally comprised of male and female members is examined.

The formalization of breweryana collecting

Tegestology, with the collection and study of breweryana in general, is a good example of militant particularism within collecting. Most aspects of the brewery industry are collected. Museums collect the industrial material, but there are individual collectors' organizations for each of the following material aspects of it: beer mats, labels, cans and bottles. Certainly the British Beer-mat Collectors' Society (BBCS) and the International Label Collectors' Society, or The Labologist's Society (LS) as it is more commonly known, promote joint activities and share a high level of dual membership. The Bottled Beer Collectors' Club (BBCC) and the Beer Can Collectors' Club (BCCC) also engage with the other two organizations, but to a lesser extent than the LS. All of these organizations have contact with other brewery-related groups such as the Campaign for Real Ale (CAMRA). They stage joint events in which the whole world of beer can be 'lived'.

The LS is the oldest of the organizations, having been started in 1958. The BBCS is a close second, having been established in 1960. The other two were established in the 1980s. Beer mats seem more popular than the other three areas of breweryana collecting, perhaps because they are easier to obtain from pubs and are more easily kept. The BBCS has 388 members, of whom 47 live overseas (BBCS pers. comm., 1993). The secretary of the club, John Freeman, asserts that the club does much to encourage their 'unusual hobby' . Their functions with CAMRA and other groups help raise funds, which they donate to charities.

The BBCS officers relate to the members (who are all male) in a client–patron pattern. This is on one level vertically structured, in that material comes to the officers for distribution downwards. On another level the relationship is horizontal, in that all are made to feel equal in sharing knowledge and pleasure in the hobby. This is largely demonstrated at meetings, where mats are displayed and exchanged. The competitive spirit is demonstrated via comparison of collections, which can be dismissive or appreciative, thus placing those with the collections deemed of the best quality in a stronger position:

> Most months our 'society shop' offers [as] a service to our members specific mats that can be obtained. They are usually new issue mats that will be described in that current month's magazine. In addition we have a member from Leamington who runs a beginners' bargain section. (BBCS pers. comm., 1993).

In this way the society helps to hook a new member to the hobby by providing the bedrock of a collection at a cheap rate. This is of course common practice amongst junior stamp clubs, and companies such as Stanley Gibbons have turned it into an art form.

The Society also runs a 'beer-mat museum'. This is not an edifice of public benefaction, but four drawers containing 16,000 beer mats in the study of one of its officials to which breweries regularly contribute to keep it updated. Other officials are designated curators who compile beer mat collections relating to specific breweries or types of alcoholic beverage (e.g. cider). These are used by club members for their own research and by the breweries themselves. The 'museum' materially confirms the society's efforts by housing examples of nearly all known British beer mats, and through the compilation of a catalogue with over 20,000 entries in it. This is now being upgraded to floppy disk and will be sold to members in this format. The beer

Plate 6.1 Collectors' club journals
Photograph copyright the author. Journals copyright the collectors' clubs.

mat museum is as sacred a trust to the society as the public collections are to a municipal museum.

The society's officers are also at the bottom of a power relationship with the breweries themselves, as it is from the breweries that they get their information and mats for members and the magazine:

> Various members have the delicate task of forming good communication links with such breweries in order to obtain mats for the membership. (BBCS pers. comm., 1993)

Breweryana also testifies to the competitive and largely male side of collecting. One member of the BBCS, solicitor Tim Stannard, is calculated to have the largest collection of beer mats in the world. He has 69,000 British, 80,000 German and some 100,000 other foreign mats which he describes as his favourite way of relaxing (Fewins, 1994). By the time he appeared on Channel 4's *Collectors' Lot* (21 April 1997) he was in the *Guinness Book of Records* with a collection of 500,000 mats. He estimated the total weight of his collection to be one ton and has had to reinforce his loft to take the strain! He describes the compulsion to collect as a fear that if he stops he might get overtaken. Not being able to 'keep up' (like Opie) would mean a loss of prestige or respect from his peers and a blow to his self-confidence. Being overtaken would mean defeat. The competitive element of much male collecting can sometimes take too strong a lead. A former secretary of the Labologist's Society, Keith Osborne, was jailed for 18 months (cut to six on appeal) in 1994. He allegedly stole 28 beer labels printed between 1884 and 1925 from the Public Records Office, where he had been a regular reader for 25 years. He was in the *Guinness Book of Records* for the largest collection of beer labels (currently 36,000) (Grice, 1995: 22–6). The psychological approach to collecting (e.g Muensterberger, 1994) would probably cite such an example as a cautionary tale against serious (rather than passive) collecting. It has, though, even if true, to be placed in context with the majority of collectors for whom there is no evidence that such activity is common.

On one level, breweryana collecting offers a male bonding environment in which the ephemera of the bonding process can be asserted as the optic of attention. The male propensity for competition is acted out through numeric accumulation of beer mats, labels, etc., making each major collector chief of his own personal fiefdom, with due homage or respect paid by other lesser collectors. To 'fall behind' with the collection is to lose face and to lose respect. On the other hand, the bonding has a higher level of authority vested in the club officials. The beer mat museum is the holy grail of beer mat collectors, the officials its high priests and guardians. Like all sacred objects, however, it offers a rich source of social and cultural history to a much wider audience (such as museums and, by extension, the public) should they choose to recognize it as such.

The extent of knowledge in collectors' clubs

Given the quantity and variety of the material collected by clubs, it seemed pertinent to enquire whether any research had been made available on it. Clubs were asked if they had published anything detailing or listing known examples of the material their members collected. If stamps and coins are excluded (as they have been so widely written about over the years), the results indicate a substantial body of specialist literature. It varies in quality and research, but does at least provide some reference for collectors and museums alike, where otherwise none would exist. Of those who

reported not having researched or published anything, a good number (such as mineral collectors) stated it to be impossible to do so because of the infinite number of examples.

Table 6.4 Has your club published a catalogue or list of all known examples of the items your members collect?

Response	Frequency	%
No	65	50
Yes	41	32
Partially	14	10
Being considered	7	5
Unanswered	1	0
	128	97

Following from this a large number of respondents said there were members of their club who were regarded as authorities on the subject collected. The authorities were not often cited, but it was implied that it was not the respondent. This deflates the charge of self-aggrandisement often levelled at collectors. If such a large number of acknowledged authorities on collected material reside outside of museums, as is implied by the findings, then it would be as well for museums to identify them for their reference.

Table 6.5 Does any member of your club regard themselves as an authority on their subject?

Response	Frequency	%
Yes	109	85
No	15	11
Unanswered	4	3
	128	99

It would be reasonable to suppose that like-minded individuals would seek each other out organizationally as well as individually. A good number of respondents reported having affiliations with other clubs. These included opposite-number clubs in other countries and related organizations in Britain. Some were with museums or museum staff, although they did not figure highly overall. A typical comment was: 'we have international affiliations'. Many clubs are clearly not functioning in a vacuum or isolation from other organizations.

Table 6.6 Has your club any affiliations with any other organization?

Response	Frequency	%
No	77	60
Yes	47	36
Unanswered	3	2
Being considered	1	0
	128	98

The formalization of souvenir spoon collecting

The United Kingdom Spoon Collectors' Club (UKSCC) was established in 1980. Its 500 members are mainly female and middle-aged to elderly. The kind of spoons collected are the variety often found in souvenir shops and flea-markets, depicting crests or scenes of a town or vista. The secretary of the UKSCC extended an invitation to the club's half-yearly meeting. This was held on 7 May 1994 in Reading, Berkshire, in a local community centre from 1.00pm to 5.30pm. The UKSCC were chosen as a case study, partly because there was enthusiasm expressed for this from the club itself and partly because, as an almost entirely female organization, it offered the opportunity to make a useful comparison with the male practices and environments of the breweryana collectors' clubs.

The room in which the half-yearly meeting is being held is judged to be too small by those attending. The club would like to have had the hall next door, the same as last year, but it was already booked by a dance troupe. A slide show is being given by an ex-guide at Hampton Court, who is also a member of the club.

There are over 80 people seated closely together, most of them women aged between 50 and 80, all of them Caucasian. Some of their husbands are also in attendance, who are referred to as 'honorary members' and help their wives and act as ushers for late arrivals. There are a few male members and the President is male, but the club's five hundred members are mainly middle-aged or elderly women. Several of the officers of the club were asked why they thought this was. None of them had a definite answer, other than to say that it was perhaps because spoons are associated with domestic work, which has traditionally also been women's work.

The collected objects are clearly defined as collections and men, who dominated museum collecting, are in a secondary role and seemingly happy to be so. Lilian (the club magazine editor) finds that husbands of female members are not interested in the spoons, but that wives of the few male members are very interested in the meetings. Friendship seems to be as important if not more so than the collected objects they are ostensibly there to celebrate. This is illustrated by one elderly man.

Bob is an honorary member whose wife had been a member but had died a few years ago. His wife had collected spoons over a twenty-year period. She picked them up at places they visited and eventually amassed four hundred. He adds one or two spoons to the collection in her memory. He says, though, that he stays in the club because of the people he met with his wife since they joined in 1980 when the club first formed. Bob says he comes for the people not the spoons. Women's openness and friendship have allowed some husbands access to their networks. As honorary members, they are in some ways honorary women. Many of the UKSCC are also members of the Women's Institute (WI) or the National Union of Townswomen's Guilds (NUTWG) and have learned public speaking, presentation and catering skills there which they now also apply to the UKSCC.

The Hampton Court guide struggles to be heard above the loud extractor fan at the back of the room. Down the left hand side of the hall are three trestle tables, offering goods for sale such as membership spoons, home-made jam and cakes. A large plastic wall sticker above one table reads 'Natal Spoon Club – Natal The Last Outpost', with a Union Jack next to it. Many of the women are sporting home-made badges with their name and town of residence or club branch on them. They appear to be deftly made, some have miniature spoons which have clearly been lovingly

mounted on the badges. The men wear ties with the club name and spoon motif on them. The President is wearing a sports shirt with the name and motif woven on one side, like a darts club shirt. The club symbols are seemingly gendered. The elaborate badges have a resonance of embroidery samplers or sewing prowess about them. For this older generation of women, many of whom would have been brought up with sewing skills, the club insignia seems to act as a signifier of commitment and loyalty to the organization. The men's insignia is displayed on typical male adornments such as ties, which have been 'expressly made for honorary members'. The embroidered sports shirt worn by the President of the club was a 'one off' he had specially made. Perhaps this was to differentiate him from the tie-wearing honorary members, thus asserting a male authority position amongst them in a predominantly women's organization. The club committee members adjourned for a meeting at lunch-time.

There are competitions for displays of spoons with an advertising theme arranged at the front of the room. Next to the speaker, ballot papers are distributed for electing new officers. A woman appears at the conclusion of the slide lecture, bearing plates of ploughman's lunches (included in the ticket price). Obliging husbands help distribute them. She asks if anyone wants a squirt of salad cream. To follow there is chocolate gateau and coffee.

The helpmate role of the male honorary members seems indispensable and willingly entered into. Perhaps it is a way of saying thank you for your friendship, or just a way of feeling part of the proceedings. There may also be an element of pride in their wives' involvement, and wanting to enhance it through exemplary behaviour. The lunch period was successful because of the women's organizational ability in a very small and crowded room. Years of WI and NUTWG activity, as well as no doubt motherhood, finds another application in this environment. The food ritual aspect was every bit as important as the spoon collecting. The whole adds up to creating and extending the friendship network, sharing rather than competing as Figure 6.1 demonstrates.

Figure 6.1 Outcome of UKSCC meeting activities

Activity	Equation
Collecting	Cherishing
Organizing	Meeting
Cooking	Relieving
Presenting	Entertaining
Informing	Providing
Accompanying	Befriending
=	=
an accommodating superstructure	nurturing, giving, sharing

This is not to suggest that such friendship networks are solely restricted to women. Dannefer's study of old car collectors shows that men too can join collectors' clubs without initially collecting the relevant material, in order to make friends and contacts (Dannefer, 1981: 404). It does, however, seem to be more characteristic of women.

Lilian, editor of the club's magazine (*Spoonerama*), is a large bustling lady in a terrible rush. She rummages in her handbag and finds a handful of souvenir spoons with various enamel badges on the end and places them on one of the trestle tables.

Soon there is an eager huddle of elderly women competing for the spoons. This was the one occasion on which competition between collectors was witnessed. Their contest to get to the spoons on sale first was every bit as competitive as any male collectors' might have been. Everything sold. Some of the spoons seemed, to the uninformed eye, modest at best, but were perhaps bought as a symbol of success in having got near them at all, or as a souvenir of the meeting. The type of spoons collected are themselves souvenirs in essence. Bob's wife had amassed her collection from souvenir buying as had another member, Vivienne, the Midland branch secretary. The competition for the spoons, though, was not enjoined by all those present by any means and is not enough to undermine the wider picture of a friendship network. The confined space of the room may well have lent an added element of competition when in fact it would otherwise have been more seemly.

The day ended with a demonstration of handbell ringing from a group of five men and women playing traditional folk songs to which the audience were invited to hum along. The meeting was very well conducted and arranged, despite the constant squeeze on space and chairs as late arrivals came in. Some members had travelled down the previous evening and were going back the following evening, so they had more time to meet people. This was one of only two or three occasions in the year when they all got together. One could see the meeting in male terms as an old comrades' reunion, the badges representing honours or colours of the regiment. The ostensible reason for the gathering seemed almost an excuse to meet.

Linda, a middle-aged member from London, has a collection of some five hundred spoons, which she keeps in a suitcase. They are all catalogued. She has a carrier bag full of spoons acquired over the last year which she hasn't yet dealt with. She also collects other things. She began by picking up spoons on holiday on behalf of the West Midlands regional secretary, Vivienne, who is a friend. Whenever Linda went on holiday Vivienne would give her some money to buy spoons for her. In so doing, she became interested herself and started collecting. At the same time her (now ex-) husband was a model railway fan. He couldn't find authentic Edwardian figures for his layout, so he began making his own and researching the period for information on style of dress. This so fascinated him that it took over from the railway models and he got totally absorbed in making figures. On the principle of 'if you can't beat them, join them', she also began making models of military figures. She judges hers to be better because she was able to make a profit by selling them to collectors. She also collects postcards, which she has in another suitcase in her wardrobe, as well as thimbles.

Two elderly women from Bristol were very early members of the club. One says she finds she does a lot of research on the themes of her spoons and that she gets absorbed by this as much as collecting the spoons themselves. She feels she expands her spheres of interest through this, finding more to collect as a result. Vivienne cleans her rack of displayed spoons every two weeks with Goddard's Silver Dip or with a silver cloth. Her other spoons are kept in suitcases where the air can't get at them and tarnish them. She says the spoon sellers had arrived early and she did her buying before the committee meeting and the rush started.

The collecting practice engaged in dispels the myth of collectors' fetishism. Here the sacred objects (the fetishized) are unceremoniously cast into suitcases or carrier bags and pushed under the bed or locked in wardrobes. Also for some, as the lady from Bristol states, the contextual and historical aspects of the objects collected are as important as the objects themselves, which is not the traditional view of the collector at all.

One member from Middlesex, who has been collecting spoons for 20 years, wrote to say she 'liked the look and feel of spoons' but that it was 'the searching for information' that she enjoyed the most. She had previously collected Wade figures, but 'once acquired and displayed there is no further interest'. So clearly for her, spoons offered a material entry to social history. Another member from Essex, who has been collecting spoons for 13 years, related that she had 'nine hundred spoons, and each one a friend'. The club was seen as 'an excuse for a get-together'. For another member, club membership offered a means of 'getting knowledge on the subject'. A member from Scarborough described the meetings as 'enormous family gatherings'. Another member from Wales regarded club membership as 'belonging to a wonderful large family' and hoped her collection would, on her demise, be dispersed amongst the membership. This member was 72 in 1995, and had been collecting since 1956. The comparison with Belk's female Barbie doll collector (Belk and Wallendorf, 1994: 245–8) is salient as a means of nurturing, or repaying a perceived debt for their friendship. It is also significant that she had never considered a museum for her collection. Another member from Scarborough would like to see her collection inherited by her family, but they think it is 'a load of old rubbish', although she has been collecting since 1944.

Despondently, a rare male member from London believes: 'For the most part, interest in what I collect . . . will die with me, and they will be passed on in a skip.' For a member from Bradford, her spoons are 'really the story of my life'. A member from Surrey, who has 550 spoons, collected over 13 years, has slowed down on collecting because the sources are drying up and prices are rocketing. A member from Harrow began collecting spoons in 1978 after an aunt died and she found four spoons amongst her things, thinking them too pretty to throw away. When another aunt died, she found a further six spoons, which hooked her and she now has seven hundred! It was also noticeable that all the respondents confessed to having other collections which varied from owl ornaments to thimbles, crested china and little boxes. They were entirely within the recognized context of 'women's collecting'.

Turnover of members in collectors' clubs

To put this into context, the national memberships of other clubs were canvassed. The largest section of respondents reported that their memberships varied between 101 and 300 and the majority reported that they gained as many members as they lost. Typical comments included: 'we are a society not a "club"'; 'we are an international society'; 'postal club only'; 'we publish our own magazine/journal'; 'some members are active or work in museums'; 'museums or museum staff are members'. The questionnaire addressed individual rather than institutional membership but even so highlighted a variety of operational set-ups, widely variable in sophistication. A national or regional apparatus for contact with formal organizations like museums may well encourage more uniformity, thus aiding a working relationship.

It was the secretaries of the clubs who were contacted and when asked the number of secretaries there had been for their club, the majority reported between one and five. This reflects the recent establishment of most clubs rather than any long-term stability, although many reported that they had been the only secretary for five to ten years. A typical comment on this question was that 'there is a fixed term of office for secretaries', which implies a democratic structure.

Table 6.7 How many members does your club currently have? (1994)

Response	Frequency	%
1–100	20	15
101–300	47	36
301–500	27	21
500 plus	23	17
Unanswered or unknown	11	8
	128	97

Table 6.8 What is the annual loss of members?

Response	Frequency	%
0–25	68	53
26–50	18	14
51–100	6	4
101 plus	11	8
Unanswered or unknown	25	19
	128	98

Table 6.9 What is the annual gain of members?

Response	Frequency	%
0–25	62	48
26–50	18	14
51–100	11	8
101 plus	12	9
Unanswered or unknown	25	19
	128	98

Table 6.10 To your knowledge, how many corresponding secretaries have you had?

Response	Frequency	%
1–5	92	71
6–10	13	10
11 or more	1	0
Unanswered or unknown	22	17
	128	98

United Kingdom Spoon Collectors' Club Midland branch meeting, 23 July 1994

Having participated in a national meeting of the UKSCC and observed its functioning on a macro level, I decided to attend a smaller, regional meeting to observe it on a micro level. The meeting was held in the back garden of one of the members' houses on a hot afternoon, where five members were present, including the National President. This constituted the branch for the whole region at the time. The President comes from Suffolk and was trying to visit all the branches. The others all live in Wolverhampton and all present were either middle aged or elderly. There was one other member who had to resign due to other pressures. There had also been a couple that came from Coventry, but who stopped coming some time ago.

Vivienne, the secretary of the Midland branch of the UKSCC, has been collecting spoons since 1963 and has about nine hundred spoons from over 60 countries. Her sister was also a club member but has recently died. She had over eight hundred spoons. Vivienne joined the club in 1984 and she finds the visual aspect of the spoons more important than their value. This is in marked contrast to another organization, the Silver Spoon Collectors' Club (SSCC). When the meeting is asked about the SSCC, some have never heard of it, others say they have contacted them once or twice to ask about an exchange of guest speakers at meetings or mutual outings. They got a very cold response. The SSCC are held to be 'antique collectors' whereas the UKSCC is a 'fun and friendship club'. Thus within the UKSCC, the collected becomes part of the membership's identity, but not more so than the friendship, all aspects are equal. The SSCC membership, however, collect or 'acquire' for prestige, profit and investment and are therefore not organic in the sense of the UKSCC.

A tour of the Exquisite spoon factory had to be cancelled because they wouldn't pay the special insurance that such visits entail. A decision is made to visit the Wedgwood factory instead (they make ceramic spoons). Vivienne shows one ceramic and one silver spoon made by Wedgwood to the others. The ceramic spoon is in its original box and much is made of this. This is very much in line with collectors of model vehicles, who place as much emphasis on the box or packaging the model comes in as the model itself. Unboxed, models lose up to half their value, even in good condition. One collector of Dinky toys even paid £1500 for an empty box (Connolly, 1994b: 15). This demonstrates the importance of presentation and the pleasing of the eye. The box represents completeness and sanctuary for the object. Advertising agencies have always known this. Friday 12 August is decided on as the day for the visit with everyone checking their diaries. Many branches apparently have an outing or visit rather than a branch meeting. This is again in line with WI and NUTWG practice and a friendship-inspired idea rather than a competitive or confrontational one, sharing an experience rather than monopolizing it. A design of a bridge in spoons is debated as the branch submission for the competition at the club AGM in October. The exhibit has to conform to club rules, which state that it should be no more than ten spoons maximum, and the size of a handkerchief.

When asked if any of the members had heard of John and his huge collection of 30,000 spoons, they say they know him and have met him. They don't class him as a collector. It is felt he set out quite deliberately to get into the *Guinness Book of Records* and buys spoons indiscriminately, in bulk for quantity rather than quality. He had a spoon made picturing himself, but only one copy, so he could have the only one,

although he has made others in quantity. The fact that he has so many spoons does not engender envy, but rather contempt. He cannot possibly have acquired them all with any sense of real choice or discrimination, therefore his collection is profane.

One member, Joan, says: 'the way in which a spoon is given to me means I could never get rid of it'. John's collection, they assume, has been compiled from quantity buying and not careful selection. Therefore he has more in common with dealers and manufacturers than collectors. John's collection cannot possibly have any aesthetic quality because its components were not acquired individually, with a memory attached to each. With the attached profanity, his collection is so large as to become a non-collection. It has exceeded the bounds of the known and accepted. The UKSCC awards certificates for members who reach one, two, five hundred or a thousand spoons in their collections, but more from a sense of shared pride and celebration than from a competitive achievement. John's collection exceeds these boundaries and profanes the nuances involved. His collection represents transgressive behaviour. He becomes someone who makes acquisitions rather than collections. It is implied that the discerning collector would exercise more restraint. This is borne out by a letter from another member of the UKSCC, who states:

> I am much more discerning now than when I first started, the modern spoons I don't really save for. I would rather have something with a bit of history attached to it and have several of one hundred years [old].

They once asked John about insurance or security problems for his collection in his specially built house extension. All he would say is that people could possibly get in, but they would never get out.

There was a lot of hostility expressed by branches at the suggestion that spoon dealers be allowed to join the club on the same basis as ordinary members. This underlines the strong friendship element of the club. Dealers are anathema as their interests are purely monetary. Lilian (the magazine editor) is the only member allowed to sell at meetings, unless express permission is approved by the committee. Ten per cent of all profits realized are contributed towards the club's funds. There is a move, though, from the Welsh branch to allow other dealers to sell at club meetings (though not to join the club) as it is felt that Lilian's selections have been going downhill of late. Lilian has contacts with all the spoon manufacturers and runs her own business in trading, buying and selling them. The desire to keep dealers outside of the club is an attempt to prevent commercial contamination of the 'purity' of the friendship aspect of the club. By contrast, other clubs such as the Badge Collectors' Circle are made up to some extent of dealers whose payments for advertisements in the club magazine contribute enormously to the content therein, and help pay the running costs of the club.

Vivienne has a wall-mounted cabinet with sliding doors which she won at a club raffle and in which some of her favourite spoons are displayed. They don't tarnish behind glass. The rest of her collection is stored on velvet-covered boards in boxes which she occasionally cleans. She has all her spoons listed along with notes on where they came from, who gave them to her, etc. She enters their values in her own code in case of burglars. Another member has all her spoons on open display on wall racks in her hobby room. If they come in their own boxes they stay in them. The main comment evoked from the display is that 'you can tell they need cleaning'. If each object in the collection is not ascribed a sacredness in the way it was acquired, with

affection, good will or happy memories, then it has no place in what might be called 'collection heaven'. Each addition is cement in a wall of sentiment. The profane acquisition acts as a dissolving agent on the wall's cement. It is an unbeliever in a temple and has to be vanquished. When asked if there are any special spoons they'd like to get for their collections, they confessed to never having really thought about it before, but came up with the following suggestions: a 'mummy spoon' (from Egypt) where the finial (end of the spoon) is a casket which opens to reveal a mummy, and a Japanese geisha girl spoon (both are very expensive); a medicine spoon which is hallmarked silver and not made after the eighteenth century; and a moat spoon. The novelty of the question to them suggests that unlike acquisition for its own sake, no 'wish-lists' exist. Although this may not hold true for the club as a whole, it does add weight to the assertion that the objects are only as important as the people, perhaps less so.

Asked where they might like their collections to end up, they were unanimous in their desire for their collections to be given to the club and split up amongst the members, another sign of the friendship nature of the club. Surprisingly, none of them had ever considered offering them to a museum. Some thought the objects too trivial to interest a museum, others never go to museums and had not thought of it before. They are often asked if they ever use their spoons functionally, which they don't, as they are for collecting, but their collectable status is often misunderstood. They have had meetings when serving tea and coffee they couldn't find a (utilitarian) spoon for stirring tea, even though they all have spoon collections on the wall! The absurdity of the situation is obvious to them all, and yet they would never consider using their spoons for any functional (profane) purpose. Spoons are not for eating or stirring with, they are for exhibiting and making pictures of bridges with. We play subversively with the objects, like dressing animals in human clothes or dyeing their fur in Day-Glo colours.

The UKSCC is perhaps unusual amongst collectors' clubs in that the competitive element is almost entirely replaced by a co-operative one. It extends a hand of friendship instead of one of competition. Of the 20 members of the UKSCC with whom correspondence was entered into, all made reference to the 'friendship' of the club and of the 'one big extended family' nature of it. Collecting is only one component of the reasons for the club's existence. Certainly, many of the members are widows, or else widowers, whose spouses had been members. To keep going in memory of the deceased spouse, to keep alive friendships made through the club and thus keep alive the essence and memory of the loved one is as much a reason as the actual collecting, probably more so. As one member put it: 'You don't have to be a collector to be accepted by the club, it's the people you come for not the spoons.'

Having analysed a male and female collecting club, one with a representative mix of gender and age was studied in order to see if it functioned differently, or if it was more or less competitive.

Leicestershire Collectors' Club

The Leicestershire Collectors' Club (LCC) was formed in October 1994 by exhibitors at Leicester Museum's 'People's Show' (see Chapter 7). A room is hired at a local adult education college on a monthly basis. The meetings last for two hours from 7.00pm to 9.00pm. The attendance is usually between 14 and 30 from a maximum

possible 50 members (later increasing to 75). Norman as co-ordinator gives a welcoming address, especially to new members, which is followed by club business and the financial report. After members' comments and discussion, there follows a half-hour presentation by one of the club's members on their particular collection. Themes included camel images, bells, model vehicles and domestic electrical light fittings (see Chapter 5). There is always a raffle for club funds, with the prizes usually being donated objects for collections. After this there was a period of interaction between members.

Norman is an active Christian and devised a period of 'thanksgiving' during club meetings in which the Anglican practice of greeting is substituted with an exchange of gifts which Norman calls 'gudgies'. This Norman insisted was a club word for those objects exchanged between members. Many members, male and female, confess to now looking for objects to get for friends they've made at the club. This occupies them more than seeking material for their own collections when they are at collectors' fairs and car-boot sales, etc. The members are made up of a wide age-range. They range from parental collectors who have encouraged their children to take part, to old-age pensioners, both single and couples. Younger adult members also attend. Norman believes there are two types of collector: those who collect for gain and those who collect for fun. He sees collecting as territorially defined: 'it's about being able to say this is mine, it belongs to me'. Being unemployed, perhaps property ownership helps reassure him of a place in society and lends a prestige which he may feel he lacked. As proposed in Chapter 4, collecting is, subconsciously, a means for the dispossessed to re-enter or find their niche in society.

The editor of the LCC magazine (*Collecting Now*), Joan has a number of collections which in total are symbolic of her life. She collects vintage fountain pens, because she and her husband had both got old Parker pens (thus symbolizing marriage). She collects writing equipment, because she is a journalist by profession (occupation). She collects ephemera of children's clubs that she was a member of as a girl and also collects wombles replicas and ephemera, because her daughter loved them as a girl. Finally, she likes Stratton enamelled pill boxes, which she attributes to the rather fetching example of one that her mother used to keep her pills in.

As in the UKSCC, there is a general consensus of opinion against 'trade fair' organizers and dealers. Their pricing is distrusted and it is repeatedly emphasized that dealers and traders will not be eligible for club membership. There are two 'guests' at the initial meeting, who Norman later suspects of being dealers looking for 'punters'. It is agreed that the club is a nice way to meet other collectors (i.e. a legitimizing structure for collecting activity, a self-help group?). Norman sees the club as his legacy to society and hopes to have the club magazine sold through W.H. Smith's. He grandiosely envisages an office in town with paid staff for the club. He wants to have a separate membership secretary so he can adopt the title of 'President'. It is apparent that female members are a lot more willing to stand as officers than men. The men seem to be far more interested in the object of their collections. It is pointed out that the nature of the club is designed for those whose interests do not fit into any other specific club. A number of those present make reference to friends who 'save' things without thinking of themselves as collectors. As one woman put it: 'I don't think he knows he's a collector.' Another collector of model frogs states, 'I had a collection, but I didn't know it was a collection, until it was pointed out to me.'

There are trestle tables set up along the sides of the hall and members' collections are displayed on them for others to see and comment on. The half-hour talks prove popular. There are new members, and someone who collects 'named spanners' volunteers to give a talk on his collection. New collectors are introduced to the other members, who are all encouraged to state what they collect. The 'friendship' nature of the club seems here to be most on a par with the UKSCC. The seating arrangements have been in rows. Norman tries putting the chairs in small group circles for better interaction between members. However, as people come in they put the chairs back into rows. The membership has risen to 75, and Norman doesn't want any more members until he can find someone willing to help him run the club. The *Collectomania* People's Show, staged in the summer of 1995 by the LCC, did a lot to encourage members in their hobby. A number are now actively seeking reference material on their subjects and have become interested in provenance. As one member who collects RAF uniforms attested, 'It's not the uniform so much as the people behind them. I'm interested in the history.' This, at least, would indicate that such events as People's Shows encourage a deeper interest in the subject collected for the collector.

Anatomy of collectors' club meetings

It was felt appropriate to ask if collecting clubs had meetings or if they only existed as a postal organization. Structurally, the majority of respondents reported that their clubs met at least once a year (sometimes more often). Local meetings were often reported as 'frequent'. This implies that collectors' clubs are active organizations which exchange information and knowledge on the subject collected amongst members. A number of clubs reported themselves as being postal only, but these were a small minority. The purpose of the meetings varies. Overall, 86 (67 per cent) reported that their meetings incorporated both discussions and swapping as well as other activities. A number reported that their annual meeting might take the form of a visit (e.g. to Southampton Docks in the case of the Titanic Society) followed by a group meal at a hotel. The variety of activities demonstrates the proactive nature of collectors' clubs, who are 'ant-like' in what they discover and turn up.

Table 6.11 Does your club meet nationally?

Response	Frequency	%
Yes	97	75
No	20	15
Unanswered	4	3
N/A	3	2
Longer than annually (e.g. biannually)	2	1
Variable	2	1
	128	97

Table 6.12 Does your club meet locally?

Response	Frequency	%
No	49	38
Yes	39	30
Unanswered	19	14
Variable	15	11
N/A	5	3
Being arranged	1	0
	128	96

Table 6.13 Are the meetings predominantly for discussions?

Response	Frequency	%
No	66	51
Yes	41	32
N/A	16	12
Unanswered	4	3
Partially	1	0
	128	98

Table 6.14 Are the meetings predominantly for swapping?

Response	Frequency	%
Yes	59	46
No	46	35
N/A	16	12
Unanswered	7	5
	128	98

Table 6.15 Do the meetings additionally incorporate functions other than the above?

Response	Frequency	%
Yes	86	67
No	22	17
N/A	15	11
Unanswered	5	3
	128	98

Overall, collectors' clubs seem to be active and informative. They seem to have a serious interest in the subject collected, to the extent of often privately publishing authoritative works on the subject. The hive of activity that these organizations collectively represent formalizes collecting on an individual basis and provides a representative grouping for museums to work with.

The culture of model vehicle collecting

Having examined the structures of the collecting club using what they collect as the backdrop, it is now important to focus on a particular collected item. The importance of this lies in the example it makes of the variegation of meaning in different collected objects. The fact that collecting exists, and that there are various overarching characteristics related to it, does not inform us about the specific meaning different objects have for different collectors. Therefore this micro-study intends to tease out some of those specifics using one collected object as the instrument. Model vehicles are a particularly popular example of a contemporary collectable. They are also a very good example of the way in which an essentially children's item has been recommodified as an adult collectable in a process known as 'infantilization' (Green, 1995: 10). There are a number of clubs catering for model vehicles. Model cars in particular are very popular and have been chosen as an example of the genre. Many model collectors belong to the clubs listed in Figure 6.2.

Figure 6.2 Model vehicle collectors' clubs

Club	Membership
Corgi Collectors' Club	15,000
Exclusive First Editions Official Collectors' Club	900
Lledo Collectors' Club	40,000
Matchbox International Collectors' Association	8000
UK Hotwheels Collectors' Club	60

Sources: *Hoole's Guide to British Collecting Clubs* (1992) and Lledo Models

Even allowing for the overlap of dual membership, there is an enormous gulf between the smallest and largest of these clubs. This indicates that such organizations either are more widespread and diversified, or have grown in the years since Merriman's survey, in which it was found that 'Few people, however, actually join formal collectors' clubs' (Merriman, 1991: 124).

The Corgi, Exclusive First Editions and Lledo Clubs are run by the manufacturers themselves, thus establishing a captive market for their merchandise as it is produced. The Matchbox and Hotwheels clubs are run by collecting enthusiasts, the Matchbox International Collectors' Association has indeed been run by the curator of a toy museum in London. There is no doubt a large crossover of collectors with memberships of two or more of the clubs, but even so it represents a sizeable collecting interest internationally. Collectors often specialize in particular companies or types of model vehicle; in the case of Lledo at least, there is a certain militant particularism. Lledo's mainstay is the *Days Gone* series, almost endemic in toy shops around the country. These are largely inexpensive, though they can become costly. In addition there is a special 'Gold Model' club within the Lledo Collectors' Club, who specialize in gold-

plated limited edition cars, which is also run by the company. There is, however, a third faction, which numbers only some forty to fifty members who specialize in those Lledo models which can be called production errors. That is there is some minor flaw or difference between the commonly available model and the other one. This group was started by members of the formal club rather than the company. And so, however tightly the reigns of marketing may be held by the company promoting its own wares, there is still room for initiative from the membership. It may also be illustrative of collecting as subversion, undermining the role Lledo sees for its own products.

Most of these clubs produce their own magazine, in addition to which there are at least two major commercial magazines for collectors; *Model Collector* and *Classic Toys*. A copy of each was bought at random. It is immediately apparent, on looking at the pages of these magazines, that great stress is laid on serialization in collecting as indeed it is in museums. Traditionally, public collecting is revered as sacred whilst private collecting is reviled as profane. We should now ask the museum professional: why is your awareness of a gap in the museum's collection 'legitimate', whilst a private collector's is not? Also should establishments like the Corgi Heritage Centre, Rejectamenta (a privately run museum of material people have discarded) or the intended Covent Garden Cartoon Art Museum (see Atkinson, 1997: 6) be regarded as museums or 'fetish meccas' and are the two the same anyway? (see Dannefer, 1980: 393–5 for a discussion on the religiosity of collecting).

Classic Toys (Nov/Dec 1995) proved to be a rich source of applied collecting theory and is therefore examined in some detail. A caption showing eight identical cars in different colours illustrates this: '"Eight Devons", this model was to have the most numerous colour types of the 40 series' (p. 7). Similarly the caption underneath an illustration of a model of a Riley Saloon, a model in production from 1948 to 1960: 'Note four shades of green. The very pale green is not faded' (p. 6). Susan Stewart defines the collection as being constructed from its 'principal of organization' rather than its 'elements' (Stewart, 1984: 155). These examples demonstrate this through concern with colour variation and therefore serialization, as in museum collecting. Colour variation of the same model is therefore its taxonomy.

There is an article on Metasol of Portugal, illustrating how the entire world of model production is brought under psychological control and knowledgeable embrace by encompassing a global perspective of the collecting subject. On page 26 there is a colour advertisement for 'Vectis Auctions' which displays a colour photograph of numerous model vehicles side by side (Plate 6.2). Thus the collectable is instantly transformed from the individual item in which all aesthetic and emotional values are vested, in which is seen the individuality and character of the piece, into a consumable, a commodity, as though on an industrial conveyor belt. The individuality of the item disappears. On pages 28–32, Hillary Kay, a senior director of Sotheby's and 'one of the team of specialists on BBC 1 *The Antiques Roadshow*' is interviewed and asked what her top ten toys for a desert island would be (Bailey, R., 1995: 28). A senior director of a firm as prestigious as Sotheby's (who is now their new collecting lines specialist) giving their time to collectors of model cars would not have been entertained 25 years ago, but they have long since proved to be a most lucrative commodity. In 1977 (the first year of toy auctioning at Sotheby's) the turnover was £70,000, which by 1994 had increased to £4.5 million in London alone (Bailey, R., 1995: 28). Kay is modest when singled out for responsibility for this, but recognizes the change in perception of collectors and collecting (in this field at least):

Now I believe when you meet somebody and you say what it is you collect (assuming that it is something unusual), you are regarded as an object of fascination rather than certifiable . . . You look at the magazines, periodicals, books, television programmes and I think that the way in which toy collectors are regarded now is a reflection of a general change in attitudes. (Bailey, R., 1995: 29)

Pages 33 to 35 are devoted to Pete Waterman (of the famous 1980s hit pop song writing team of Stock, Aitkin and Waterman), who owns a collection of over 20,000 model trains, 36 real ones and a chunk of British Rail on which to run them (Evans, 1995: 33). This may stem from his unfulfilled passion for model trains as a boy, as he says: 'Always Triang, never Hornby, Dad could never afford Hornby' (Evans, 1995: 33). If we look at the subtitle to another article in this issue of *Classic Toys*, again on model trains, 'The trains of the dining room carpet' (Balldock, 1995: 38), it raises an interesting notion of class difference in collecting. Model trains (at least up to thirty years ago), along with Meccano sets, etc., were very much part of the lower-middle-class, male childhood experience. It is also interesting that other material of this period, such as magazines like *Practical Wireless* and similar material culture generated by the 'Hobby League' movement of the time, and aimed at the same audience, is seemingly not well collected.

Stewart sees such collections as allowing 'one to be a tourist of one's own life' (Stewart, 1984: 146). Model vehicle collections could, realistically, most often be termed 'souvenirs of the self'. Tangible material and codified expressions of journeys made and visits paid, not to any geographical destination, but to temporal vistas, real and dreamed (see Pearce, 1995: 243–5 for cogent examples).

The advertisements for model vehicles lay their emphasis entirely on the limited run, exclusivity and the 'precision engineering' nature of the models on offer, such as this one from Somerville Models:

We're starting a new collection of 'specialist interest' subjects called FIVE HUNDREDS. They will only be available direct from us and just 500 of each will be made. £70. (original emphasis)

In *Model Collector* (November 1995: 42) there is an advertisement for a gold-plated set of 'Thunderbirds models':

This special edition collectors' set of THE THUNDERBIRDS vehicles is issued in a strictly limited edition of 7,500 sets world wide. (original emphasis)

There is also a 'custom designed keepsake storage box included'. Thus, when reporting on Metosol from Portugal, the world is signified to the collector as a rich source of knowledge and potential additions to one's collection, whilst the above advertisement signifies the world as an unknowable competitive market for the limited edition, which if you should buy one, will be that much more rarefied (even if they were all sold in one country). It is useful to make comparisons between model car collectors and those who collect vintage examples of the real thing. Dannefer evokes the sensation of an old car enthusiast as he settles into the driving seat thus:

When the enthusiast – most often a male – climbs into his old car, it envelops him and insulates him from the world. When he settles back into the seat, it comforts him. When he turns the key and the engine responds, it submits to him. When he puts it into gear and drives away it serves and glorifies him. If it is a desirable car, it is anthropomorphised as a benevolent friend. If it is of massive size, it is damn near omnipotent. (Dannefer, 1980: 392)

As the real car enthusiast feels enveloped by his possession, the collector of model cars envelops his. As the real car enthusiast truncates distance from the car by being both in and of it, the model car collector seeks to put distance between himself and the collection in order to control it by engaging in an overview of it as an entirety. Whilst the vintage car is actual and of itself, the model car suffers from second-handedness by being derivative of the actual (Stewart, 1984: 172). A vintage car is penalized in competition if it is driven, its appearance is all-important, thus it is transported in an expensive trailer from contest to contest (Dannefer, 1980: 397); model cars are at their most desirable (commercially and collectably) when in mint condition, encased in their original boxes. Printed 'automobilia' of all sorts is keenly sought after by old car enthusiasts (Dannefer, 1980: 401), just as Corgi and Matchbox catalogues are sought after by model collectors. In collectors' terms this is referred to as 'related material' or 'go-withs'. This thus emphasizes the companionate or orbital nature of the material, secondary as it is to the optic of central desire, real or model. Real cars are 'stabled' in garages, model cars are 'garaged' in display cabinets (see *Model Collector*, 1995: 30, 74). As Stewart remarks:

> The toy world presents a projection of the world of everyday life; this real world is miniaturised or gigantisised in such a way as to test the relation between materiality and meaning. (Stewart, 1984: 57)

Belk and Coon (1993) show how gift-giving in college dating can be viewed in terms of economic or social relationships; economic where there is no real affection and social where there is. In the former, the male often objectified the female as a car (Belk and Coon, 1993: 396–401). If the desired individual is substituted for an object of desire, then the same mind-set prevails. Two validating factors for a collector are: is it, or will it become worth more than I'm paying for it? and does it have aesthetic or personal appeal? Formula One racing ephemera can command high prices. For instance £3000 for an empty Champagne bottle used by Ayrton Senna after a Grand Prix race in 1992, while a Senna crash helmet (one he actually used) can cost £15,000 upwards on collectors' markets (Simpson, 1995: 60). To a museum there is seemingly a more functionalist appeal. The British Museum of Road Transport in Coventry has considerable material of this nature and the cars themselves of course. It is fully aware of the value of, and interest in, such material, whereas its collection of over 16,700 model vehicles on long-term loan is seen entirely functionally:

> we thought such a large collection could not but help get people through the door and we also had ideas to use the models to show transport through the ages . . . We did not contemplate the cultural significance of such objects. (personal communication, 1995)

They are, however, displayed in showcases picturing backdrops of relevant landscapes. The model collection museologically is seen here as an adjunct to the 'serious' displays of the 'real thing', whereas in collecting behaviour the enthusiasm for both is parallel. Motor museums, too, have been the stimulus for private collections to be started (see Dannefer, 1981: 405). On an even broader basis, we can see how much of what has been discussed above is a distillation of the general car culture of our modern society. Notions of value, cherishing, anthropomorphism and personal identity are clearly recognized and used as marketing tools by car manufacturers and taken fully on board by car owners (see *A–B Motoring Tales*, BBC2, 1994; *The Car's the Star*, BBC2, 1997). Therefore having a collection of, or an enthusiasm for, cars and other vehicles

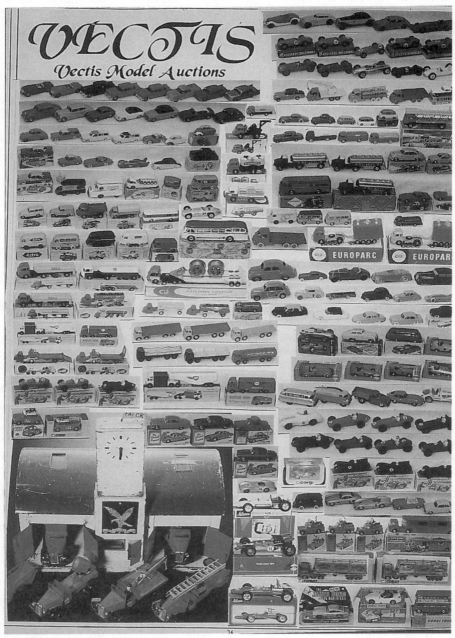

Plate 6.2 Vectis Model Auctions advertisement
Reproduced by permission of Vectis Auctions Ltd.

merely represents a sharper focus on 'vehicle cherishing' in general, which is prevalent enough to have been incorporated into permissible, even normal social behaviour.

Infantilization

The nostalgia aspect of popular collecting has been strongly reflected in commodity marketing and advertising in the early 1990s. As has been noted (Green, 1995: 10) a decade or so ago, only teenagers read comic books. These were re-coded as 'graphic novels' and commanded art prices (although interest has seemingly waned just lately, see Atkinson, 1997: 6). Video games and jive consoles, which in the 1980s were aimed at a youth market, are now marketed as adult games of strategy. In food, the Kellogg's Corn Flakes advertisements 'Have you forgotten how good they taste?' or 'I'm a grown woman who loves Kellogg's Frosties' promote these cereals as an adult indulgence in childish cuisine. The R. White's 'secret lemonade drinker' of the early 1980s is possibly the originator of the current popularity of alcoholic lemonades. Similarly the ubiquitous badges accompanying children's birthday cards, e.g. 'I AM 6', used to stop at 10; now they go all the way up to 'I AM 60'!

This phenomenon has been termed *infantilization* by cultural critics (Green, 1995: 10). In capitalist and commodity terms, it merely represents a new and larger (and more affluent) market in which to sell pre-existing products. Culturally, it means the re-coding of commodities aimed at children and adolescents with an adult slant. This is as prevalent in collecting as in other areas of popular culture. The various novelty gifts (known as premiums in the USA) given away by McDonald's with their children's 'Happy Meals' range are an example of this. They were originally aimed at children (via their parents), to increase sales of children's meals and encourage family attendance at their restaurants. Adults, though, also started to collect the give-aways. Once this had been recognized by McDonald's, they began to issue the premiums in limited editions and make more varieties, with adult collectors in mind. At the same time, their advertising for the objects was aimed at the original target group of children, thus embracing both interest cadres. Some collectors lost interest at this point, but many others, as was mentioned in Chapter 1, became even more avid in their collecting. Those who lost interest, I propose, are those who harbour a sense of originality or subversion through collecting, whilst the others accepted engagement with the spectacle and its appropriation of their hobby, in order to enhance their collection. Neither is a condemnation, but it is, I feel, important to make the distinction.

Stewart states that 'The collection's space must move . . . between display and hiding . . . we can see the entire collection but cannot see each of its elements' (Stewart, 1984: 155). An article on vintage Corgi models, however, reveals the intensity of interest in minute detail, as the following captions reveal:

> Tim's unique black Aston Martin DB4 – the self tapping screws show it's a pre-production model. (Dearsley, 1995: 48)

> The Austin Cambridge has a number on its base which shows it to be part of a series of colour samples. (Dearsley, 1995: 48)

The attention to scale model detail is the same as the attention the vintage car enthusiast would pay to the real thing, in order to ensure that it both functions and is 'original' in its components.

This concern with such detail is often associated with youthful fascination in a given subject and is tolerated, but in an adult has traditionally been frowned upon by the more conservative as retarded. The exception is when celebrities are found to collect, then they become celebrated. For instance, David Bellamy, the renowned natural scientist, has a large collection of tin toys which are celebrated in a piece of photojournalism (O'Kelly, 1994: 46). The aforementioned McDonald's 'Happy Meal' premiums are perhaps an even better example. A regular column appears on the latest issues of these in *Classic Toys*:

> The toys were made in China, whereas ones for the UK promo were made in Macau and consequently colour shade differences are in evidence. (Dunkley, 1995: 60)

> The North American version had 'Ice Cream' printed on the side of the cart, ours did not. (Dunkley, 1995: 60)

An advertisement by the article's author exalts us to 'join the toyburger boom now!' (Dunkley, 1995: 61). Initially one's reaction to such close scrutiny of such a superficial item would be highly dismissive, yet if the objects were given professional credence by, for instance, a museum curator, they would be regarded as expertly researched. The latter scenario is echoed by Hillary Kay. In *Classic Toys*, she is asked what she feels the next big popular collectable will be:

> 'I think that the other big development is premiums. That is, or is really starting to be, very big business in the States.'
> 'As an example?'
> 'The McDonald's Give-aways.'
> 'Of course we run an article on that in every issue of our magazine.'
> 'There you are, ahead of the pack.' (Bailey, 1995: 32)

The affirmation of the 'worth' of the objects by a respected auction dealer is one move towards making the trivial important, the profane sacred. A second way is by attributing monetary value to the seemingly valueless. This has now happened with McDonald's give-aways in the form of two commercially produced collectors' guides (Losonsky, 1995; Williams, 1995). These list the entire known output of McDonald's give-aways and also quote values for them.

There is of course a longer pedigree to this trend, as we are reminded in the same issue of *Classic Toys* in the previously mentioned 'The trains of the dining room carpet'. This is further emphasized by the stated aims of the West Anglia Toy Train Circle, which appear in their journal. 'Aim D' of their aims and objectives is: 'To enjoy collecting and playing with trains' (Forman, 1993: 1). The wording is entirely unselfconscious. Yet modernist collectables such as the McDonald's premiums are being collected *now*. The difference in time means that the toys of yesteryear have the time lapse to acquire the psychological and cultural patina of nostalgia, framed in a magic childhood that never was. The insecurity that is currently felt demands that an instant nostalgia be created, a synthetic time warp in which the 'collectables' being manufactured today are already looked upon as nostalgic and which require very little passing of time before they become part of 'yesterday'. The desire for such populist and fleetingly available objects from the present implies a wistful melancholia.

Whereas 'In those days [1910s] stock would stay in the shop for many years . . . the practice only stopping in the 1960s . . .' (Bailey, 1995: 29), today no excess stock

is carried, things are often produced only in one-off production runs (and are marketed as such). The rush to get them while they're still around makes things collectable. It also makes the short time lapses after they've sold out seem longer. It lends a ready-made patina, rather than an accrued one, invisibly bubble-wrapping the object. The result is speedup, both materially in the number of small production runs with minor detail differences (colour, shade, etc. on model cars) and the psychological and cultural notions of possession and scarcity. This is also reflected in the everyday world of the town centre, where often recently established businesses advertise their establishment dates (for instance, River Island clothes, 1988; Harbottle gift cards, 1994) and facilitators such as banks refer to their services as 'products'. In these scenarios, the maturity and foresight of age (read as reliability) and material (read as security) are tardily utilized to legitimize the potentially temporary and the outright invisible. It is also a reaction to the perception of change, of loss of the old and the flux in the new. Such marketing turns paucity into an art form, when recommodified as rarity. Even train-spotting, the analogy most closely associated with collecting by its detractors as anally retentive (e.g. *Anorak of Fire*, 1994) is now receiving a rose-tinted retrospective treatment in the shape of a former train-spotter, Nick Whittaker, in his autobiographical odyssey *Platform Souls: The Train Spotter as 20th Century Hero*. This, the jacket blurb proclaims, is a celebration of 'railwayness' and blames the advent of car culture for forcing the railways into decline and the train-spotters into auction rooms and steam preservation societies to indulge their passion.

Collections are like the tanks of tropical fish in the dentist's waiting room. We use them to contemplate and mediate, to reassure ourselves, to exercise self-hypnosis. They are our fetish dolls, each addition to the collection is a nail in the doll, a pull of a wishbone, a wish fulfilment enlarged. Collectors who scour the collectors' fair and make two or three finds are likely to pay good money for them and come away feeling pleased with their trophies; collectors at the fair who find themselves tempted by innumerable examples of their desired object are likely to come away dissatisfied and often not having made a purchase. In this instance, the thrill of the hunt is removed, salvaging a precious example of the collected object disappears when confronted by so many examples. The conundrum of which to choose for inclusion in one's own collection becomes so overwhelming, that the only way to deal with it is to cancel it out, come away empty-handed and convince oneself there was nothing worth having when it was in such abundance. There was no need to rescue any object on this occasion.

The age of the ultra-commodity

Commodities are made and sold largely for utilitarian purposes, for specific functions and tasks, after which they are disposed of. Most things these days have a potential afterlife (e.g. Tupperware, see Chapter 5). In an age of paucity and environmental conscientiousness, in which for altruistic and economic reasons the recycling potential of all things has to be considered (Thompson, 1979; *Scrimpers*, 1995), the monofunctional commodity has now assumed multi-potential possibilities. For instance, a black plastic bin liner, apart from its utilitarian purpose as a rubbish container, may also be used with adaptation as an article of clothing (popular with punk rockers around 1976–77), an art statement as part of a collage, a temporary

weatherproofing, a heat insulator for the homeless, or the basis of a garden compost heap. In Debord's terms nothing any longer has a singular place or order, everything is displaced (Debord, 1967/1983: 2). The commodity of the specific becomes the ultra-commodity of the general. In this way infantilization reifies and legitimizes playful indulgence as serious leisure. This seems to become noticeable from the late 1980s when manufacturers of sports shoes urged us in their advertisements to 'play to win' and to 'take sport seriously'. This was part of the cult of the self we were being encouraged to celebrate economically and socially. The mono-functional commodity of the child's toy (model car) assumes increased potential by being recommodified as an adult art object. Thus model cars are really value statements and plastic bin liners are really symbolic of the temporary.

Collecting is a means of self-expression, a way of making sense of the world, a psychological sanctuary. The fact that an egg-cup exceeds its utilitarian purpose once in the collection of a member of the Egg Cup Collectors' Club of Great Britain makes it into an ultra-commodity. This allows the disorientation inherent in this scenario (i.e. what is the egg-cup's purpose, function and proper place?) to be used to subvert the everyday by the collector, and turn disorder into order by dint of becoming the object's arbiter and controller via its inclusion in the collection.

Conclusion

Collectors' clubs can be seen as alternative environments in which to act out social relations which (as in the case of the UKSCC) are an extension of existing friendship networks. They knit into them new members who may have been outside of the originating friendship network, or who are new to it. The brewery ephemera collectors can expand their male bonding in light competition over acquisition. Through this they seek to promote pub culture as something beyond or above mere socializing. In both cases, the objects collected serve as the legitimizing focus for being together with others of like mind, but for whom the company and social activities are as important as, if not more so than, the acquisition of the collected objects. In the mixed-gender LCC, male and female roles are acted out within one setting and the best of both worlds is achieved.

Socioeconomic necessity over the last two decades has conditioned the exchange-and-resale markets of everyday goods. Car-boot sales, flea-markets and collectors' fairs have all become modern traditions. People have been forced to take objects and everyday material culture more seriously, to contemplate their 'worth' to themselves and others. This has happened both in terms of resale (commodity) value and in desirability (aesthetics). Thus a more concentrated relationship is formed with 'stuff'. This leads to both a commodity market in the utilitarian sense and a collectors' market in which some things are deemed to be outside of, or beyond, utility.

7 *The museum equation*

Introduction

Many older museums have been founded on the possessions of classical collectors. It has now to be asked in more detail how they may benefit from the activity of the 'new collecting' outside the museum arena. This chapter examines, first, the ways in which popular collecting has been and is perceived by the museum establishment. Second, it argues for a broader alliance and a greater parity between collectors and museums whilst pondering the future for both.

The methodology for the data in this chapter is to be found in Appendix 2. Questionnaires were sent to museums in order to elicit opinion on their attitudes towards collectors and to establish if any significant contact had been made with them over the last ten years. Questionnaires were also sent to collectors' clubs to canvass their opinion of museums and to discover if they had taken any proactive measures to contact them. (The questionnaire forms appear as Appendix 1.) As outlined in Chapter 6, a total of 128 of 314 collectors' clubs canvassed responded (40 per cent). Of 284 local authority museums, 196 (69 per cent) replied. The response rate is somewhat larger than numerically implied, as often one response was on behalf of up to three museums in the same area. One interesting revelation was the number of returned questionnaires from local authority museums, who stated that their opinions were not to be made public, and that the information provided was for statistical analysis only. One even went so far as to cut off the code sequence number of the returned questionnaire in an attempt to hide the museum's identity. Of the 199 independent museums canvassed, 126 (63 per cent) replied. The same questions were asked of them as of their local authority colleagues. The frequency of unanswered or 'don't know' categories is somewhat higher than with the local authority museums. This is often due to the lack of museum training in the independent sector and the unique nature of many independent museums, i.e. that they are the owners of a private collection which has been made public. Many are currently seeking Museums and Galleries Commission registration. A small number are parochial and are run by one or two volunteers on a part-time basis. Others are incorporated into the responsibilities of the local library, with occasional assistance from an area museum officer. There were also a few almost entirely unfilled questionnaires returned, with a short explanatory note to the effect that they were not equipped to answer the questions.

The collecting conundrum

The dilemma for the social history curator is what to collect now for the next century (Crook, 1993). One commentator has asserted that 'general economic and social change has brought about a rapid evolution of technologies and ways of life, and a vast increase in the availability of goods of the sort that museums collect' (Keene, 1994: 34). The Yorkshire and Humberside Museums Council's 1992 survey *Collecting for the 21st Century* suggests that there is already a wealth of material waiting to be rediscovered in existing collections that may well help to shape a future collecting policy (Kenyon, 1992: v, iii–vi). As is noted, 'there is a realisation that as well as objects themselves, material relating to their context needs to be collected' (Keene, 1994: 34). Current emphasis has shifted away from collecting in museums to retrenchment via more rigorous re-accessioning and better collection management in the stores. It is seen as a trap to succumb to 'the temptation to save objects for the nation/community/interest group'. If, as asserted, 'museums have to exercise greater restraint in collecting' (Keene, 1994: 36), collectors' homes could become more important repositories for objects than museums (pending security and access arrangements). This would clearly redefine the nature and purpose of museums, and confer greater status on collectors' organizations as bodies of equal parity with them.

The museum view of collectors in their territory

In furtherance of the above, two questions were asked of museum staff as an experiment to test their reactions (Tables 7.1 and 7.2). They were asked for their reaction to the idea of 'suitable collectors' acting as 'foster keepers' as an alternative to de-accessioning an object or freeing up space. Three categories were given: 'with enthusiasm', 'with reservations', 'with alarm'. Interestingly, a majority of 103 (52 per cent) local authority and 73 (57 per cent) of independent museums responded only with reservations. Objections were largely ethical, such as problems over ownership, monitoring, access, etc. It did at least cause respondents to address the question of outside agencies possibly having a role to play, parallel to the museums. This is not entirely without precedent. In North America, indigenous peoples have had museum-held items returned to them along with conservation advice, whilst arrangements have been made for their temporary loan-back for exhibitions.

Table 7.1 How would you react to the idea of suitable collectors acting as 'foster keepers' as an alternative to de-accessioning an object, or for freeing storage space for other objects?

Response	*Frequency*		*%*	
	LA	*Ind*	*LA*	*Ind*
With reservations	103	73	52	57
With alarm	82	44	41	34
With enthusiasm	11	9	5	7
	196	126	98	98

The second test question sought the reactions of staff to the idea of collectors being given training in basic curatorial practice. The majority of 150 (76 per cent) local

authority and 78 (61 per cent) independent museums were readily in favour, in the interest of the material and objects collected. They did, though, express reservations about who would pay for and implement it. Here the very natural concerns of hard-pressed budgets and put-upon staff were uppermost in the respondents' minds. A large number, however, were prepared to be involved in delivering such training, as long as the cost did not fall on the museum and there was sufficient interest in the idea from collectors. A further 31 (15 per cent) local authority and 25 (19 per cent) independent museums were negative about the idea, largely because they felt collectors would not be interested. Some respondents felt that if collectors were interested in training they should take up professionally based or other courses at their own expense. It was also asserted by both museum sectors that there was a greater need for such training in the independent sector, where it was more applicable, and that it should take priority over any training offered to collectors.

Table 7.2 What is your reaction to the proposition that training in basic curatorial practice be provided for interested private collectors?

Response	*Frequency*		*%*	
	LA	*Ind*	*LA*	*Ind*
Positive	150	78	76	61
Negative	31	25	15	19
Indifferent/Don't know	12	12	6	9
Unanswered	3	11	1	8
	196	126	98	97

When collectors' clubs were asked for their opinion on the idea of museum training for interested members, 69 (53 per cent) were positive about it. The statistics themselves do not wholly reflect the clubs' opinions, as much of the material they collect was believed not to exist in museums and consequently clubs saw museums as irrelevant to their interests in some cases.

Table 7.3 Is the response to the idea of museum training for your members, positive, negative or indifferent?

Response	*Frequency*	*%*
Positive	69	53
Indifferent	32	25
Negative	19	14
Unanswered	8	6
	128	98

Independent museums, the sacred and the profane

Independent museums (such as the London Transport Museum) have been interacting with collectors for years with positive results. Independent museums are

very often personal collections which have crossed the traditionally held divide between profane space (the private collection) and sacred space (the museum). Once recognized as museums, their collections become validated by that recognition. Robert Opie's The Pack-Age in Gloucester is one such example (see Wilkinson, 1997a: 19) and his weekly spot on Channel 4's *Collectors' Lot* programme lends it a higher profile. There has been noticeable participation by museum curators in shows such as BBC1's *Going for a Song*, in which financial values are placed on old objects. To price objects is a transgression of museum ethical convention and suggests therefore that attitudes are changing in response to the media attention given to non-museum collectors. Independent museum curators also often bring with them the collection practices of the private collector. Whilst offering access to the public, they continue to function within the private collecting system as well. Such institutions as the British Lawnmower Museum in Southport (White, R., 1995: 7) and the Bettenham Baby Carriage Museum in Kent (McGrandle, 1994: 16) often represent the only collections of their kind. Their collections have often grown as a result of trading and buying with dealers and other collectors.

A lack of co-operation or contact between private collectors and public ones can only be to the detriment of the material collected. One example of this involves Bob Monkhouse, a celebrity presenter and renowned film collector. Monkhouse used his film collection as the basis of a long-running television series in the 1960s *Mad Movies*, in which he showed clips from classic silent films. In 1977 he was arrested for allegedly attempting to import films belonging to major companies. Although the case against him was thrown out of court, it didn't prevent the police from destroying a good number of his films which they had previously confiscated. One of these was the only known copy of a 1931 British comedy, *Ghost Train*. Monkhouse laments that he had offered it to the British Film Institute (BFI) in the 1970s, but that they 'didn't give a toss. They hadn't got room for anything' (Rose, 1994: 40). They are now desperately seeking a copy, taking out advertisements in trade journals in an effort to locate it (Rose, 1994: 40). The independent museum demonstrates the value of professional training through its use of support from a county museums officer, whilst indicating to public museums the benefits of engaging with private collectors.

The extent of the museums' use of collectors

The majority of museum respondents stated that they had made use of collectors in some way or another over the last ten years. Most of the loans were of a material nature 'to plug a gap in a permanent collection' or as the basis of temporary exhibitions, especially when relating to the locality. The *People's Show Festival*, then in full swing in over 50 museums across Britain, was also cited as a recent use of collectors in many responses. The extent of the loans stand in marked contrast to the paucity of reported donations. This does not preclude donations from non-collectors, which is no doubt much higher, but does perhaps indicate that collectors do not necessarily see museums as a natural home for their collections on a permanent basis. It further indicates that museums are either reluctant to take in material on a permanent basis (perhaps due to storage difficulties, or indecision over a collecting policy) or that the material they require is not being donated and loans are being canvassed for exhibitions.

Table 7.4 Have you made use of private collectors/collections at all over the last decade in any capacity?

Response	Frequency		%	
	LA	Ind	LA	Ind
Yes	168	86	85	68
Unanswered	26	40	13	31
No	2	0	2	0
	196	126	100	99

If Yes, in what capacity?

Response	Frequency	%
Local authority		
Loans (only)	107	54
Other (volunteers, museum founder, scouts, talks)	46	23
Loans, plus advice, scouting, volunteers	29	14
Purchase	10	5
Donors	4	2
	196	98
Independent		
Loans	57	45
Unanswered	41	32
Donors/Purchase	9	7
Founder of museum	9	7
Advice	7	5
Networking	3	2
	126	98

When museums were asked about the way in which they made contact with collectors, a majority felt unable to answer. Of those that did, most reported that they had been approached by the collector themselves. The range of answers, though, does imply that although most museums are passive, and simply wait to be approached by interested parties (this was overtly stated a number of times, e.g. 'they know we are here'), a more proactive approach is being adopted. This seems largely due to the People's Shows. Applying a generic template to the staging of a People's Show, originated at Walsall Museum and Art Gallery, has encouraged museums to venture further into the collectors' domain than they have done before. It would be useful to make a second survey in five or ten years' time to test the trend seemingly under way here. Most respondents with experience of collectors reported a good to very good experience with them, which tends to undermine the usual clichés about fetishistic and obsessive collectors.

Table 7.5 How did you come into contact with collectors?

Response	Frequency		%	
	LA	Ind	LA	Ind
Unanswered	75	43	38	34
They approached us	34	25	17	19
Networking	28	35	14	27
Local advertising	22	7	11	5
Word of mouth	18	4	9	3
Personal	12	5	6	3
Not applicable	6	5	3	3
Don't know	1	2	0	1
	196	126	98	95

Table 7.6 How do you rate the collectors' contribution?

Response	Frequency		%	
	LA	Ind	LA	Ind
Good–Very good	144	76	73	59
Unanswered	29	43	14	34
Variable	15	1	7	0
Poor	5	0	2	0
Not applicable	3	6	1	4
	196	126	97	97

The collectors' clubs' use of museums

Asked if their club had had any contact with museums, the majority said they had. The majority also reported it as a positive experience. This indicates that where contact is made, the engagement is a positive experience for collectors and, where cited, for museums as well. The experiences varied from short-term loans to advice to museums and affiliation of some museums to the club. A big majority (79 per cent) of clubs also stated that they favoured a closer working relationship with museums.

Table 7.7 Has your club had any contact with museums?

Response	Frequency	%
Yes	95	74
No	27	21
Unanswered	4	3
Don't know	2	1
	128	99

If Yes, was it satisfactory or unsatisfactory?

Response	*Frequency*	*%*
Satisfactory	81	63
Unanswered	34	26
Unsatisfactory	9	7
Variable	4	3
	128	99

Table 7.8 Is your response to the idea of your club working more closely with museums positive, negative or indifferent?

Response	*Frequency*	*%*
Positive	102	79
Indifferent	20	15
Unanswered	6	4
Negative	0	0
	128	98

People's Shows

Private collections have often served to fill gaps in temporary exhibitions. Not until the first pioneering People's Show in 1990, however, were popular collections given independent recognition by museums. The history of museums, until then, was written largely in the Whig tradition. In this, museums developed from the Renaissance cabinets of curiosities into benevolent and respectable institutions for the benefit of the public in the nineteenth century. The only collectors who were acknowledged were those, such as Sir John Soane, who had the time, money and inclination to partake in the fashionable British pastime of amassing large collections of anything from flora and fauna to Egyptian and Greco-Roman statues. Yet, now even classic collectors have come in for postmodern deconstruction (e.g. Pomian, 1990; Elsner, 1994; Edgar, 1995).

By the late 1980s, people were collecting anything from barbed wire (Clifton, 1970) to biscuit tins (Franklin, 1984) and numerous collectors' clubs sprang up to cater for these interests. Formal museum recognition of popular collecting is generally credited to the first Walsall Museum and Art Gallery 'People's Show' in 1990, since which time People's Shows have been staged all over the country. Although this is indeed the most important benchmark of its kind to date, it would be wrong to assume that museums had not made individual attempts at this before. The Stevenage Museum and Art Gallery in Hertfordshire staged perhaps the first People's Show, entitled *Collectamania*, in 1989 (Pearce, 1992: 78). The more one looks back, the easier it is to retrospectively accredit various exhibitions with the character of a People's Show. The Midland Art Group in Nottingham staged an exhibition of lapel badges, *Pinned Down*, in 1979 (Plate 7.1). This was comprised entirely of loans from

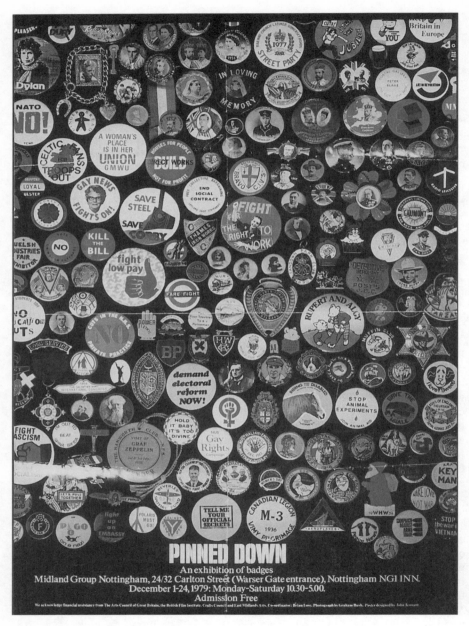

Plate 7.1 *Pinned Down* exhibition poster, 1979
Reproduced by permission of Midland Art Group, Nottingham.

Plate 7.2 *Wish You Were Here* exhibition poster, 1988 Reproduced by permission of the Towner Art Gallery & Local Museum, Eastbourne.

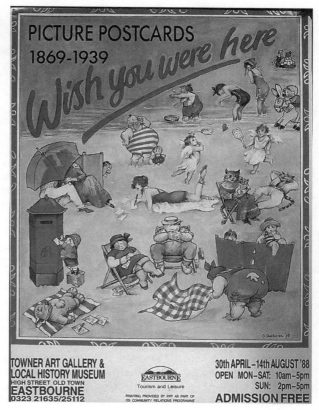

private collectors and was the idea of one of the curators, Vinny Cleary, who was himself a collector of badges. The exhibition attracted over 3000 visitors (Vinny Cleary, personal communication, 1980). Indeed, every time a museum stages a single-subject exhibition, it can be said to share the traits of the private collector. Such exhibitions as Hove Art Gallery and Museum's *Pennywise: 500 Years of the Moneybox* (1989), or the Towner Museum and Art Gallery's *Wish You Were Here: Picture Postcards 1869–1939* (1988, see Plate 7.2), could, on inspection, as easily be the collection of a private collector as that of a museum.

At Londonderry's Tower Museum in Northern Ireland, the exhibits are largely composed of such objects as rubber bullets and the material culture of 'the Troubles' (Carnegie, 1994: 29; Lacey, 1994: 28). This can be read as a People's Show with a serious agenda, whereas conventional People's Shows are light-hearted and celebratory. This in turn parallels the 'light' and 'dark' sides of private collecting. Similarly, there have been exhibitions such as *The Art of the People* staged at the Angel Row Gallery, Nottingham, in 1994. These might be regarded as parallel with, but different to, People's Shows. In this instance the objects and images on display were 'made' by people rather than 'collected' by them (Cooper, 1994). Objects on display included World War I trench art made from shell cases; anthracite coal carvings of boots; scrimshaw carving and decorated fairground panels. Much of the material could be

interpreted as a means of externalizing convictions as much as collecting does. This, however, clearly pre-dates popular collecting (of the 1880s) as changes in society led people to adapt age-old traditional skills, art traditions, etc. to changed circumstances (anthracite, wood carving, etc.). Further abroad, the Jean Moulin Institute in Bordeaux, France, is a three-storey museum of the French Resistance. Home-made arm-bands, forged identity documents, Free French Army medals and flags, etc. form a sobering and permanent 'People's Show', whilst by extension the silent attestation to human brutality that the piles of prisoners' shoes and other pitiful belongings make in Holocaust museums are the ultimate material dark side of this conception.

In *The Art of the People*, a Falklands War banner which featured commemorative regimental badges was on display. This was made and raffled to raise funds for the South Atlantic Fund. It was bought back from the winners for the Gallery. It was as much about education as about enjoyment, but was designed as spectacle. Similarly, a collection of material belonging to a Gulf War veteran was displayed at the Market Harborough People's Show in 1994 for the same reasons (Fardell, 1995: 43–4). As an expression of popular feeling and values, the more popular arts-and-crafts-oriented exhibitions can be seen as part of a wider ambit of the People's Shows criteria. A synthesis of the two may be found in such collections as the People's Palace in Glasgow (King, 1985: 4–11) and Manchester's National Museum of Labour History, where the permanent collections are both *of* and *by* the people.

Most People's Shows were exhibited as celebratory spectacles. In this respect, they have much historically in common with imperial exhibitions (Greenhalgh, 1988; Richards, 1991; Bennett, 1994) and department stores (Belk, 1995). They are all commodity extravaganzas. The difference being that in People's Shows, the collections have been created and imbued with the collector's own meaning and values. In Debordian terms, they subvert the original intention of the object collected. This is especially so where the collection is of material such as airline sick bags, which were displayed at the 1990 Walsall People's Show. This can be read as a very English way of mocking convention, through eccentricity. It is, though, perhaps more about material control. Collecting, then, can be read as resistance to the spectacle by deliberately imparting meanings other than the intended ones into objects. This is done in an attempt to gain or regain a sense of proportion in a society increasingly at odds with itself, and to reassure ourselves that we still have our basic understanding of what things are. In reconfiguring the meaning of an object, through its collection, we demonstrate that understanding, through our confidence to change the object's meaning for ourselves whilst still retaining our grounding in its material reality.

It is in such environments that (for instance) Andy Warhol's graphic painting of a Campbell's soup tin can be attributed value and meaning, whereas the collecting of an actual Campbell's soup tin for the same reasons as Warhol painted one would not be. This, it would be argued, is because Warhol has given us interpretation through his representation, whereas the actuality of the tin itself does not do this. Gell makes the same point: 'not just any Brillo box, but a Warhol Brillo box is art' (Gell, 1996: 20). However, Pearce hits the nail on the head when writing on the Warhol auction at Sotheby's, New York, in 1989: 'What is on offer here is not art, but lifestyle' (Pearce, 1992: 237). The object has 'lived' just as much as a representation of one and the interpretation can be as subjective in the eye of any beholder, artist or not.

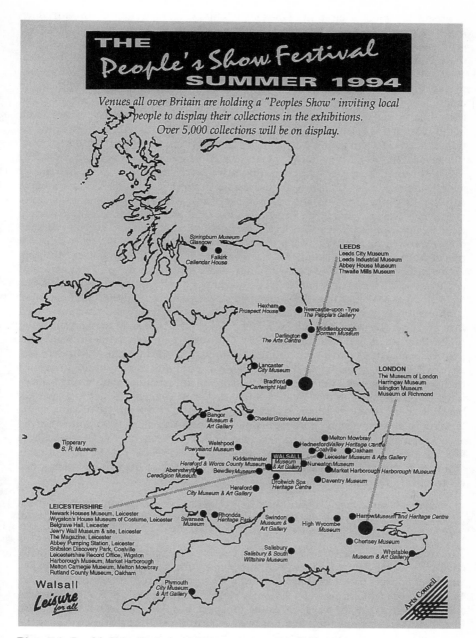

Plate 7.3 *People's Show Festival,* exhibiting museums handbill, 1994
Reproduced by permission of Walsall Museum and Art Gallery.

Despite the pioneering spirit of the People's Shows and the enthusiasm with which some museums embraced collectors at a local level, there is still an institutionalized grudge towards private collectors as is shown by the rift between Neil Cossons, then of the National Railway Museum, and the steam engine preservationist lobby (Mason, 1994: 14; Harris, 1994: 52; Scott, 1994: 52–3). It should be remembered that museum professionals are invariably white, middle class and university-educated, with all the cultural baggage this often brings with it, whilst private collectors cut across all social and ethnic boundaries. The potential for conflict of perception is always present. Even in the 1930s it was believed that 'hobbies built friendships . . . and that such friendships transcended class and national divisions . . . hobbies were therefore more democratic' (Gelber, 1991: 747). Many museums who staged People's Shows in 1994 (Plate 7.3) did, however, make a very proactive approach towards the public. Local newspaper advertising was utilized, yielding good coverage in most cases. Some larger museums (e.g. the Museum of London) staged a number of associated events, including children's trails, which were rewarded with future free admissions and a badge, meet-the-collectors days and swap-meets. They also alerted the public to what museum curators actually do, for possibly the first time. To this extent, People's Shows are a landmark in museum practice. An artist's installation, *The Curator's Egg*, held at the Ashmolean Museum, Oxford (December 1991–May 1992), also more directly challenged the nature of professional decisions on what would or would not be shown in a museum. Visitors were urged to challenge the value judgements being made by museum staff and were confronted with genuine and reproduction objects and asked why one was more valued than the other (Beard and Henderson, 1994: 5–42). This is a line of thought still being pursued by others (e.g. Emmanuel, 1995). The Ashmolean was an interesting venue. John Carman asserts that if such traditional museums as the Fitzwilliam Museum and Art Gallery in Cambridge and the British Museum are, as they claim, 'rocks of traditional certainty and values in a sea of changing uncertainties and shifting values', it is a tragic response to that change. Such modernist conservatism, it is suggested, becomes increasingly irrelevant in a postmodern world (Carman, 1996: 4).

Mark Suggitt, reviewing the first People's Show at Walsall in 1990 noted that the 'doorkeeping' role of the curators was relaxed but still evident: 'the People's Show was still a club, but with no dress restrictions' (Suggitt, 1990b: 30). Some museums that took part in the 1994 *People's Show Festival* were still anxious to maintain social control over potential exhibitors:

> Because of your in depth knowledge of your collection, the decision on which items will create the most interesting display will be yours. Although staff will have the final word. (Museum letter to exhibitors, 1994)

The cause of the museum and that of the collector are being projected as mutually exclusive, rather than competitive. Another museum stated that collectors 'had to volunteer collections for lending – we did not target collectors themselves' (Lovatt, 1995: 9). Some museums were obviously staging a People's Show for the first time and were somewhat apprehensive at the prospect, but none the less, it would seem to suggest that due attention had not been paid to the Walsall experience over the four years since the first People's Show. It was felt in some quarters that museums were staging People's Shows as a one-off event because they were flavour of the month and would boost visitor figures and simultaneously please councillors in the funding authority (Lovatt, 1995: 9).

On the other hand, some museums were called on to act with great tact. One exhibitor at the 1994 Walsall People's Show, Angie, aged 18, died of cystic fibrosis shortly after hearing that her collection of Coca-Cola memorabilia had been accepted for display in the exhibition (Digger, 1995: 23). She requested that a number of the items in her collection be buried with her. All the material she collected was got for her by friends and family, brought back from holiday, etc.; each item had a special meaning for her (Digger, 1995: 24). The use of Coca-Cola memorabilia as grave goods is touching because of the obvious affinity they had for her with those who had given them. Beyond this, it can be seen that practices we find common in ancient times are still with us in a consumer society today. Angie was presumably able to share in people's holidays and lives through the memorabilia as souvenirs; psychologically it must have helped her to share their experiences.

Perhaps one of the strangest collections at a People's Show belonged to a museum professional.

Sarah: I collect my fingernails and hair.
PM: Why?
Sarah: I am in awe of the fact that we eat food and it turns into skin, bone, etc. I would like to collect my skin if it peeled off. I have collected large pieces that have peeled off from sunburn in the past. When I was a little girl I collected my toenail clippings, but my mother threw them out, she said they were nasty and smelly, I was extremely upset.
PM: What about dust, that's mainly dead skin?
Sarah: I don't collect that because it's too difficult and ephemeral, but if it was possible I would collect that too.

Museums are not the only ones to hold a pejorative view of collectors. They are, however, the most important agencies by which these attitudes can be changed, if for no other reason than that they have more in common with collectors than anyone else.

At Walsall, the age groups of exhibitors of all three People's Shows were canvassed as follows:

First People's Show, 1990 Largest % age group 46–60 (27%) 26 respondents
Second People's Show, 1992 Largest % age group 36–45 (31%) 36 respondents
Third People's Show, 1994 Largest % age group 26–35 (29%) 43 respondents

Source: Digger, 1995: Appendix 3

Although this is not scientific proof of anything, and is not claimed to be, it does indicate the wide age range across which people collect, at least in Walsall. Classically, collecting is associated with males in childhood, resurfacing in middle age, as a surrogate for a diminishing sex drive. Some, like Baudrillard, still cling to this definition (Baudrillard, 1994: 9). Others, such as Pearce, are contemptuous of such notions as anal retention and believe it should be 'taken with a pinch of salt' (Pearce, 1995: 8).

The attitude of the museum toward the private collector is undergoing a reappraisal in some quarters, which the People's Shows have initiated, though this should be regarded as only a beginning, not an end in itself. Lovatt found that many curators believed that they had already produced People's Shows in the past. On further enquiry, what they had done was to augment museum material with loans to form an exhibition (see museum survey; Lovatt, 1995: 6). This, Lovatt contends, is not

A

B

Plate 7.4 Professional museum display as playfulness
A. Tea towel display, Bangor Museum & Art Gallery
Reproduced by permission of Bangor Museum & Art Gallery, Gwynedd.
B. Tea towel display, Newcastle Discovery Museum
Reproduced by permission of Tyne & Wear Museums.

the same as a People's Show, as the private collection is only being drawn on for content rather than as the central point (Lovatt, 1995: 6). Further, if collecting is simply codified play, the museum can also be seen the same way. Two different tea towel displays at People's Shows in 1994 (Bangor Museum and Art Gallery and Newcastle Discovery) illustrate the museum display design as play (Plate 7.4). In Leicester (see Chapter 6) and Newcastle upon Tyne collectors' clubs were formed by exhibitors at the regional People's Shows. Workshops in basic conservation practice for collectors would help them meet museum standards, which can only be in the best interest of the objects collected. It would also serve to integrate collectors with museums from which longer-term relationships might be forged. These could be held at further education colleges as evening classes and could be funded either by lottery money, the European Social Research Council, collectors themselves or a combination of the three. It was found at Walsall, for instance, that the People's Shows had changed visitors' attitudes towards museums. Many now saw museums as being about people rather than things (Digger, 1995: 34). Once an organic and human perception is encouraged, enthusiasm blossoms.

In America, at the Anacostia Museum, Washington, the curator, Steven Newsome, initiated a 'collector in residence' scheme. This encourages neighbourhood collectors to work in the museum for a few months, helping to strengthen community ties. In addition archival quality material such as acid-free tissue and storage boxes are on sale in the shop to collectors (Digger, 1995: 15). Such an approach would be a logical next step up from the People's Shows in Britain. The *glasnost* of the 1980s, brought about by the 'punk-rockers' of the culture world, the heritage industry (Hewison, 1987; Wright, 1985; Bennett, 1988; West, 1988; Sorenson, 1989; Samuel, 1995), has caused critical re-evaluation of the cultural significance of many objects. This means that definitions of what is valuable or desirable, based on long-cherished bourgeois perceptions of good taste, have been eclipsed by wider criteria based on an upsurge of interest in popular culture at all levels. For instance, the expensive decorated wooden Tunbridgeware, notably boxes, has always been collected by those who could afford it. Similar but cheaper objects such as Mauchlineware, however, which utilized varnished, lithographic transfers of tourist sites and holiday destinations, has been equally collectable with a much wider public. This *glasnost* should hopefully thaw the concept of 'the heritage' sufficiently to include within it 'material culture from below', such as collections of bus tickets held in private hands. There seems to be no good reason why such collections should not be lottery assisted, in order to make them publicly accessible. With museum-aided interpretation, new avenues of popular expression, and partnership ventures could be opened up.

Museum marketing aimed at collectors

When asked if their sales point had ever marketed anything specifically for a collectors' market, most museums reported that they had. When the objects mentioned as being aimed at collectors were examined, however, it was found that the objects were those which are most commonly found in museum shops anyway, and that very little material has been produced and marketed as collectable. This is perhaps a little surprising given the current emphasis on marketing, and the whole cultural bandwagon revolving around collecting currently prevalent. Of those who reported that they had not made anything for collectors, many reported that it was because

they felt it unethical to do so (e.g. making replicas of museum objects for sale, as it would give the wrong impression). Of those who replied that it was not applicable, most said it was because their museum was not big enough or sufficiently well funded to facilitate a sales point, although many said they had considered it over the last decade (see Weeks, 1997: 29 for the Museum Association's ethical guidelines on museum shop products).

Table 7.9 Has your museums sales point ever marketed any items with the collecting fraternity in mind?

Response	Frequency		%	
	LA	Ind	LA	Ind
Yes	94	57	47	45
No	80	63	40	50
N/A	22	6	11	4
	196	126	98	99

If No, has the idea ever arisen?

Response	Frequency		%	
	LA	Ind	LA	Ind
Yes	52	43	65	68
No	28	20	35	31
	80	63	100	99

Collectors' clubs and special materials

Collectors' clubs were asked if they had used or needed any special materials for their collections. Half of the collectors' clubs stated that they did use special substances or materials in relation to their collecting. Where identified these ranged from washing-up liquid for cleaning, to acid-free envelopes for the storage of delicate paper material. Clearly there is a requirement for greater knowledge on this subject and it is one which the private sector is beginning to recognize. The popular collectors' magazine *Collect It!* regularly features a section on conservation methods. One respondent suggested the joint purchase of materials such as acid-free paper between museums and collectors' clubs. It may soon be a matter of necessity to do so.

The rising popularity of collecting, and the sophistication of many serious collectors, is inevitably leading to an increasing level of technical and professional knowledge and ability. The market value of many previously 'unconsidered trifles', even if solely for insurance purposes, now necessitates better care than a box in the loft. When something captures the public imagination on a large scale, information and know-how are always in demand on a par with that of the professionals. This is historically demonstrated in the popular rise of the record and the advent of the private audiophile, who demanded parity of access to developments in the market with that of the professionals and dealers:

Table 7.10 Are there any special materials used by club members for storage, display or cleaning and maintaining their collection?

Response	Frequency	%
Yes	65	50
No	60	46
Don't know	2	1
Unanswered	1	0
	128	97

The hi-fi public became as knowledgeable as the makers and sellers. They used the same technology, a massive increase in technical magazines on audio kept the public as informed as the industry. Trade shows for dealers became frequented by the public as well, as they knew as much. (Millard, 1995: 211)

The comparison is an apt one. Music, like souvenirs and collected objects, serves as 'a personal time calendar' (McKenna, 1996: 67).

The attitudes of curators of People's Shows, based on personal correspondence after the event was over, show enthusiasm with very little negative experience. One curator wrote with corporate pride:

We had a number of really positive comments on how much better our show looked than other people's shows – from exhibitors and visitors alike. I must say – though I am biased – that our exhibition staff did another REALLY GOOD JOB.

The worst experience seems to have occurred at Middlesbrough's Dorman Museum. Here, thieves broke into the museum from the roof in a 'Pink Panther style raid', stealing the best of a valuable collection of model lorries and trucks (Williams and Harris, 1994: 5). This, if nothing else, highlights the contemporary financial worth of the 'toy cupboards emissaries' (Suggitt, 1990b). Negative comments were enlightening and constructive in a number of cases. At Leicester, a collector of West African clothing textiles complained that museums usually mounted such fabrics as wall displays when they were in fact meant to be worn. She was pleased that at Leicester they had used a mannequin to display her exhibits, but was unhappy the mannequin was white (*Carry On Collecting*, 1994). There was a predictable spread of opinions on the same issues. At the Museum of London's show, a design team was brought in to arrange the display, even though it was a small one. Because of the multimedia nature of the material, it was decided to use low lux lighting, which gave an overall impression of a darkened 'Aladdin's Cave'. One exhibitor thought this was good because it seemed to value the material, displaying it as any other precious item would be displayed. Another exhibitor disliked it because he felt it distanced people from the material (*Carry On Collecting*, 1994).

The way in which People's Shows were marketed varied. Lovatt cites two common themes. First, and perhaps typically British, is the idea that the visitor can act as voyeur by seeing what local people are hiding behind closed doors. This is echoed elsewhere, when it is asserted that car-booting is 'a chance to indulge that unique British passion for nosing into what other people have or had, and being able to

buy it for less than they did. A sort of salve for jealousy if you like' (Morgan, 1993: 3). Second, is the celebration of collectors and personalities (Lovatt, 1995: 26).

Walsall Museum's Peter Jenkinson cites a number of reasons why collector *refuseniks* didn't want their collections to be included in the festival. Some feared burglary after publicity, others didn't want their collections displayed with perceived 'vulgar' collections (*Carry On Collecting*, 1994). In any event, this disproves the belief cherished by curators, that collectors see museums as valorizing their collections through their display. One collector perhaps made the definitive statement about People's Shows that would please the staff of any museum that staged one: 'it makes museums exciting, museums are never exciting' (*Carry On Collecting*, 1994), whilst Jenkinson sees the People's Shows as one way in which museums are reinventing themselves.

It seems that the art gallery is also turning its attention to the People's Show ethic. A notable exhibition, *At Home with Constable's Cornfield*, ran at the National Gallery, London, from February to April 1996. The subject was the forms in which Constable's famous painting of 1826 have been reproduced. Ordinary people were invited, via a London newspaper advertisement, to report on ownership of the painting. It was found to be reproduced on enamel pendants, wallpaper, cushion covers and fire screens amongst other things (Painter, 1996). The exhibition featured the owners and their opinions on the painting as the central feature, with the art history taking second place. Whereas the People's Shows sought to display as many collections of their local populace as possible, *Cornfield* sought to turn the idiom inside-out, and show as many people as possible in possession of the same thing.

One benefit of the People's Show experience for many museum staff was the completely different perspective it gave them on often modest objects comprising people's collections. It necessitated a different kind of cultural valuing as defined by the collector, and a stepping outside of the usual professional perimeters. The implications of this in art galleries are perhaps even more profound, in that art galleries and art collectors usually share the same classical and aesthetic appreciation which they mutually acknowledge. They have been seen by the public and have viewed each other as aspects of a single entity (Cumming, 1997). One commentator has suggested that there should be two distinct markets, 'one for art as art, and the other for art as collectable or investment' (Banfield, 1982: 30). Collectors outside of the traditional arts elite may be said to represent a new collecting aesthetic which arguably has put this assertion into practice. In so doing, a wider interpretation of art values becomes necessary. *Cornfield* promotes a broader definition of art, thus implying a democratization of value and aesthetic judgement, while the resistance to its staging from within the National Gallery itself (personal communication, 1997) demonstrates the conservatism that still remains to be overcome in the art world. On balance, despite some reservations, this is a battle which in museums has now largely been won. Perhaps, therefore, the acid test for the democratization of art galleries will come when objects which reproduce fine art, such as those used in *Cornfield*, become exhibited not just as 'the people's idea of art' but as the gallery's as well.

Some collectors' organizations, such as the British Beer-mat Collectors' Society, hold significant, often complete collections of the objects collected (see Chapter 6). With a tactful approach, such collections could serve museums well. If museums reciprocate with conservation advice and are more open about their relevant holdings on a given subject, which most seem to be willing to do, then a mutual knowledge-sharing nexus could be established. Already, some museums are experimenting with the idea of freeing

the object from the confines of the museum. There is of course a tradition of outreach work, of taking things out of museums for use in school projects and reminiscence work with the elderly, but a broader application is more recent. Harborough Museum took material from their People's Show to Gartree Prison: 'the resulting discussions about the importance of certain items to individuals was enlightening' (Fardell, 1995: 48). In Oxfordshire, certain things have been designated *flying objects*, which are housed on a rotating monthly basis at various non-museum venues, such as residential homes, dentists' waiting rooms and community centres (Hull, 1994: 25). Their experience is that

> An artefact in an unusual location draws attention to itself in a different way than would an object traditionally displayed in a museum. The audience is a wider one, the ways of looking infinitely variable. Without categories to confine, or definitions to divert – these objects can provoke imagination and wonder. (Hull, 1994: 26)

Kirkcaldy Museum and Art Gallery launched its 'mobile museum' in January 1996, in the form of a double-decker coach, which it hopes will 'encourage an informal approach to displays, which can be backed up by talks, activities and events' (Emma Nicolson, personal communication, 1995). In this way a reciprocal relationship can be initiated, as has been advocated elsewhere (Merriman, 1991: 136–7). The recognition of the value of such practices in the museums profession may go a long way towards breaking down traditional barriers between collectors and museums.

This has perhaps been taken furthest by Croydon's Clocktower Museum. About 90 per cent of its exhibits are loans from local people (Sally MacDonald, personal communication, 1995). It staged its own People's Show, *Collectormania*, in 1995. This was designed to look like a house, using labels to inform. However, most of its resources are focused on interactives rather than objects as a means of communicating and informing. If this trend continues to develop, collectors would then become an indispensable sector of an expanded museum service, allowing museums to move in other directions. These could include greater utilization of museum spaces as community activity areas (see Fleming, 1997: 32–3).

The keen eye knows

The issue of specialist knowledge, in which the collector invariably has the edge over the curator, due to their dedication to one or two areas as against the curator's many, has wide recognition in the museum profession. Mauchlineware, for instance, were cheap wooden souvenir objects decorated with lithographed images of tourist sites. The Mauchlineware Collectors' Club openly courts museum membership. Its secretary has noted inaccurate information on the labelling of Mauchlineware exhibitions and displays in museums, to which he and his members would like to contribute their collective wisdom (Barry Kottler, personal communication, 1993).

Collectors, preservationist and folklorists (Hobsbawm, 1984b: 66), amongst others, are invariably those who write detailed and closely observed books and articles on the very objects museums end up chasing once they have become popularized by collectors and the prices have escalated. It was indeed the National Railway Museum that in 1990 paid a high price for a collection of railway trade union badges and medals when they came up for auction. It was, though, the vendor of this collection who had spent 15 years inexpensively collecting and researching them, not the NRM. One has only to look at the excellent Shire series of books, which are largely written

by collectors, to realize the extent and variety of knowledge residing in the private collecting domain. These books are almost obligatory at every museum sales point and deal with many popular collecting interests from eighteenth-century dummy boards (life-size cut-out printed figures, often known as silent companions) to Victorian souvenir medals and twentieth-century car mascots.

It is private collectors who keep a vigilant eye on new collecting developments, not museums. Social history curators are the cultural guardians of the same material which the auction house exists only to sell (Suggitt, 1993: 184–5). Collectors are a prior link in the chain to auction houses. If museums took greater notice of collectors at a grassroots level, they may find they had more in common with them than the auction room. One has only to look and listen to tap the undercurrents that generate collecting enthusiasms. At Christmas 1992, it was Thunderbirds and Batman merchandise of which people could not get enough; at Christmas 1993, it was Captain Scarlet and Dinosaurs. BBC Radio 4's *Finance News* (1993) discussed the whole idea of re-licensing 1950s and 1960s characters for ranges of toys and other products which have enjoyed a rekindled nostalgia interest. This (it was felt) was a reaction against fast-moving video games, violence on television and the perceived lack of positive role models in society. The *Leicester Mercury* (1993) reported that the demand for Barbie Dolls was such that they had to be imported from America. Such trends are as culturally salient for their local manifestation as they are as reflections of national sentiment. In fact, the Christmas run-up in demand for certain children's toys has always made seasonal media news, usually involving efforts by desperate parents seeking to delight and avoid disappointing their children on Christmas Day, and exasperated toy-shop staff who can't meet demand. The collecting press, however, is now advising adult collectors which of these toys is worth buying as a collectable investment, carefully kept in mint condition, unwrapped or played with (Spicer, 1997: 52–4). A car-boot dealer, Roger Morgan, advises scrutiny of auction catalogues, Sunday newspaper articles on collecting, 'and various published guides for new trends in "coll"[ecting] ... Catch a trend early, or START one, and you can make a fortune' (Morgan, 1993: 83). More altruistically, Olmsted asserts:

> little is known about the collectable object, an essential factor for collectors and collecting. Little is known of what objects and sets of objects give pleasure to certain individuals. The range of objects collected is so wide that common characteristics of size, texture, age, materials, functions, etc. give no clues. (Olmsted, 1991: 302)

Museums cannot afford to ignore extra-mural collecting communities. They should make cultural allies of them, work with them and develop new strategies in tandem with them.

Museum and collectors' club mutuality

Both museums and collectors' clubs made much the same suggestions when asked in which ways they felt they could be of use to each other. This may suggest a recognition of the value of collectors and a growing awareness of their importance to the museum. Amongst the qualitative comments made by collectors on mutual aid, the following were most common: 'libraries are more helpful than museums'; 'a database of museums' holdings would be useful'; 'we know more than museums anyway'; 'we have no contact with museums'; 'the club is already used by museums'; 'museum affiliations or contacts have been made'.

Table 7.11 In what areas, if any, do you feel collectors' clubs could be of service to museums?

Response	Frequency	%
Local Authority		
Specialist knowledge/loans/ donations/volunteers	79	40
Loans and donations only	47	23
Specialist knowledge only	26	13
Networking	20	10
No experience of this	10	5
None	7	3
Unanswered	7	3
	196	97
Independent		
Specialist knowledge and research	31	24
Loans	21	16
Networking	15	11
Unanswered	12	9
Don't know	12	9
None	11	8
Scouts	10	7
N/A	5	3
Donations	4	3
Identification	2	1
Volunteers	2	1
Storage	1	0
	126	92

Table 7.12 In what areas, if any, do you feel your museum could be of service to collectors' clubs?

Response	Frequency		%	
	LA	Ind	LA	Ind
Specialist and professional advice and information	70	49	35	38
Research facility	22		11	
Networking	20	12	10	9
Identification	18	7	9	5
Display venue	17	13	8	10
Venue to meet at	16		8	
Unanswered	11	11	5	8
Access to reserves	10	4	5	3
Other	7		3	
None	5	13	2	10
Don't know		12		9
N/A		3		2
Loans		1		0
Volunteers		1		0
	196	126	96	94

Table 7.13 In what areas do you feel your club could be of service to museums?

Response	Frequency	%
Specialist knowledge	45	35
Unanswered	26	20
Access to specialist material	29	22
Talks and presentations	14	10
Don't know	8	6
Specialist research	2	1
Cataloguing	1	0
Publicity	1	0
Volunteers	1	0
Conservation	1	0
	128	94

Table 7.14 In what area do you feel museums can be of service to your club?

Response	Frequency	%
Unanswered	26	20
Accommodate displays	21	16
Access to reserve collections	15	11
Publicity	15	11
Share specialist knowledge	13	10
Don't know	9	7
None	9	7
Research	8	6
Be more receptive	4	3
Offer a meeting place	3	2
Repository for collections	2	1
Education	2	1
Loans	1	0
	128	95

Overall independent and local authority museums mirrored each other's responses both in relative percentage and in the nature of responses. Very often, however, the independent sector respondent would make a point of asserting their origins as a collector who had founded a museum. This, plus their often deeper links with collectors and membership of collectors' clubs, does not seem to differentiate their opinions markedly from their local authority colleagues. This is borne out by the high number of independent respondents who expressed caution on the question of foster-keeping. Seemingly in contradiction, however, a number of independent museums stated that collectors' clubs would be useful for exchanging surplus or duplicate material; this included large museums like the London Transport Museum.

Of democracy and treasure troves

It has been written that the way in which a collector deals with his/her inability to compete in a given collecting field is by trivializing or denying the relevance of that which is collected and those who collect it (Thompson, 1979: 107–8). Such behaviour in an individual collector surprises no-one, in an institution it should. Yet in a real sense, this is the way museum professionals have traditionally treated collectors. Museums, until the advent of the 'heritage industry' in the 1980s, existed very largely in their own cultural vacuum. The popularity of the theme park and the fear that fictitious entertainment was being passed off as 'real' history caused initial panic, and subsequently the reshaping of the museum world. Most museums have now at least paid lip-service to wider involvement of the community in exhibitions, and many have gone a great deal further.

An article entitled 'Power to the People' (Carrington, 1995b: 21–4) gave voice to a number of curators who described exhibitions based on extension work. These involved, variously, the single homeless (Glasgow Open Museum), The Afro-Caribbean front room of the 1960s (Grange Museum, Neasden, London) and the famous *Peopling of London* exhibition (Museum of London). All three were admirable and highly commendable projects and were used as examples of how broadly museums were casting their net in an attempt to be relevant to traditional non-museum users.

It is interesting then to compare this laudable aim with letters which appeared in both the October and November 1995 issues of *Museums Journal*. These decried the cost of professional training and the virtually mandatory requirement of such training in order to get a job in a museum. The writer of the second letter, Emma Cook, asserted that 'entry into the museum profession is becoming increasingly elitist' (Cook, 1995: 18). The Museums Association (MA) commissioned an investigation into freelance museum practitioners. These are largely redundant museum specialists who now provide expertise for specific functions. Writing on the job situation in the USA, William Bridges notes:

> Temporary professionals are increasing twice as fast as the temporary workforce as a whole – and temporaries as a whole have increased almost sixty percent since 1980. These figures are probably low, since they do not count the professionals who are technically consultants but whose roles and relationships to the rest of the organisation are more like those of temporary workers. (Bridges, 1995: 9)

The MA report recommends that a freelance register be set up and that training should be available to freelances funded via the National Lottery through training agencies (Carrington, 1996b: 25). Whilst museums seek to raise their attendance figures by embracing an ever greater and more disparate range of traditionally non-museum users, their own specialists become marginalized. If even the white, middle-class, elite arts cognoscenti are finding it hard to maintain employment, there is little likelihood of other social groups, such as the museums are currently wooing as visitors and 'advisers', gaining entry to the profession. This rather contradicts the professed ethos of the exercise.

Finbarr Whoolley, curator of the Grange Museum, believes, 'Encouraging local people to participate in the work of the museum requires different skills from those traditionally taught by museum studies courses' (Whoolley, 1995: 22). Forging links

with local people is even being written into job descriptions at Glasgow's Open Museum (Edwards, 1995: 22). This implies that emphasis should be placed upon the broadening of professional training provided for new entrants from traditional backgrounds, rather than on encouraging entry into it from new or different ones.

As the necessity of partnerships, networking and advocacy takes on ever-increasing importance in museum funding, so the requirements for the job of the museum professional will change. No doubt existing museum studies courses will take this on board and more specialist courses in museum fund-raising will be launched. This suggests a further narrowing of the aims and objectives of the museum fraternity and the acceleration of a preference for business managers and marketing staff over subject specialists. This would not preclude a public image of a broadened and more egalitarian approach being projected, 'As museums seek to move away from their image as a preserve of university educated, white middle class residents and broaden their appeal . . .' (Carrington, 1995b: 21). Clearly the desire to be relevant to a wider community is being acted upon. The real acid test of museum democracy, though, would be the incorporation of some of this extended community into the museum profession itself. Whilst museums genuinely seek to move beyond the traditional white, middle-class, educated audience that are normally associated with museums (see Merriman, 1991: 134), there seems to be little recognition that this very social group dominates the profession itself and therefore, very often, the view of the institution.

In February 1993, the Museums Association-sponsored *Equal Opportunities Awareness Study* carried out by McCann Mathew Millman (MMM) was published. MMM used a sample of 50 museum professionals, including five Governors or Elected Members, the rest being paid employees (2: 1.3.2). Amongst their findings were: 'The majority of Black and Asian staff appear to be concentrated in the technical and attendant grades' (4: iii) and further that 'the more senior the interviewee, the more difficult the respondent found it to comment upon the visitor profile' (6: 2.2.4). Only a minority of those interviewed could give any kind of visitor profile at all. Senior staff, it was found, regarded customer care training as: 'appropriate only to attendants' (7: 2.2.4). This last point highlights the invisibility of the staff beyond attendant level to the public and perhaps indicates an unwillingness of some of those surveyed to come into contact with them any more than necessary. 'This job would be great if it wasn't for the public' is an ironical jibe espoused by many a museum professional in the author's experience.

There is a discernible tension between a broader involvement with the community and the closing of ranks within the profession itself. It has to be asked in this case, to what extent the courted extra-mural community can have a real effect rather than a transitory one on the museum establishment whilst the main imperative for the museum is the appeasement of the funding authority. It also suggests that the increasing number of non-museum/institutional collectors should be drawn upon as subject specialists at a time when museum curators are seemingly metamorphosing into business managers.

One museum which has taken this further is the previously mentioned Croydon Clocktower Museum. It may well be unique in being a museum which owns very few of its own object collections (Davies, 1995: 20). Its resources are directed at touch-screen technology and CD-ROM as a means of communicating knowledge. Its lack of collections frees it from the prickly problem of de-accessioning, enabling

it to close down and sell the fabric of its building if necessary. To this extent it becomes a virtual museum, and is reflective of the transitory society in which it is based. The museum's *Lifetimes* exhibition is described in its development plan (January 1992) as 'a multimedia, interactive exhibition of life since 1850 reflecting the community's development and cultural diversity' (Croydon Libraries, Museums and Arts (CLMA), 1992: 3). Its principal museum officer, Sally MacDonald, finds it hard, though, to comment on whether the museum serves a community as such, which seems to highlight this point:

> I feel that Croydon has many communities – all sorts of different social and cultural and interest groups, residents, workers, students, shoppers, etc. And lots of people who wouldn't regard themselves as part of a community at all. (Sally MacDonald, personal communication, 1995)

With such heterogeneity, of whom or what then is the *Lifetimes* exhibition the story? Rather than the history of a developing community, it relates to the increasing ambiguity and transience of the museum's social catchment area. *Lifetimes* is intended to be 'a unique history challenge, or three dimensional computer game' (CLMA, 1992: 8). It is perhaps the first museum in Britain at least to state in its development plan that 'It is important to emphasise that Croydon Museums Service will not be defined by its collections, as many museums have been in the past' (CLMA, 1992: Appendix 1, 1.3). In so doing we are perhaps witnessing the first instance of a museum in which objects lose their centrality, which hitherto they have always had. The implications are therefore that as communities become more transient, temporary and migratory they leave less behind them of substance. Video and digital interactives, then, may better capture the fleeting nature of these postmodern communities, and hold more in common with the televisual medium of social documentary than with the tactility and solidity of objects. If this trend develops, private collections will become the primary repository for the popular material culture of the late twentieth century. In the early decades of the twenty-first century, therefore, private collectors of popular material culture may well take on greater importance as institutional cultural interpreters. Collectors may come to be the collecting and lending section of a broader and much-changed museum profession.

Museums redefined

Increasingly, museums are ceasing to be the only institutions which have an authoritative voice in object identification and conservation. The love–hate relationship between museum archaeologists and metal detectorists illustrates this. Museums have traditionally been the place where detectorists have taken their finds for identification. But as an article in the metal detectorist's magazine *Treasure Hunting* points out,

> this [restoring and preserving artefacts] does not necessarily mean taking your finds to a museum . . . there are now many people within or associated with our hobby (e.g. coin and antiquity dealers) who are skilled in these arts. (Bailey, 1995b: 16)

As long ago as 1983 the potential popularity of archaeology with a broader audience was recognized in the aftermath of the raising of the *Mary Rose*, the sunken Tudor warship (Gregory, 1983: 7). Television companies, it was advocated, should be

convinced of the audience potential for archaeology programmes. Other than the occasional grandiose feature on Egyptology or Ancient Greece, this went largely unheeded until Channel 4's *Time Team* series was launched in 1994. This popularity, it was felt, was 'the space archaeologists must fill – which is now filled by *Treasure Hunting* – providing information and entertainment at the level of *The Sun* and the *Daily Mirror* (Gregory, 1983: 7). This demonstrates the class divide between classically trained archaeological practitioners and weekend hobbyists, as Gregory admits: 'Archaeology is now, and has always been, a largely middle class pursuit' (Gregory, 1983: 5).

Exhibitions by non-museum personnel in non-museum spaces are becoming increasingly common. Where once the museum would have been courted for advice, it no longer has this relevance for many collectors. The wealth of subject knowledge discerned by collectors and shared amongst other enthusiasts through collectors' clubs and their publications has created an international community of subject specialists with no formal museum training. Many of these organizations and individuals think of their collections as museums. This has been especially so with the metal detectorists.

To some extent the *People's Show Festival* in 1994 has been unwittingly responsible for the organization of collectors. In September 1994, a group of exhibitors from the Leicestershire Museums People's Show decided to set up their own collectors' club. Over the August 1995 Bank Holiday they staged their own People's Show in Leicester's Guildhall, without any museum involvement (Plate 7.5). The display paralleled that of the county museums from the previous year over a shorter period of two weeks. Similar clubs were set up elsewhere in England as a result of the *People's Show Festival*.

The relationship between archaeologists and metal detectorists is also one of gentlemen and players, to use the old cricketing analogy. The Council for British Archaeology (CBA), while admitting that attitudes towards detectorists vary from encouragement to complete opposition within its own profession, takes a definite anti-detectorist stand as a body. It deplores metal detecting when the motive is monetary gain or private collecting, but grudgingly accepts it where there is an altruistic motive of placing finds in museums (Council for British Archaeology, 1993). The position of the National Council for Metal Detecting recognizes that there is no single motive for metal detecting but sketches a variety of reasons from monetary gain or historical curiosity to a relaxing hobby. Most interestingly they state:

> The collecting and study of metal items made and used by our forebears is a cerebral activity enjoyed by thousands who may not all have found equivalent interest during early education. These detector users share a tactile experience with their ancestors through handling artefacts unearthed after hundreds and sometimes thousands of years. The more they learn about their finds, the more varied and intense are the satisfactions to be gained from their hobby. (National Council for Metal Detecting, 1992)

This sounds more constructive. It is an assertion of self-education and self-realization, whereas the bald urging of the CBA not to use metal detectors and join a local archaeology club does not inspire. Gregory, as an archaeologist, attests that archaeology has had little regard for the public over the last several decades (Gregory, 1983: 5) and freely admits that metal detectorists are as motivated by the desire to 'find and own something old as to make a fortune' and that 'metal detecting's success is a measure of archaeology's failure' (Gregory, 1983: 6).

Plate 7.5 Leicestershire Collectors' Club *Collectomania '95* poster Reproduced by permission of Leicester City Council Leisure Services.

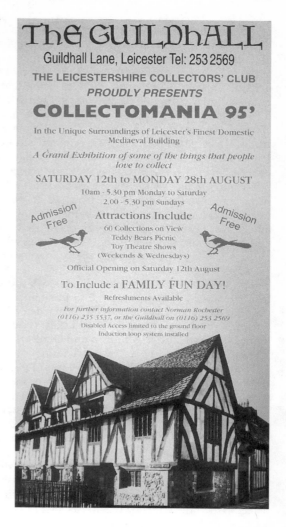

The GUILDhALL

Guildhall Lane, Leicester Tel: 253 2569

THE LEICESTERSHIRE COLLECTORS' CLUB
PROUDLY PRESENTS

COLLECTOMANIA 95'

In the Unique Surroundings of Leicester's Finest Domestic
Mediaeval Building

*A Grand Exhibition of some of the things that people
love to collect*

SATURDAY 12th to MONDAY 28th AUGUST

10am - 5.30 pm Monday to Saturday
2.00 - 5.30 pm Sundays

Admission Free Attractions Include Admission Free

60 Collections on View
Teddy Bears Picnic
Toy Theatre Shows
(Weekends & Wednesdays)

Official Opening on Saturday 12th August

To Include a FAMILY FUN DAY!

Refreshments Available

*For further information contact Norman Rochester
(0116) 235 3537, or the Guildhall on (0116) 253 2569*
Disabled Access limited to the ground floor
Induction loop system installed

The *Museums Journal* reported in September 1995 on the attitudes of some museum archaeologists towards the detecting fraternity, citing the examples of London, Norfolk and Leicestershire as good working relationships (Carrington, 1995a: 33–5). In Norfolk, staff from the archaeology service visit the four regional metal detectorist clubs to give talks and regularly come back with boxes of finds to identify. Nick Merriman (then of the Museum of London) would like to see such a service implemented nation-wide and thus extend good working relationships with detectorists nationally, such as the Museum of London has with the Thames Mud-Larks (Merriman, 1995: 35).

However, if at a local level there are signs of museums taking detectorists seriously and attempting to link with them, at a national level detectorists have launched their own campaign which has by-passed the museum establishment and has been launched

as a response to institutionally backed legislation aimed at curtailing their activities. The proposed legislation, backed by the CBA, English Heritage, Museums Association and others, would make it a legal obligation to report most finds to museums. This led to the inauguration in October 1995, through the pages of *Treasure Hunting*, of a 'Mini-Museum Campaign', the idea being that all detectorists should mount a rotating display of finds in display cabinets and exhibit them in various establishments. These include country pubs, churches, dentists' and doctors' waiting rooms, libraries, shopping centres and supermarkets, etc. This, it was held, would draw attention to metal detectorists and their positive contribution to finding the nation's heritage. Each display is to be accompanied by the following slogan, which was adopted for the campaign: 'Every person has the right, acting within the terms of the law, to find his or her own past by means of a metal detector.' Articles have appeared on how to make your own display cabinets from old drawers, and all readers have been urged to establish a mini-museum site in their locality (Bailey, 1995a: 45–9). To a lesser extent, this initiative has also been taken up by some museum services. In 1994, Oxfordshire initiated their *Flying Objects* series with posters on buses advertising the displays as *belongings*, and placing objects in some of the same places as the detectorists are advocating.

The 1995 report undertaken by the CBA and English Heritage, *Metal Detecting and Archaeology in England*, came to some interesting conclusions. In its summary the authors stated that the effect of 'metal detecting on archaeology in England has been for good as well as for ill, and that its potential benefits have not yet been harnessed to the full' (Dobinson and Denison, 1995: x). They further found that 'detecting clubs have found nearly ten times more Roman brooches per club since 1988 than archaeological units have found per unit without the use of detecting technology' (42–3). In conclusion the report asserts that more archaeological units should employ metal detectors themselves and urge the co-operation of detectorists to take part with them. This is something which as long ago as 1983 was being advocated (Gregory, 1983: 7).

The report states that very few finds make their way into the archaeological record. Conversely, in the pages of *Treasure Hunting*, there appears a regular column 'The Boudicca Campaign', which seeks to spotlight what it sees as museum malpractice and incompetence. It makes public the reluctance of museum staff to give access to specific items in the museums' stores and to find items listed in the register for detectorists. This Gregory regards as an 'anti-archaeological campaign' (Gregory, 1983: 8) so a tit-for-tat exchange exists between detectorists and archaeologists. The report also found that:

> There is little evidence – for example in the metal detecting press that detectorists in general operate in an environment in which the vital importance of provenance is widely appreciated, or even discussed. (27)

The piece on mini-museums in the November 1995 issue of *Treasure Hunting* does, however, make the point of stating the importance of provenance (Bailey, 1995b: 16). The accusation by detectorists that archaeologists' mechanical stripping of topsoil prior to excavation results in a loss of metallic objects is grudgingly admitted in the report (36) and further that many archaeological finds would not have been discovered without their aid (37). The reasons given by those archaeological field units not using metal detectorists are varied: reservations about the efficacy of the application; ethical

difficulty in being seen to condone the use of detectorists, while some preferred to use their own staff with detectors, even though they were not experienced in their use (38). It also sees as desirable the removal of hobbyist detectorists to 'less sensitive land' (xi). Thus the report has accepted the importance of the metal detector and the skill involved in its use and so seeks to elevate it to an archaeological tool, whilst simultaneously disassociating it from the hobbyists. Of the nine conclusions made from the report (61–2), four are negative and five positive. The best results, the survey found, were when detectorists and archaeologists worked together, making the following recommendations (62):

1. Improve liaison between archaeologists and the detecting community
2. Improve communications amongst archaeologists themselves
3. Investigate ways of managing a large increase in the referral data
4. Investigate new methods of protecting scheduled sites from illicit metal detecting
5. Investigate the relationship between illicit detector finds and antiquities market
6. Educate archaeologists about the metal detector
7. Investigate finds erosion in plough soil

Interestingly enough, the Department of National Heritage (DNH) suggested in April 1996 that metal detecting societies could act as recording agencies for finds not covered by the current treasure trove legislation (Carrington, 1996a: 10). This was suggested as an alternative to spending £70,000 on setting up a recording agency. It was cautiously welcomed by the archaeological community, but it was felt that an arrangement to stop material being sold on without proper provenance would also be welcome. It was reported further that Dover Museum had, since 1992, been working with two metal-detectorist groups who acted as recording agencies (Carrington, 1996a: 10). It would seem most probable, then, that a closer and more professional relationship between detectorists and archaeologists will be achieved through the pressure of economic necessity and on a museum-by-museum and club-by-club basis.

The archaeology-versus-detectorist debate is probably the oldest and most well-known example of the tension between collectors and museums. Over the last five years, however, great strides have been made by private collectors while at the same time museums have been effectively downgraded in terms of resources and consequently quality (along with teachers and other public professionals). Now, with the cessation of the development of MODES (Material Object Data Entry System), there is not even a consensus on accessioning practice, and in the interim, collectors have developed programmes such as the 'Collectable Collectors' Workbook' (*Classic Toys*, 1995: 37), which approaches MODES in its utility. As we approach the millennium, we are rapidly reaching the stage where terms such as 'professional' and 'amateur' (see Stebbins, 1979) will become redundant, and some other term, such as 'facilitator', will have to be employed to describe those who use objects to educate and entertain. A broad front will have to be consolidated in order to protect the socially and culturally valid from economic asset-stripping, as was the case at the Chatterley Whitfield Museum (Davies, 1994: 19).

Figure 7.1 illustrates the similarities between what museums do and what collectors do. This model, if viewed negatively, sustains the public accusation of private fetishism (for an enlightened discussion of which see Ellen, 1988) but only if public professionalism is seen as its mirror image. Because we accept and encourage public

professionalism, the model should be seen as positive, with private collecting being mirrored in the same light. As private collectors become more sophisticated, which much of their literature suggests they are, the parallels leave their polarities and move closer together. This is also illustrated in Plate 7.4, where two museum displays of tea towels at People's Shows imply a playfulness normally attributed only to collectors. Indeed, it was held in 1930s America that 'Captains of industry collecting European masters and ten-year-old boys collecting milk bottle tops were . . . brothers under the skin' (Gelber, 1991: 747), so why not collectors and curators?

Figure 7.1 Binary parallels

Private collecting (profane/leisure)	Museums (sacred/work)
Collecting	Acquisition
Collector	Curator
Fetishist	Specialist
Hobby space	Museum
Private	Public
Practical display	Display policy
Kept in a safe place	Collection management
Check for condition	Micro environment
Treat carefully	Conservation
Make a list	Accession/catalogue
Interest in history and context of objects collected	Research
Arrangement of collection	Taxonomy
Too much to display at once	Reserve collections
Personalia	Provenance
=	=
Self-gratification	Public edification
Collecting = Hobby	Curating = Work

In the model for Figure 7.1, professionalization equals the hijacking of the collecting instinct and renders it institutionalized, thus imposing hierarchies on it and thereby structurally distancing museums from their objective clientele – the public.

Conclusion

A symbiotic relationship should be fostered between museums and collectors. The latter could, for instance, act as an alternative or complementary collecting agency, whilst museums provide professional collection-care advice. Professionals should not be discouraged from establishing client–patron relationships with dealers on markets and car-boot sales for specific items, or from working with collectors as intermediaries. Even on a casual basis, it can produce results (see Suggitt, 1990a: 27–9). In such circumstances there would be less likelihood of cultural appropriation (Merriman, 1991; Pearce, 1994b).

Despite the new enthusiasm from some quarters (by no means universal), the museum establishment still often views collecting as undesirable in its own staff for

ethical reasons. Having reached a point where curators are inviting collectors into museums as exhibitors and encouraging *their* participation, they simultaneously frown on professional staff reciprocating (and thereby forging stronger links) by regarding the idea of staff entering the collector's world as suspicious, unethical, or completely irresponsible. The concern over control and the neurosis which the conflict-of-interests question *can* become, will only hinder the widening of extension work. Museums and collectors should celebrate their mutual interests and establish a mutual knowledge-sharing nexus. The maxim of the Trade Union Badge Collectors' Club is 'saving our past for the future'; do we not all share this concern? One survey found that 'those who tend not to go to museums would most prefer finding out about the past at home, by watching television or reading a book (Merriman, 1991: 126). It is such programmes as those mentioned in Chapter 4 (*Collectors' Lot, The Exchange,* etc.) and associated magazines such as *Eyeglass, Homes and Antiques, What's it Worth?* and *Collect It!* which serve to activate non-museum visitors to visit markets, fairs and car-boot sales at weekends and perhaps to start their own collections. The same stimulus would not necessarily cause them to visit museums. They could, though, be found or encouraged to communicate with them if suggestions such as Merriman's for a museum bus to tour non-museum venues, offering an '*Antiques Roadshow*' service, with advice and information on people's belongings, were acted on (Merriman, 1991: 133).

A formal platform on which museums and collectors' clubs can exchange information would be useful. It would help dispel some of the reservations held about collectors. The specialist knowledge held by collectors is too valuable an asset to dismiss. Museums likewise have, for example, the professional conservation and display knowledge which many collectors would value. In this way museum practice would become democratized. The collecting public increasingly want to know about conservation materials. There seems no good reason, save cost (which could be negotiated), why museum practice should remain contained within an ivory tower. Representatives of collectors' clubs could be invited to speak at the Museums Association annual conference, whilst museums and others interested in building links with collectors should be free to attend collectors' meetings or to affiliate their museum to collectors' clubs. For museums to gain a truly holistic view for compliance with their collecting policy and to fully exploit their outreach potential, they should invite collectors not only to display in museums (very big first step though that is), but to become part of the network that collectors operate within by involving themselves with them, their clubs, markets and dealers.

8 Round and round they go: client–patron relationships

Introduction

A long-standing relationship has existed between auction houses and art dealers. It is ethically governed and well understood by all parties. Collectors too have client–patron relationships with dealers at flea-markets, collectors' fairs, etc. In this chapter these relationships are examined both in themselves and in relation to museum practice. If it is in the interests of museums and collectors to form closer alliances, then it is necessary for museums to understand the nature of client–patron relationships between collectors and their sources. In furtherance of this, participant observation was undertaken with three market dealers at two different venues over a three-week period, the results of which appear in this chapter. From the museum standpoint, there is little written on such relationships in Britain, and what little there is, is written from an ethical position based on the museum profession's traditional suspicion of collectors (i.e. Suggitt, 1993; Crook, 1993; Viner, 1993).

In recent years this has opened up somewhat. Debate was stimulated by the People's Shows, especially the *People's Show Festival* in 1994. There is a genuine passion for collecting original material, as one exhibitor at the Museum of London's People's Show observed:

> It's quite interesting, you look at the collectors' mags, specialist mags, whether it's Dinky cars, or whether it might be buttons, or whether it might be comic books. You see 'Wanted' ads. People say 'I urgently need' . . . 'I require badly', 'desperately'. Why do they need these things desperately? Why does someone need X Men No. 73, really, really desperately? (*Carry On Collecting*, 1994)

Conversely, working on the old adage that you can fool some of the people some of the time, but you can't fool all of the people all of the time, collectors have been questioning the dubious nature of limited editions. These are purpose-made by manufacturers and aimed at collectors' markets. They are often held in low esteem, as the same collector observed:

> You have items like silver medallions for commemorations, to start people collecting things. These are manufactured things for people who might not actually be collectors, but who want to push the idea of investment. (*Carry On Collecting*, 1994)

Debord wrote of collecting key chains, for example, as 'indulgences of the spectacle' (Debord, 1983: 65). Such 'indulgences' would also include many of the opportunist objects, such as commemorative merchandise made and sold ostensibly to mourn

the death of Princess Diana. There is, though, perhaps a difference between them and the quality objects which are sold to collectors by manufacturers who run their own clubs. These would include much of the best output of the British potteries and individual designers working for themselves. Even if in overview they may seem the same, to the 'discerning' collector they are quite distinct. This suggests that the bottom end of the 'made-for-collectors' market is spurned by 'real' collectors, while the upper reaches of it straddle the apex of the popular and the lower regions of the classical collecting market, where objects are used to represent status through conspicuous consumption (see Mason, 1981).

The economics and environments of collecting have undergone serious analysis in recent years, mainly in America (e.g. Maisel, 1974; Hermann and Soiffer, 1984; Stoller, 1984; Glancy, 1988; Belk, 1991a; Smith, 1989; Olmsted, 1991). In Britain several studies of car-boot sales have recently been published (Gregson and Crewe, 1994; 1997; Gregson *et al.*, 1997). It is the voice of street culture, however, that has been most vocal on this aspect of collecting, as, for example, the collecting press demonstrates.

Antique dealers

One commentator concluded that collecting antiques was mainly a means of escapism (Hillier, 1981: 81–2), whilst another sees an historical trend in the look of the old being linked with the virtues of home (Muthesius, 1988: 232). A radio programme which involved conversations with antique dealers provides a good example of dealers' philosophy towards their clientele. One dealer imaginatively put the collecting impulse thus:

> Antiques are bought to extend your life backwards. Old furniture lets you off making your own choices. A bit of other people's lives rubs off with the polish. (*Ad Lib*, 1995)

The antique dealer's view of the collector has more in common with the traditional attitude of the museum professional. It was felt by one dealer that stock was better acquired from other dealers, as they know the market prices and understand the mark-up element of the transaction. Auctions did not offer a good profit, because one had to bid against collectors. Collectors, he added, can become emotionally attached to objects and easily overpay for things (*Ad Lib*, 1995). This is also intimated by Glancy, though she found that the auction environment became a hyper-reality not only for new attenders, but for seasoned ones as well (Glancy, 1988: 142). Dealers were anxious to disown the allegation of overpricing. The price, it was proffered, is set by the last person to buy the object. This price is limited to the specialist nature of the item and the collectors of it. There was a consensus that the trade is over-populated with newcomers and glorified second-hand dealers. Their level of knowledge was held to be very low. It is believed that they are involved in the trade as a result of unemployment, bolstered by programmes such as *The Antiques Roadshow* and *The Great Antiques Hunt*.

It was pointed out that some recent material, such as 1950s toys, are now worth more than seventeenth-century antiques. Certainly they seemed to resent this, possibly because it undermined their knowledge and judgement of what has been traditionally accepted as collectable or valuable. In this respect at least they have more in common with museum curators. If antique dealers have held themselves to be the traditional

arbiters of an object's fiscal value, museum professionals have held themselves to be the arbiters of an object's cultural value. In the current environment such easily assumed monopolies have been seriously pressured by collecting and dealing interests outside of this traditional ambit. Material after about 1830 is given its own name, such as 'Victoriana', 'Art Nouveau' or 'Art Deco', after which it becomes 'collecting'. The trend in collecting items of the recent past is frowned upon by the antiques trade. After 1830, material becomes mass produced and has a lot less quality about it. People collect small things, because they have no room for larger items and because often it reminds them of their childhood. As one dealer put it, 'in-your-head stuff' (*Ad Lib*, 1995). The antiques trade's dislike of the mass produced also helps set them at the polar opposite to contemporary collectors, whose interests are very often of this nature.

It was the experience of the antique dealers that people now expect to get a trade price, i.e. a lower-than-target price. This was attributed to people travelling more and expecting to get a better deal. Dealers are often asked, 'What's the best you can do?' They are now expected to have to haggle with the public. This was felt to be the result of TV programmes like *Lovejoy* (a light drama series based on a roguish antiques dealer) and *The Antiques Roadshow*. Most bargains in the trade it was agreed came from other dealers. This seems, though, to suggest that the public is getting bolder and more confident about what they should be expected to pay for an old object. Many who would take such an approach would have served an apprenticeship as a collector or dealer in car-boot sales (see Morgan, 1993; Gregson and Crewe, 1997) and flea-markets (Maisel, 1974; McCree, 1984). Therefore they don't see why they shouldn't adopt the same code of conduct in the more rarefied world of antiques. Maisel believed that

> without proper guidelines to deference and demeanour it is perhaps inevitable that public demonstrations of bargaining prowess tend to be avoided in favour of private negotiations. (Maisel, 1974: 500)

The niceties of private negotiations are, however, more often an option for established dealers who know each other's codes; the public usually have to be bolder in order to strike a deal. Muthesius, writing on the attraction of antique furniture, reminds us that this is in any event not a new trait. Some twenty years after the development of a taste for old furniture in the upper end of the (antique) trade of the 1870s, private collectors began to move in, and consequently there were fewer pieces to be had. Those that were available rose concomitantly in price (Muthesius, 1988: 242). This is perhaps the true gripe of antique dealers, that their trade and knowledge are no longer rarefied, as they once were.

Car-boot sales

It was estimated in 1994, that two million people went 'booting' (i.e. attended car-boot sales) every week in Britain (*Scrimpers*, 31 October 1994). The anthropologist Sol Tax referred to such activities as 'penny capitalism' (Maisel, 1974: 489). However, one experienced car-boot vendor, Roger Morgan, has written a book, *£500 a Week from Car Boot Sales*, which outlines the ways of becoming established in the 'booting trade'. It is such people that the antique dealers were complaining about. It is far from a 'penny' business in today's market and forms a significant part of the informal

economy (Hermann and Soiffer, 1984: 398). It has been estimated that in the United States 'there are at least six million garage sales per year, with a gross of six hundred million to one billion dollars' (Hermann and Soiffer, 1984: 401). The turnover in Britain would presumably be less, but no doubt impressive.

In America, the rise of the garage sale has been linked to reduced income in real terms and 'is also reflected in the widespread mood of shrinking expectations' (Hermann and Soiffer, 1984: 413). America invented the belief 'that unbridled access to things should lead to unbridled happiness' (Belk, 1995: 1). As incomes failed to match expectations and material aspirations, material commodities began to lose some of their magic. However, an increasing number of articles in respectable magazines on garage sales throughout the 1970s gave them legitimacy to middle America (Hermann and Soiffer, 1984: 402). In Britain, mass unemployment resulted from Conservative government policies of running down traditional industries from the early 1980s onwards. The increasing preference for cheaper, part-time, female labour in the new, booming service sector led to many role reversals and reappraisals in familial homes. Car-booting became both a source of income for vendors and a source of cheap goods for customers (see Gregson and Crewe, 1997).

In the same way that art galleries and antique dealers cultivate affluent clients, the boot sale and flea-market trader likewise cultivate theirs. Morgan early on refers to boot-trading as a 'service industry'. Attending flea-markets, auctions, etc. has traditionally been seen as a purely leisure activity, an arena for adult play (Christ, 1965; Maisel, 1974; Glancy, 1988). This is now undergoing revision. Belk, citing Stebbins (1982), qualifies activity in such environments as 'serious leisure' (Belk, 1995: 55). The decision to attend car-boot sales early on Sunday mornings, usually a designated leisure day, when one could stay in bed, especially in cold weather, represents a commitment to a certain work ethic. Things to be rescued from the profanity of the market stall demand a decided mind-set and regimented routine, rather than the incidental or casual decisions of a leisure activity. If the market is work codified as enjoyment for the trader, it is equally so for the buyer. Therefore, the value of the commitment given by both to being in the same place at the same time is what is being decided in pricing and haggling. If the vendor ends the day with a good profit it has been worth their while getting up; if the buyer comes away with a good bargain it has been worth their while also.

Morgan cultivates a network of clients who ring him 'out of hours with requests for particular items' (Morgan, 1993: 4). He holds to the conventional wisdom that collectors are eccentrics, and sees them as he seems to see all other booters as mug punters: 'Collectors will pay the earth and go without food for a missing item in the collection' (Morgan, 1993: 79). When he reaches collectables he states:

> If you've got something odd on the flash [stall] and you know it's not worth a carrot, as we say, you stick a ticket on it saying 'very collectable'. Some twit will pay good money and start collecting them in the hope that the stuff will go up in value. (Morgan, 1993: 83)

The 'flash' (the stall's frontage) will be full of 'pot' (e.g. china, glass or other breakables): 'the fancy terms and maker names are just for the punter' (Morgan, 1993: 14). Morgan cites case histories of booters who were previously unemployed, and now earn more at booting than they could in an ordinary job; some also have part-time stalls in covered markets. Maisel believes that the distinction between buyer and seller is arbitrary, as most sellers buy from each other for resale or for themselves.

The clearer distinction, he states, is between those who are knowledgeable about markets for used goods and those who are naive (Maisel, 1974: 494). This is borne out both by fieldwork (Gregson and Crewe, 1997: 102) and by Morgan, when he relates the sources of acquisitions. However, collectors are often as knowledgeable. Attenders of car-boot sales are often as shrewd as the vendors (Gregson and Crewe, 1997: 92–6). A member of the United Kingdom Spoon Collectors' Club found a dozen blackened spoons tied in a rubber band on a stall at a market. She only wanted one, but the dealer only wanted to sell them as a lot. He was told that they would be easier to sell individually. Two weeks later he was asked if he'd sold them and he admitted that he had, individually. He admitted that dealers didn't know how to sell some items, as they don't have the knowledge of the objects or of the type of person who would buy them.

Pricing

Pricing objects seems variable. Morgan, ever the cynic, prices according to his perception of the individual punter. Others are more concerned with building a reputation in a circuit of boot sales and collectors' fairs. Malcolm, a vendor in a Brighton flea-market, deals in many things, but likes dealing in badges especially. He keeps back badges on certain subjects for regular clients, revealing them surreptitiously from under his display cabinet to the 'right collector'. He doesn't collect himself, but will often keep hold of certain 'pieces' because they take his fancy. He is at pains to stress that he always tries to ask a fair price in order to keep the patronage of the collectors.

Another dealer, Andy, this time in London, works many markets around the country, again specializing in badges of many kinds. He works on a regular basis from an established market on Saturdays. There was a period, he says, when rival collectors of trade union ephemera would all turn up together at 7.00am when the dealers arrive, and solicit any available items as they were setting up their stalls. Having bought any desired material (usually at any price, sometimes almost resulting in fights!), they would rush off to the next market, trying to get there before their rivals. They came to an agreement eventually and took alternate turns in doing the rounds at the markets. Andy subscribes to a number of collectors' organizations and uses their magazines, which feature postal auctions, as a price guide for buying and selling. Robertson's Golly brooches can sometimes sell for a hundred pounds or more. He acquires a lot of his stock by advertising in local papers. He also frequents the sorting depots of such events as the 'Blue Peter Appeal' (a children's TV programme which makes regular appeals for various material for resale for worthy causes). He recently obtained a huge box of unsorted enamel badges this way. He bought them by weight as scrap metal, but sold them individually to collectors. This is something Dick (see below) also does, but with the antique trade.

A Brighton dealer, Dick has a large clientele in militaria, jewellery, watch-chain fobs, etc. He works exclusively in Sussex and has a friendly patter and personality, which immediately wins over the punter. His prices tend to be a lot higher than other dealers in similar material, but he still manages to sell, usually by holding out and refusing to drop his asking price by very much, which other dealers are more willing to do. He tends to have a strong core of regular customers who are collectors. He also sells to other dealers in antiques and collectables who

travel more widely than Sussex. His contacts within the jewellery and antique trade often lead to bulk purchases of groups of interesting material such as trade tokens, watch-chain fobs and medals which to the antique or precious-metal dealers are scrap, but which to the right punter are collectors' pieces. So by buying such material at scrap-metal prices, he resells at collectors' prices for his profits. He prices his material according to price guides and condition. If it is material that isn't catalogued, he will double or treble the buying price, or decide when he is approached by a potential buyer.

In his study of California flea-market dealers, Maisel states that most material falls into two categories: 'an item is either of utility or of cultural significance' (Maisel, 1974: 496). Utilitarian objects, he states, are often priced according to their replacement cost on the retail market, but 'cultural' objects are harder to price. He bears out the practices of Morgan and the three dealers cited above:

> Antiques, collectables, memorabilia, or 'funk' cannot be evaluated in terms of their use value or compared with their new counterparts, but must be assessed in terms of highly specialised market knowledge. Further, the swiftly moving currents of fashionable interest in nostalgia reshapes these markets in an almost dizzying way. (Maisel, 1974: 496)

Regular dealers at boot fairs know what sells and what they need to stock up on. They often arrive earlier than the 'one-shotters' (Maisel, 1974: 496), who have genuinely come to sell the contents of their attic, and see if they have anything they can buy cheaply from them to sell at higher prices to an informed clientele later on. Maisel found that such dealers varied in their approaches to this. Some disguised their intentions whilst others were open (Maisel, 1974: 497).

Catalogues and price guides

There are of course an ever-increasing number of catalogues and price guides for virtually anything that can be collected. There is a split in the collecting world as to the worth of such guides. Some strongly dislike price guides, blaming them for increasing the costs on markets and fairs:

> Kovel wants to put a book out on swizzle sticks. Of course that will kill the business. It'll make the prices sky high like antiques and everything else went. (Tuchman, 1994: 39)

Others see them as a bonus which enables them to know if they're being overcharged or finding a bargain on market stalls. On the positive side, price guides do provide a stable pricing system for collectable commodities; Stanley Gibbons (stamps) and Spink's (coins) are amongst the most respected price guides. It also makes it harder for the dealers such as Morgan to pull one over on the 'mug punter' when both dealer and buyer know the book price of an object (see Stoller, 1984: 93). However, one disadvantage is that when an acknowledged authority on a subject dominates the pricing in the guides, there is the potential for manipulation of the market. Stoller cites one example of a leading price-guide contributor in American baseball cards who regularly undervalues those he wishes to buy and overvalues those he wishes to sell (Stoller, 1984: 103, n. 8). In Britain, the book price for Robertson's Golly brooches in some price guides is so low that collectors do not take them seriously. Collectors have contributed their knowledge to the compilation of their own guide for Golly brooches, which gives information on all aspects of collecting them other than what

to pay (Dodds, 1994: 6–7). The demand for Golly brooches is now so widespread that there is a parallel market in reproductions (sold as such) and fakes of the older, rarer ones. Therefore they are on a par with more conventional collectable material which is more often faked, especially in the area of pottery or paintings. Ironically, the quality of many of the legitimate reproductions is far superior to the contemporary acrylic Gollies issued by Robertsons. Collectors set great store by the non-reproducibility of an 'authentic' collectable object. That is to say that if it is reproduced, it must be clearly marketed as a reproduction. This is usually the province of the heritage industry and National Trust shops.

Maisel concluded that the motivations of most flea-market traders was based on idealizations. Some lived in hope of a big find which would facilitate better things for them. Sociability was another motivation, where

> economic exchange is seen as incidental to social pleasantry. Buying is 'finding nice things', selling is performing 'a service' or 'sharing with others one's own pleasures'. (Maisel, 1974: 502)

Ultimately he concludes:

> It provides participants with a sense of risk, uncertainty, consequential chance and thus produces experiences usually absent in ordinary social life. (Maisel, 1974: 503)

If so, dealing (the pragmatic) and collecting (the romantic) have a shared hyper-reality, and both provide a form of escape from routine. It would, though, be equally true to argue that the boot sale, like collecting, offers an alternative society and more hope and optimism than the reality of day-to-day living.

Limited editions and orchestrated collectables

The attitudes towards limited editions, which were mentioned earlier in this chapter, divide into two schools of thought. One school derides them, including dealers (Morgan, 1993: 83) as much as collectors. The other school subscribes willingly to them, as was exemplified by collectors of McDonald's premiums in Chapter 6. Both Belk (1995: 57–9) and Olmsted (1991: 293) assert that such material as sold by the Franklin Mint or Bradford Exchange is not bought by 'real' collectors. In some ways this is true in that such material is not usually actively sought, but is instead provided. Full-page advertisements, usually in the colour supplements of the Sunday papers, seek to draw out the collecting instinct in the reader. They often operate on the notion that collecting is based on investment (hence the limited-edition nature of the objects) or serialization (collecting the set over a period). These are the hooks used for bait, together with rhapsodizing the intrinsic beauty of the piece and attention to detail, the dignity with which it is made. For example, one such advertisement, which appeared in *What's On TV* magazine (31 July 1993: 3) for a series of enamelled thimbles, had the following highlighted subheadings: 'rare museum pieces'; 'lavishly decorated'; '22-carat gold'; 'special collectors price'; 'free display cabinet'. The nature of the publications in which they are advertised (colour supplements, women's magazines) suggest a target audience comprised largely of the middle-aged and retired, with disposable income (there is a paper waiting to be written on the nature, impact and perceived clientele of these advertisements). Olmsted sees the collectors' initiation thus:

Recruitment to a specific collectors' world through collecting a specific class of object is associated with the collectors' perception of passion for the specific object. Sometimes entry is a change in perception: objects are acquired before they are seen as a collection. (Olmsted, 1991: 299).

The kind of material that manufacturers such as Royal Doulton and Royal Worcester promote can be read as an attempt to convince middle-class, middle-aged women that their family dinner service which was a wedding present, the decorative wall plaque or plate bought as a souvenir years ago, are actually collectable. They will, it is implied, be enhanced by additions to them from the manufacturer's 'collection'. In this sense, then, the existing decorative possessions in such houses are recommodified as collectables. The manufacturers seek to persuade the reader of the advertisement that what they have in their home is something other or more than they think it is, which should be added to. Therefore recommodification and hyper-reality are being transmitted psychologically at long distance. It should, however, be remembered that collectors of such items are numerous. Even if the decision to begin collecting is differently initiated, the objects still seem to offer the same parallel reality found in other material (see various articles in *Collect It!* magazine, No. 1, June/July–No. 6, December 1997). The case for the collectability of such objects is strongest in the form of contemporary decorative figurines. These, if made by reputable manufacturers like Doulton, can fetch great prices. Gwynn Jones, editor of *Collect It!* magazine, guesting on the business news programme, *Working Lunch*, advised would-be 'investors' to look for limited editions of 2000 or fewer, as they stood a better chance of holding their value (*Working Lunch*, 1997).

The example of the Swatch (i.e.'Substitute watch') utilizes a similar strategy. The brainchild of Nicholas Hayek, the Swatch is a cheap watch sold in a range of innovative plastic designs and commonly available. Some, though, are marketed as very limited editions and some are only sold in one country. Collectors can never tell which will be available where, and a number of very exclusive designs have been made for the famous which are numbered and consequently become valuable. One such example, in a limited edition of 120, sold for £13,200 at Christie's in 1989 (Windsor, 1994: 61). This could perhaps be usefully distinguished as commodity buying. That is to say, such items which come readily available through shops or mail order, masquerade as collectables. By utilizing the collectors' mind-set to make them attractive, by 'retiring' pieces to make them more desirable, but always ensuring a general supply, they impersonate a 'genuine' collectable.

The Collectable World Studios in Staffordshire make a whole range of character collectables. Small (and larger) pottery and metal figures are grouped together in series. Examples include Piggin (as 'Pig in clover'), a range of model humorous pigs; pocket dragons; Isis rising (a range of bronze fantasy figures); Wizards and dragons; and Land of legend. These ranges are split into three distinct international collectors' clubs: Pocket Dragons and Friends Collectors' Club; Land of Legend Fellowship; and Piggin Collectors' Club. These are initiated and run by the company itself. Sue Holmes, the manager of these various clubs, states their aims as follows:

> to provide as much information as possible to our members by way of magazines, catalogues, providing opportunities to meet the artists by touring both here and abroad, by enabling members to have a tour of the studios and also a freephone number which connects members directly to our three members of staff. (Sue Holmes, personal communication, 1994)

The company has 'in excess of 20,000 people on [their] mailing lists' which demonstrates the success of the captive-audience strategy. The drip-feeding of new additions to this kind of collectors' market indicates that there is a constituency of passive collectors as big as, if not bigger than, active ones. One school of collectors views this sort of activity as frippery and no more than a marketing ploy. 'Real' collectors, it is believed, only collect that which was not intended to be collected. The marketing of all sorts of commodities as collectables and limited editions successfully harnesses the fascination with collecting for commercial ends.

Collecting can be conditioned by difference (a teacher collecting guns) or sameness (a postal employee collecting stamps). These Olmsted defines as recuperative-compensatory leisure and role-determined leisure (Olmsted, 1991: 299, n. 9). Legitimate businesses which once distanced themselves from collectors have now targeted them as a lucrative market. Belk cites the example of the Post Office. The American and Canadian Post Offices initially made it illegal to buy and sell used stamps at more than face value (Belk, 1995: 55). Now, along with the British Post Office, they manufacture and aim products specifically for collectors, such as postcards of stamp designs. This is the kind of activity that has turned many collectors away from the hobby (such as Tony in Chapter 5).

Sizing up the punter

Morgan discusses at some length the 'sizing up' of a potential punter. There are no prices on the goods for sale. The price depends on the appearance, and verbal and body language, of the punter. If they look disguised (i.e. middle class dressing down to try and get a better price) he will usually spot it and charge twice as much (Morgan, 1993: 90–1). He employs psychology and lists a whole range of buying signs conveyed by body language from a punter (Morgan, 1993: 98–9). To get the best prices, presentation is important. Morgan warns against using vans to sell from: 'vans say "trade" which makes the punter wary' (Morgan, 1993: 13). Morgan's 'professional' advice is endorsed by an article on boot sales in a women's magazine, which warns readers to avoid 'Sellers with large vans or signs who are more likely to be traders' (Drummond, 1996: 150). Morgan further asserts that 'Joe Public in his quaint way likes to think he's dealing with an amateur, not with a pro trader unless he's selling new goods' (Morgan, 1993: 14). This is not just Morgan's bias. It is borne out by the American commentator on garage sales who found that 'There are too many of them, you don't find treasures anymore' (Hermann and Soiffer, 1984: 403). A Brighton car-boot buyer complained that car-boot sales are full of traders, not ordinary people with stuff from their attics (*Scrimpers*, 1994).

On a lower economic level yet, raiding dustbins, or 'bin diving' as Morgan calls it (or 'skip raiding') for thrown-away stuff, is also viewed positively. Morgan believes most people will not mind you doing this if you ask them first, because from an ecological point of view, people would be happier having their rubbish put to use than buried in a tip. One American, Ward Harrison, has turned this into an art form by raiding the rubbish bins of the famous in the Hollywood Hills (Mueller, 1993: 59–60). Even on the council tips there are the 'shitehawks', those who make a living from scavenging tips (Morgan, 1993: 39). It may be that the original owner of an

item will sell it second-hand or sell it in a boot sale. If thrown away, however, the netherworld of bin divers and tip scavengers takes over and recommodifies the secret life of the object! This is aided by the cash-economy nature of second-hand goods in most arenas. Morgan advises against taking cheques (or 'kites', as he calls them): 'NO NO NO. Not ever. Never!! At boots it's CASH ONLY. Even with a bankers card they can be dodgy' (Morgan, 1993: 62, original emphasis). In the informal economy, cash is king, largely due to the undeclared nature of the earnings made through such transactions. It should, though, be said that many traders in the author's experience are willing to accept cheques.

It is important to differentiate between those who attend as buyers or sellers on a casual basis (which may depend on the weather, or leisure activity options, etc.) and those who will always attend as a matter of routine. The latter category applies to Stebbins's serious leisure cadre, for whom the Sunday boot sale is a commitment, and therefore work-like. Vendors attend in the expectation of obtaining good prices for what they see largely as inexplicably desirable by the public, whilst buyers attend in anticipation of the bargain. The vendor (or those resembling Morgan) believes that there is always a mug punter willing to part with too much money for an item; the buyer believes that the vendor doesn't often know what they're selling and so prices can be haggled down. The air of expectation that applies at sales time in the high street shops applies permanently in the informal economy. There is also a love–hate relationship between collectors and dealers at all events, be they collectors' fairs or car-boot sales. The collector resents the dealer for owning what the collector wants, and being in the position to ask for their own price. The collector, though, also depends on the dealer to supply the goods, which they might otherwise not have been able to get, or may never have even known about. Therefore their relationship is at one and the same time oppositional and co-operative.

Collectors as dealers/dealers as collectors

In many cases collectors who develop a sophisticated knowledge of their subject, or who patronize a wide circle of dealers and collectors' fairs, become dealers, even if only part-time. This is a poacher-turned-gamekeeper syndrome. To some collectors the idea of dealing is obnoxious, as Christ reported in his study of elderly American stamp collectors:

> To me, stamp dealing never entered my mind. The way I saw it, you couldn't collect and deal at the same time, because then you had to think of your collection as so much 'merchandise'. I love stamps too much. (Christ, 1965: 99)

Conversely, another retired man, a lifelong stamp collector, saw his activities as an investment fund, which far outweighed the potential of pension plans. He held onto his stamp collection in the most adverse of economic circumstances, when he was laid off work. When he was working he put aside spare stamps with a rarity value as a nest-egg. He then began selling the reserve collection at stamp fairs and made enough money to have a good retirement: 'I got my own social security – you get what I mean?' (Christ, 1965: 107). In Britain, as state pensions become increasingly meagre and private pension plans are seen as being run by financial sharks, the use of judicious collecting may well come to be a legitimate long-term pension plan.

Auctions

Glancy (1988) and Danet and Katriel (1989), amongst others, conclude that collecting is about play. The auction, it is suggested, is a play-world setting for adults (Glancy, 1988: 135). The auctioneer is portrayed as a play leader who initiates the trance and encourages bidders to play his game (Glancy, 1988: 143–4). Ultimately, the auction is 'a display of work skill by the auctioneer who creates contests for non-serious use of money for tangible prizes that represent honourable achievement' (Glancy, 1988: 151). Belk concludes that auctions turn commodities into sacred collectables (Belk, 1995: 69). He gives four examples of excuses (he calls them sins) that collectors give for buying, which in an auction situation are no doubt heightened: (1) to blame the collecting instinct on human nature, to believe it is unavoidable; (2) to cite investment as a reason; (3) to call it a disease, which amounts to a denial of responsibility; (4) to portray oneself as a saviour of a lost, neglected or endangered object (Belk, 1995: 78–81). Pearce, meanwhile, surmises that it is competition which drives the adrenalin and is the same drive to head a queue for a village fête, as for an important auction sale (Pearce, 1992: 51).

An auction of collectables at Phillips in London (attended by the author, May 1994) tended to bear out some of these hypotheses. Unsuccessful bidders for lots either dismissed the price paid by the winner as excessive and thus exonerated themselves from not successfully bidding for the lot, or approached the successful bidder in an attempt to make a higher offer, or to purchase a part of the lot which they especially wanted. Those lots which remained unsold at the end of the auction were privately canvassed from the vendor by auction attenders, for an amount reasonably below the reserve price. This was portrayed as a subterfuge to get the lot cheaper, but was almost certainly not the case, despite the contrary beliefs engendered by such programmes as *Lovejoy* (BBC1). The purchasing of an unsold lot after the auction's finish was more to do with not wanting to come away empty-handed or disappointed. Even if part or the majority of the lot was unwanted, or would be used for exchange or resale rather than as an addition to the attender's own collection, approaches were made.

As discussed in Chapter 6, collectors' clubs can act as alternative communities and serve as a legitimizing structure. The publications, especially the club journals (see Appendix 3), are the material link between the members. The auction acts in the same way. Smith (1989) remarks that auctions legitimize acquisition, by showing that others were willing to pay almost as much for the item, whilst for sellers they serve to reassure that the item was sold at the highest price that the market would stand at that time (Smith, 1989: 90). A further organic link between auction practice and collectors' clubs is made, when Smith observes:

> When strong communities exist, the particular practice whatever it might be, is commonly accepted. When such communities do not exist, there is more concern with legitimating the practice. (Smith, 1989: 99)

In this respect, the inclusion of the profane (e.g. set sales and items for auction) is tolerated in the pages of the sacred (the collectors' club journals), if the vendor is a club member. The prices and practice are then considered 'legitimate' if proffered by one from amongst their community (see Appendix 3). Conversely, the pages of the collecting press are often scattered with scornful letters and comments about

'external' vendors (traders) at fairs and collectors' shops. They are sometimes perceived as outside of the community. Some collectors see them as hawks who target the 'legitimate' community as soft touches (Morgan, 1993, seems to justify their distrust). Others, though, strike up long-term relationships with dealers and facilitate many additions to the collection as a result.

Although Smith's is probably the most in-depth study of auctions from a sociological aspect, he does not make reference to postal auctions (he refers to 'sealed-bid' auctions, but these are more associated with business contracts). In this scenario, the items on offer are listed or photocopied and distributed to club members through the pages of the journal. Bids are invited, with a closing date, usually within two weeks of the journal's publication. Successful bidders are then notified by post. This differs markedly from other auctions, as neither the vendor nor vendee are present at the sale. This, interestingly, has more in common with the Internet and virtual communities than with conventional auctions. The (usually cheaply photocopied) image of the auction item invites curiosity and repeated examination in an attempt to give three dimensions in the mind's eye to the two-dimensional image, until such time as it might be 'won'. In this scenario, the object's poetic aura can be extended over a period of time, until the outcome of the bid is made known. In the author's experience, the postal auction is the type in which collectors of small, easily transportable items most often take part.

Market trading

Car-boot sales are not the only street-culture environments in which client–patron apprenticeships are served. Market pitching is another informal training in the art of commodity trading. One market trader, Mick Gill-Carson, who sells from Birmingham's Bullring market, has sought to professionalize his presentation to the public. He watches comedians on TV: 'I miss half the gags because I'm watching their delivery, how they get the audience back if they lose them' (*The Pitcher*, 1995). A 'system worker' has the same 'spiel' every day, Carson asserts: 'I'm not a system worker. I believe I can get people tightly packed in, relaxed, smiling. I can sell anything to them' (*The Pitcher*, 1995). He tries to buy cheaper than things are made for, such as end-of-line things that can be bought very cheaply, because money has already been made on the first three-quarters of the sale. He also buys large quantities of mail-order catalogue surplus material: 'My magic figures are 50p or £1. I mark up 25 per cent, but may only make ten pence on something. It keeps the punters happy, even if I have a bad week, and I'll hopefully get a better deal next week.' His favourite customers are middle-aged Afro-Caribbean women, because they have a good sense of humour, they like a laugh. He's now opened two shops called 'It's A Knockout'. His market call is: 'I'm the cheapest, I'm the best, buy from Mickey and f—— the rest' (*The Pitcher*, 1995).

Exchange

Bartering is normally associated with underdeveloped societies or with advanced ones whose economies have collapsed, such as Germany in the early 1920s. However, in late-twentieth-century Europe, exchange of collectable as well as everyday things has become a growth industry. Latterly, the rise of the number of free advertisement

Figure 8.1 Client–patron relationships

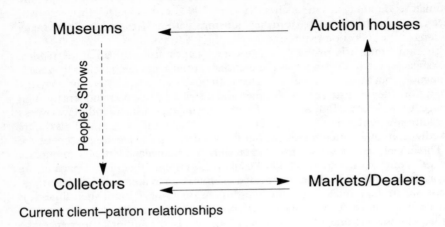

Current client–patron relationships

Potential client–patron relationships

papers has demonstrated the importance of bartering. The symbolic exchange value of the object often overrides any financial value (Baudrillard, 1975; 1981). To Debord this would represent the decontextualization of the object, implying: 'that which appears is good, that which is good appears' (Debord, 1983: 12), in which 'the concrete life of everyone has been degraded into a speculative universe' (Debord, 1983: 19). Classified advertisement papers are to the 1990s 'what car boot sales were to the eighties: popular marketplaces which somehow catch the enthusiasms of the moment' (Chesshyre, 1995: 5).

One of these papers, *Loot*, has now even sponsored a television series, Carlton Television's *The Exchange*. Here the practical needs or the hyper-real desires of the public were indulged on air via a huge database; people were matched who had offers and wanted items to exchange. In programme one (broadcast on 23 April 1995), a century-old French stove was exchanged for a top-loading pottery kiln; seven Doulton character jugs were exchanged for a long-case grandfather clock; a man with a reproduction nineteenth-century suit of armour sought an exchange for a rough-terrain pickup truck. The programme featured a 'profile' spot, in this case Andy Fleetwood, who had a large outdoor steam train layout he wanted to exchange for a working traction steamroller 'to play with'. The star exchange was someone wanting to part with a 1969 Rolls Royce for a Suzuki Vitaria automatic. The point here is that the items on offer or wanted were seen largely to have a material worth above their utilitarian one. No doubt economics played a large part, but the idea of exchanging exotic or esoteric objects rather than buying them seems to have an appeal which supersedes the purely financial one.

Conclusion

The museum professional may know full well what to look for in terms of fakes and reproductions within their own speciality, but they are not likely to be able to do so within the field of the popular collectable. It is necessary, therefore, to be able to call on expert advice. This advice would come largely from collectors and dealers who are used to seeing multitudes of the social historical material that museums still need, even if only for temporary exhibitions. The current communication arrangements are outlined in Figure 8.1(a) whilst a preferable arrangement is set out in Figure 8.1(b). Ultimately, museums must recognize and accept that the nature of the material that will represent mid- to late-twentieth-century society will not be quite the same as in previous generations. They, in tandem with collectors, are best placed to save the most representative collection possible, if they work together. Mass-produced items have been eagerly sought for design exhibitions and domestic-life displays by museums in the past. The contemporary nature of limited-edition culture in Britain has further stories to tell in a museum context. By the very nature of the ephemerality of the material involved in such a culture, it stands to reason that collectors are the obvious choice as a museum agency to obtain such material.

9 *Conclusion*

We have seen how, historically, collecting behaviour has been variously sanctioned and deplored at different times since the mid-nineteenth century. Women were 'permitted' to collect when it was seen as a harmless indulgence or pastime, but once such objects as they had collected showed signs of financial value, they were appropriated by men as business ventures. Women attempting to collect on the same terms as men (i.e. scientifically rather than decoratively) often protested that they were being marginalized by men's appropriation and control of the practice. As a more obscure example of yet another social sphere which men controlled, it fits well into the wider pattern of social convention of the period. This would explain why the blue china and its circle of women collectors of the late nineteenth century has remained more of a folk memory than an historical fact. Had it been deemed worthy of men's attention in the same way that stamps were, we should have heard a lot more about it. Certainly in 1920s and 1930s America, hobbies generally, as we have seen, were promoted as an alternative means of earning a living or in which to apply the work ethic.

Contemporary popular collecting has very strong surrogate work ethic traits, at least for men, who commodified it as such in the first place. For women, it seems more often to offer the means of building friendship networks and consolidating mutual support structures. For one hundred years or so, then, it would seem that popular collecting has been a material expression of socially approved gender roles. What is collected, the way it is collected, the subliminal implications it posits and the social attitude towards it, all suggest this. In contemporary terms, as our society has become increasingly refined and market-dominated so popular collecting has been used to reify this. Collecting is variously used to resist the intensity of the hard sell by the spectacle, as talisman or a means of self-assurance, as a vehicle for the reconstruction of identity and as a vessel for the safe-keeping of personal values. In short, it is proposed that popular collecting represents the externalization of the values, anxieties and enthusiasms of society at a given point in time.

The urge or instinct to collect is seemingly inherent in human nature but becomes activated in various ways. As was explored in Chapter 5, it can be something as basic as a pleasingly smooth stone or a small cache of broken coloured glass which catches our imagination at a point in time when we are preoccupied with changes in our lives and perceptions. What is being proposed is that we articulate our sense of right and wrong or our grievances through collecting objects, and that we use objects psychologically and culturally as a means of resistance to the imposition of wider social change on our personal lives. Objects, I feel, can also act as material protests or

talismans against perceived injustice or social demons that possess us in some way. Being inherent, collecting behaviour is prone to spontaneity in its expression. This is perhaps why it is so often attributed to serendipity. In consumer society, there are more potential triggers to initiate it; the variety of consumables enables us to create our own values and taxonomies for it. Fluctuations in the stability of social structures and the undermining of our confidence in ourselves are, I have suggested, now reflected through collecting behaviour. Self-defined taxonomy is subversive and an assertion of independence from the intention of the spectacle, resulting in the reinterpretation of objects in our own aesthetic likeness. A complete set of stamps from lowest to highest values exemplifies the engraver's art, but to include the one in which the monarch's head is printed invertedly is to deify the flaw, to subvert by valuing the rejected and to turn printer's waste into a priceless commodity.

The spectacle takes our anxiety about social and economic inclusion and commodifies it through limited editions. We are encouraged to feel apprehension about not being able to get such objects (cars, consumables and collectables) if we delay in ordering them. Increasingly, employment practice adopts the same traits, in that short-term and temporary contracts, cover periods for absentee employees, etc., all have a clearly limited time-span. In this sense, collecting can be seen as very much a behavioural trait of a wider cultural malaise. As jobs disappear, collecting seems to increase. Completing sets of collectables (whether marketed as such or self-defined) takes on a heightened sense of accomplishment in the absence of workplace achievement. To be 'part of' rather than 'excluded from' is a natural human instinct. Collecting helps us feel we belong. It variously helps us to feel civically reconnected in an age of social atomization or reassures us that we are fulfilling our modernist function as consumers.

That collecting is essentially a leisure pursuit has been axiomatic, probably for as long as collecting has existed. This should now be widened and deepened by a more sophisticated understanding of the complexities of collecting behaviour which hitherto has been attributed largely to psychological maladies. Stebbins's idea of serious leisure provides us with a useful cultural template. That collecting is as much about work as leisure is a concept now gaining more acceptance (Gelber, 1991; Gregson and Crewe, 1997; Chibnall, in preparation). If collections are a narrative (Bal, 1994), then the objects that comprise them are the vocabulary. To utilize or articulate this vocabulary, one has to become one with it. The objects become extensions of the self (Belk, 1988b; Lancaster and Foddy, 1988). The stories objects tell are largely reiterations of our own sentiments and values (Stewart, 1984; Gordon, 1986; Pearce, 1995). Through them, we strive to make subtle and sometimes grandiose statements which words do not empower us to make in everyday life. Objects liberate us from the inadequacies of verbal language and facilitate a parallel one. We survey the collection in the same way we might chant a mantra. Collections exercise a self-hypnosis on us and we psych ourselves up with them to face the world anew.

As conventional employment shrinks and centralized workplaces decline, new social arenas of interaction and competition, in which a newly re-articulated work ethic can be applied, begin to appear and multiply. Car-boot sales are perhaps the most common. They are events which mimic the corporate aspirations of the times. They are business arenas, with low overheads and a peripatetic structure, geared for maximum profit. They require an early start, typically by 7.00 a.m. for the vendor, and are therefore imbued with the rigidity of time-keeping of the factory clock. They

involve competition for both vendor and customer, which generates anticipation and excitement, elements missing from the low-paid and soulless service sector many now find themselves working in. They also require judgement and acumen in buying, pitching and selling, thereby incorporating management skills. Car-boot sales, collectors' fairs and flea-markets are also celebratory. Given that what they deal in is largely (though not exclusively) second-hand material, they can be read as arenas of recommodification in which objects can be salvaged and imbued with alternative meanings, hostile to the spectacle.

'Truth' or the 'real' are speculative. It depends on how one perceives things. The spectacle seeks to define itself as 'the truth'. Collecting (as resistance) seeks other truths and realities in the spectacle's projections and produce. This is often subversive (e.g. the collection of airline sick bags or pulp fiction). Placing value on the worthless is an act of independence from the spectacle's influence. By not identifying with the intended meaning of the spectacle's output, but subverting it or aspiring to control it, collecting can be perceived as a self-defensive process. In short, the spectacle disguises or conceals (i.e. recommodifies) meaning whilst collecting reveals (i.e. decommodifies) it. In furtherance of this, a game of cat-and-mouse ensues between the spectacle and collectors. As material with immediate commodity value becomes regarded as collectable by the public, so the spectacle seeks to appropriate the trend by re-marketing the commodity as a collectable rather than a gimmick. At the same time it does so, the commodity ceases to be desired by some collectors because of this appropriation, whilst others intensify their collecting activity for this very reason.

The aim of the spectacle is not to hypnotize the consumer with a dazzling array of new innovations, but rather to present the new or the wondrous as essential everyday conventions and accoutrements. These demand assimilation and commitment from consumers in order for them to know that they 'belong'. If people at any one time make a loud enough protest against this, the spectacle simply shifts to commodify the protesters' own social values. This is essentially how the corporate world was 'greened'. It is how financial institutions acquired consciences about ethical investment and how distaste for the material hedonism of the 1980s led to the marketing concept of the 'caring Nineties'. There is no altruism involved, just market response. It is therefore no surprise that for 18 years Conservative governments, which always denied the existence of society and which always advocated the abandonment of governmental responsibility of its citizens' best interests to the spectacle, should have sought to accommodate its every requirement. Collecting allows the individual to make choices over the collection's environment. It allows the collectors to see reflected what they most want to see in it. This is in contrast to the spectacle, which, like any monopoly, only concedes the illusion of choice.

Collectors may play along with the spectacle's recommodification of products (e.g. through infantilization). Like the collectors of model vehicle variations, however, it is often on the collectors' own terms. The intention (i.e. to sell limited editions) may be subverted. The provision and decision-making processes affecting the material collected can be ignored by the target group (the collectors). That which was never meant for them (e.g. pre-production models and production variations) become the desired. Tony (Chapter 5) illustrates this in his travelling to places where he was not supposed to be, in order to obtain material he was not supposed to have.

Given that most contemporary collectables are the products of mass production, collecting can be seen as a means of individualizing the uniformity of the

mass-produced. In a consumer society, we all look for ways to alleviate the routine of the functional. In collecting, a certain depth or another dimension is found. This is expressed through swap-meets, collectors' fairs, flea-markets, car-boot sales and auctions. Nowhere, however, is it more pronounced than in the collectors' club. Only here does the collector associate socially with others of like mind. At the club meeting, collectors can relax in their role and do not have to explain, justify or defend their interests. In the club, they are amongst a chosen few. Here, the indulgences of collecting can be admitted or revelled in, notes compared and commitments for future engagements made. In other scenarios, although collectors might gather en masse, such as at swap-meets, fairs and auctions, collectors are essentially competing for acquisitions. They are acting alone, even in a group. Within the club, they are part of a cadre with whom collecting can become a shared experience. Although men's collecting is competitive, the club more often acts as an arena for mutual showmanship. This is variously expressed by the displaying of collections; allowing access to unusual varieties of the collected object owned; benefiting other members with accrued knowledge; and seasoned collectors' displaying largesse in giving duplicates away or exchanging them on very favourable terms to lesser endowed collectors. This confers status and rank within the club and is also a competitive trait. Conversely, it can be read as a male-coded example of the friendship network paradigm, more common in women's social organization.

Since the mid-nineteenth century, the collecting of things has been associated either with education or with celebration. These idioms were re-exemplified in the People's Shows of the early 1990s. These collections, shown as spectacle, sit comfortably both in the tradition of the convention of museum display and in the wider sociological arena of consumer studies. The idea of collecting as a deeper, darker and more potent expression of disquiet has yet to be explored in a museological context. For it to be so would probably require a closer relationship with and a stronger trust of collectors. The museum's experience of the collector is largely positive, as Tables 7.1–7.3, 7.4–7.8 and 7.11–7.14 indicate. Lovatt's (1995) survey of museums participating in the *People's Show Festival* of 1994 also indicates this. A local register of collectors would be a good starting-point, based on the list of contributors to People's Shows. For museums without such initial resources to draw on, the template used by participating museums could be used to attract an initial collectors' group (through the use of local advertising). If such local registers were co-ordinated nationally through bodies such as the Museums Association and the various collectors' clubs (who could be encouraged to start an umbrella group), then a very valuable knowledge-sharing forum could be established. This does, however, require museums to treat collectors and their organizations seriously rather than parochially. As a result individual collectors would be recruited into collectors' clubs and museums would be better informed about specific ranges of material. Museums would have a ready resource on which to draw for exhibitions and for contextual research information. In forming a wider and stronger front with collectors, museums could also be widening their own support base at an institutional level and as lobbying bodies.

It seems increasingly likely that new alliances will be forged in the museum sector. In recent years, museums have increasingly had to find alternative sources of funding. The National Lottery, and European and business partnership funding account for an ever-growing share of museum income whilst core funding withers away. This has happened at a time when museums have been fundamentally questioning their

future role. Objects, if current trends are anything to go by, may cease to be central to the museum's purpose. Museums may become centres or spaces in which the collections are used as props or interior decoration for wooing corporate sponsorship (see Weeks, 1997: 26–9 for the Museum Association's ethical guidelines on this issue). In order to survive, the concern about funding may override museums' social provision role and render them little more than hospitality suites for local authority receptions and self-promotional exercises in order to attract publicity or investment. In such circumstances, collectors would be a natural ally for any professional counter-offensive.

The Internet poses an interesting pointer to the future. Its proponents cite its democratic nature, first, in its ability to make images of objects universally available, and second, through its role in bringing people together with similar material interests, so that they may more usefully pursue them (McGee Wood, 1997). Its detractors cite the failure of the present generation to engage socially or to seek 'real' experiences, instead preferring to absorb simulations of them (Zinberg, 1996). In practice, there is probably more symbiotic than oppositional credibility here. However, it remains to be seen to what extent digital imagery will displace the traditional object-centred display and how the coming of digital interactive television will deter engagement with the material environment. It remains a fact that the wealth of knowledge and contacts that collectors and their organizations have are a resource museums should be actively canvassing as a means of widening cultural access. As Tables 6.4–6.6 and 6.11–6.15 indicate, collectors' clubs are proactive and industrious in pursuit of their aims, which stand in contrast to the attitude of museums, who still seem to feel that the fact that they exist is advertisement enough to draw their requirements to them. If museums are (or should be) about telling stories, opening gateways to our past, they are also commentators on our present and our future. The story of our own *fin de siècle*, however, will need to be told if we are to understand the social, economic and technological changes in our society. As things currently are, museums are going to find it difficult to do this without assistance from outside agencies. If corporate partners are important for the financial survival of museums, then collectors' organizations are important as social partners for the survival of the museum's interpretive role. Collectors' sources should also become museum sources. If the current trend and interest in objects and collecting are subconsciously motivated by a millennial apprehension, it does not mean that this impetus should be lost when such concerns subside. Museums have started to tap the resource that this offers, and are thus presented with the opportunity to produce a positive outcome from a negative experience. It would be to everyone's loss if the opportunity was not built upon.

It is likely that the collecting behaviour of the late twentieth century will survive as an historical and social record. We have the benefits of television and video which Victorian collectors did not have. The reflections in these media of the contemporary fascination with collecting should in time come to be seen in context as an aspect of the social anxiety and insecurity felt by so many at the end of the twentieth century. To deepen such understanding, oral testimonies from collectors should be collected. Reflection and thought should be encouraged in collectors on their subliminal reasons for collecting, whilst museum initiatives, building on the work of the People's Shows, should be implemented. This might include the encouragement of collectors to consider and describe what it is like to be separated from their collections; what is the difference to them between before they collected and now that they have a

collection; what single object means the most to them and why. The utilization of their outcomes, findings and insights could hold great importance psychologically, sociologically and museologically. These could be used to open doors to other realities, values and concepts of belief that still require some cultural distance to be travelled before we are able to adequately comprehend them. What seems noticeable, though, is that the number of collectors is growing, the range of material collected is widening and the sophistication, knowledge and expertise of many collectors is increasing. Ultimately there may soon be a case for the assertion that to some extent at least, 'we are all curators now'. What the result of this will be for heritage and museum interpretation will be very interesting to see.

Appendix 1
Examples of questionnaires

Club questionnaire

1. Management

Has your club published a catalogue or list of all known examples of the items your members collect?

 Yes No Being considered

Are there any special materials used by club members for storage/display, or cleaning and maintaining their collections?

 Yes No

Has your club any affiliations with any other organisations?

 Yes No Being considered

How often does your club meet?

 Nationally_____per year Locally_____per year

What form do the club meetings predominantly take?

 Discussion of rules/constitution Swap-meetings Other

Any further comments on any of the above information

2. Museums

Has your club had any contact with museums?

Yes No Don't know

If Yes, was the experience: Satisfactory Unsatisfactory

What would be your response to the idea of training in object conservation for private collectors from museum staff?

Positive Indifferent Negative

What is your reaction to the idea of private collectors working more closely with museums?

Positive Indifferent Negative

What areas, if any, do you feel your club could be of service to museums?

What areas, if any, do you feel museums could be of service to your club?

Any further comments on any of the above information

3. Statistical Analysis

What are the percentages of male and female members in your club?

Male Female

What is the percentage of junior (under 16) members in your club?

%

What percentage of your members are also members of other collecting clubs that you know of?

%

How many members does your club currently have?

How many members would you expect to gain or lose in a year?

To your knowledge, how many corresponding secretaries has your club had since its initiation?

Any further comment on any of the above information

Museum questionnaire

Have you made use of private collectors/collections at all over the last decade in any capacity?

> If yes, in what capacity?

> How did you contact them?

> How do you rate their contribution?

> If no, have you ever considered using them?

How would you react to the idea of suitable collectors acting as 'foster keepers' as an alternative to de-accessioning an object or for freeing storage space for other objects?

> With alarm (why?)

> With reservations (why?)

> With enthusiasm (why?)

What is your reaction to the proposition that training in basic curatorial practice be provided for interested private collectors?

Has your museum sales point ever marketed any items with the collecting fraternity in mind?

> If yes, what?

> If no, has the idea ever arisen?

> If yes, why was it not implemented?

In what areas, if any, do you feel collecting clubs could be of service to museums?

In what areas, if any, do you feel your museum could be of service to collectors?

Appendix 2
Methodology

Questionnaire methodology

Questionnaires were sent to three groups of institutions: local authority museums, independent museums and collectors' clubs in 1994. Local authority and independent museums were treated separately in order to see how they differed from each other, especially as many independent museums are private collections given public access.

The purpose of the questionnaires was to evaluate attitudes of practising museum staff towards collectors, and collectors' clubs towards museums. The questionnaires were designed to incorporate both quantitative and qualitative information. This was necessary in order to sample professional attitudes of museum staff and collectors' club experiences with museums. Since museum staff were not only being asked for their personal opinions, but for the experiences of their institutions with collectors, it was only fair to compare like with like (as near as could be achieved) by sampling the experiences of collectors' institutions – their clubs.

The qualitative data has been organized and interpreted using cluster analysis. The percentage rates have been rounded down to the nearest whole percentage point. The discounted fractions amount in total within each table to between 1 and 6 per cent, with one at 8 per cent (Table 7.11, Independent museums). The higher range relates only where there are a high number of qualitative answers, often with only one answer applicable to the category. As one answer only equals a fraction of 1 per cent it has been discounted. The cluster groupings under which the answers have been arranged are necessarily subjective, but approximate as closely as possible to the original answers. In some cases, only one opinion has been given a certain point of view. While this could sometimes be more conveniently incorporated into a general answer cluster, it has sometimes been included in its own right in order to demonstrate the paucity of what might seem an obvious answer. For instance Table 7.13 asks collectors' clubs how they feel they could be of service to museums; only one answered 'publicity'. In other cases it is because the answer itself is unusual. Table 7.14 asks in what way collectors' clubs feel museums could be of service to them; one answered 'loans'.

The results have been listed in order of the greatest frequency of reply. This is exempted in Tables 6.1–6.3 because they deal with percentages according to numeric categories. The answers that were given to some questions were often multiple rather than single opinions. In order to represent as accurate an opinion as possible, the first opinion given by the respondent in the questionnaire was used, assuming this to be the most important or most obvious answer to the respondent. For instance,

Table 7.4 lists 'loans' as the primary capacity in which local authority museums have made use of collectors. Of the 196 replies, 107 (54 per cent) list loans as a sole use of collectors. However, 29 further respondents (14 per cent) listed loans plus other capacities of use. This is listed separately in order to illustrate the range of museum experience. Where 'scouts' occurs in the replies, this means the use of collectors as a means of searching for, and informing the museum of, finds of material on its wanted list.

There are questions which have elicited qualitative replies, but which have been arranged as quantitative data. For instance, Table 7.2 asks for local museum practitioners' responses to the idea of giving basic curatorial training to collectors. The questions allowed for 'positive', 'negative' and 'indifferent' responses, which have been used here quantitatively. Respondents did, however, on many occasions, give qualitative answers such as 'Fine, but who pays?' Rather than include these in the tables themselves and disrupt their uniformity, they have been mentioned in the discussion of the relevant questions.

Collectors and collecting methodology

For most of 1994, regular contact was maintained with two collectors' clubs in particular, which were followed as case studies. These were first, the United Kingdom Spoon Collectors' Club (UKSCC) and the Leicestershire Collectors' Club (LCC). The UKSCC was virtually an all-female organization. The half-yearly national conference held in Reading, Berkshire, was attended, as was a regional meeting in Wolverhampton. The methodology employed was participant observation and random sampling. The LCC was formed in October 1994 by a group of collectors who had exhibited at the Leicestershire People's Show that summer. They were 'co-ordinated' by Norman Rochester, a man in his fifties and one of the exhibitors who had a background in television and theatrical design. The methodology employed was again participant observation and random sampling at the club's monthly meetings, which were attended between October 1994 and August 1995. The results from the participant observation are spread throughout the book, but especially in Chapter 5.

The information on individual collectors referred to in the text has been derived from a variety of sources – reportage, television, radio, interview, conversation and participant observation. Other than Robert Opie, whose inclusion it was felt necessary to explain, the collectors below are those actually spoken to and observed. Those not cited in the public domain have been given pseudonyms. For references on the other collectors, see the references provided.

The sources for the individual collectors cited in Chapter 5 are as follows: Robert Opie is widely interviewed, and a thorough example is to be found in Elsner and Cardinal (1994a). This, along with a Sunday colour supplement article, formed the basis of the material used. Three collectors, Tony, Anita and Gloria, were all respondents to an open letter, similar to the one reproduced below, which appeared in *The Badger*, newsletter of the Badge Collectors' Circle, in January 1994. In Tony's case, he asked that he be provided with written questions on which information was requested. These were similar to those contained in the letter below. Thus, the source for Tony's information is oral testimony from an hour-long cassette tape. Anita and Gloria both wrote detailing their collecting interests and other information in a number of letters over the following few months.

Gregory is a personal friend, and he was asked questions during casual conversation which he was very willing to answer. Interestingly, he confessed that it was the first time he had talked about some things in many years and that he had never really thought about relating his collecting interests to the paucity of his childhood. Notes were taken both during and after our conversation. John was contacted because of the sheer enormity of his collection. He replied enclosing numerous local newspaper cuttings detailing his displays and accumulations, and seemed very happy and proud of his fame. He maintains contacts with spoon clubs around the world and initiates correspondence daily. A picture was built from his letter, the cuttings and conversations with other collectors who knew him. Jenny, Mark, Don, Helga and Joan were all speakers at (and members of) the LCC. Norman is the founder of the LCC and was very co-operative and always ready to talk and answer questions in person, by letter and over the phone. The information related in connection with their collecting was derived from participant observation. Vince was an exhibitor at the *Collectomania* exhibition in 1995. He was not originally a member of the LCC, but worked for the Guildhall where the exhibition was held. His collection of RAF uniforms was included as a consequence. Graham is also a member of the LCC and was interviewed at the *Collectomania* exhibition.

Dick, Andy and Malcolm are all dealers and traders on collectors' markets. Three consecutive Saturday mornings were spent in participant observation on their stalls in 1995. The information used is based on observation and conversation with them over this period.

A certain amount of personal correspondence with club members was entered into, often after a list of questions in the club's journal had been published. The correspondence was not to prove any particular point, but in order to elicit as many opinions as possible. The following example was published in *Spoonerama*, the journal of the UKSCC, in 1994. Enquiries to the clubs were usually met with enthusiasm and co-operation.

Spoon Fed?

Collectors, Museums and People's Shows

Hello and greetings to all spooners! My name is Paul Martin. I'm researching the extent and diversity of what people collect in Britain today which includes spoons of course. I am interested in the ways collectors' clubs such as the UKSCC can be of use to museums and vice versa. Collectors often have special and extensive knowledge of their chosen subject which museum staff do not and which could prove valuable to museums when they are formulating collecting and exhibition policy. Similarly, professional museum staff have training in areas such as conservation which could be of use to collectors. My aim is to bring museums and collectors (through their clubs) closer together.

The increasing demand on museum storage space and the squeeze on their funding by hard pressed local authorities means that acquisitions by museums are at an all-time low. It is my contention that interested collectors (there may be some amongst you who are active in museum friends groups?) could gain by a day or weekend course in basic curatorial practice. It would surely be useful for UKSCC members to know which museums hold collections of spoons and for museums to be able to make appeals for loans of specific types of spoons for temporary display or exhibition. These are areas where there needs to be more parity between museums and collectors.

One way in which this is beginning to happen is through the medium of the 'People's Show'. A People's Show is an exhibition of various collections belonging to private individuals displayed collectively in a museum. These were pioneered at Walsall Museum in 1990 and there is currently one at Manchester's Museum of Science and Industry. There is one planned for the Museum of London as part of which I will be conducting a talk on July 1st at 1.10pm in the museum entitled: 'I simply must have it: popular collecting and museums'. Anyone able to attend is most welcome.

I would be grateful to any members of the UKSCC who would be willing to answer a few questions for me which would help me with my research, as follows:

How long have you been collecting spoons and do you collect anything else (or have you in the past)?

Why do you collect?

Where would you like to see your collection ending up (e.g. in a museum, passed on through the family, etc.)?

What does being a member mean to you (and do you belong to any other clubs)?

Your co-operation would be very much appreciated and whilst on the subject of co-operation, I would like to take this opportunity to thank Mrs Lilian Edgar for all the help she has given me with my research so far. It has been invaluable. Finally, I intend to be present at the half-yearly meeting in Reading in May as an observer. I would very much value meeting and talking with UKSCC members at this time to discuss their interests and collections, etc. So hopefully I will see you there. Happy spooning!

The letter resulted in twenty useful replies, which have been drawn on and incorporated into Chapter 6. A similar letter was also published in *The Badger*, the newsletter of the Badge Collectors' Circle in January 1994 as noted above. The warmth of most of the responses and the enthusiasm of the respondents seem to support the assertion that the collectors' club serves as a surrogate family in many cases.

Appendix 3
Collectors' club journals, newsletters and magazines

In order to obtain an overview of collectors' club organization, requests were made to all collectors' clubs that could be identified for sample copies of their journal or newsletter. There were 46 replies. From these samples a larger picture was gained of collectors' club organization and concerns. The source of most of the contact addresses for these clubs can be found in Hoole (1992). There were also a number of additional clubs found in Henderson and Henderson (1994). Where the title of the publication is not necessarily indicative of the organization, the name of the publishing organization and, where necessary, a description of the subject collected, have been included.

The following periodicals published by collectors' clubs themselves were consulted for contextual analysis and comparison. It was partly from studying these journals that the concept of the club as an alternative society or environment evolved. The nature of the journals varies from duplicated news-sheet to the professionally or desktop published magazine. In general, half the contents comprise news on the availability of, and information on, new issues of the items collected, and auction and sales lists of objects under offer, usually from club members. In this sense there is an incorporation of a profane environment, but presumably because it emanates from the club membership it is regarded as legitimate. Seemingly, accepted and acknowledged prices are asked, rather than speculative ones. The other half of the contents usually comprise articles by and letters from the members on the objects collected. In this context, there is no mention of costs or accepted prices to be paid for the objects. There are common and accepted prices paid by collectors, even in the absence of price guides, but they are seldom mentioned within the journals; they are more often discussed at meetings.

The Badger (Badge Collectors' Circle)
Bearings (British Teddy Bear Association)
Beer Can News
Bill's Bulletin (International Bowls Badge Collectors' Club)
The Boutonneur (Buttonhook Society)
British Beer-mat Magazine
British Matchbox Label and Booklet Society Newsletter
Button Lines (British Button Society)
Cartophilic Notes and News (Cartophilic Society – trade card collectors)
The Cigarette Packet
Cirplan (Society of Cirplanologists – Methodist preachers' circuit routes)
C.J. Publications Catalogue of Reference Books and Comic Indexes (Association of Comic Enthusiasts)

Collectible World News
Collecting Now (Leicestershire Collectors' Club)
The Crested Circle (crested china)
Cricket Memorabilia Society Magazine
Egg Cup World (Egg Cup Collectors' Club of Great Britain)
The Finial (Silver Spoon Collectors' Club)
Association of Football League Badge Collectors' Badge Directory
Association of Football Statisticians Report
Goss and Crested China Club Monthly Catalogue
The Gosshawk (Goss Collectors' Club)
The Hornby Railway Collector
The Labologists' Society Newsletter (International Label Collectors' Society)
Land of Legend Chronicle (Collectible World Studios)
Letterbox Study Group Newsletter
Life's a Hoot (International Owl Collectors' Club)
Lledo Collector (Lledo Collectors' Club – model vehicles)
Mauchlineware Collectors' Club Newsletter
Mini-Bottle Starter Pack (Mini-Bottle Collectors' Club)
New Golly Collectors' Club
The Pewter Society Newsletter
Photographic Collectors' Compendium (Photographic Collectors' Club of Great Britain)
Piggin News (Collectible World Studios)
Plastics Historical Society Newsletter (monthly)
The Plastiquarian (Plastics Historical Society quarterly journal)
Pocket Dragon Gazette (Collectible World Studios)
Rugby League Collectors' Federation Member's Booklet and Catalogue
Spoonerama (United Kingdom Spoon Collectors' Club)
Thimble Society of London Magazine
Through the Green (British Golf Collectors' Society)
Tie-Tack Directory (Police Insignia Collectors' Association)
Trade Union Badge Collectors' Newsletter
Train Collectors' Society News
Transport Ticket Society Journal
Trix Twin Railway Collectors' Society Gazette
What's Bottling (Association of Bottled Beer Collectors)

Bibliography

Primary sources

Participant observation

The Art of the People (1994) Nottingham, Angel Row Gallery
Auction of contemporary collectables (1994) London, Phillips
Leicestershire Collectors' Club (1994–95)
People's Shows (1993–94)
United Kingdom Spoon Collectors' Club (1994–95)
Collectors' markets in Brighton and London (1995)

Research documents

Returned questionnaires from 128 collectors' clubs (1994)
Returned questionnaires from 196 local authority museums (1994)
Returned questionnaires from 126 private museums (1994)
Written correspondence with 40 curators of People's Shows (1994)
Written correspondence with members of 46 collectors' clubs as listed in Appendix 3
Personal communication with private collectors
Personal communication with museum curators (other than for People's Shows)

Secondary sources

Print

Achlen, U., Reichelt, M. and Schultz, R. (eds) (1986) *Mein Vaterland 1st international: internationale illustrierte Geschichte des 1 Mai 1886 bis heute*. Berlin: Asso Verlag
Alsop, J. (1982) *The Rare Art Traditions*. London: Thames & Hudson
Anderson, J. and Swinglehurst, E. (1981) *Train and Transport: A Collector's Guide*. London: New Cavendish
Appadurai, A. (1986a) 'Commodities And The Politics Of Values' in A. Appadurai (ed.) *The Social Life of Things: Commodities in Cultural Perspective*. Cambridge: Cambridge University Press, 3–30
Appadurai, A. (ed.) (1986b) *The Social Life of Things: Commodities in Cultural Perspective*. Cambridge: Cambridge University Press
Askegaard, S. and Fuat Firat, A. (1997) 'Towards a critique of material culture, consumption and markets' in S.M. Pearce (ed.) *Experiencing Material Culture in the Western World*. Leicester: Leicester University Press, 114–39

Assendorf, C. (1993) *Batteries of Life: On the History of Things and their Perception in Modernity*, trans. Don Reneau. Berkeley California: University of California Press

Atkinson, D. (1992) *The Purple, White and Green: Suffragettes in London 1906–1914*. London: Museum of London

Atkinson, D. (1996) '£100m sector feeds our past to the addicts', *Guardian*, 3 January, 11

Atkinson, D. (1997) 'Q: It began in the U.K. then the Americans bought up all the talent. What is it?', *Guardian (The Week)*, 8 March, 6

Baddiel, S. (1989) *Golf, the Golden Years: A Pictorial Anthology*. London: Studio Editions

Baddock, C. (1989) *Essential Freud*. Oxford: Blackwell, 65–103

Baekeland, F. (1981) 'Psychological aspects of art collecting', *Psychiatry*, 44, February, 45–59

Baglee, C. and Morley, A. (1988) *Street Jewellery*, 2nd edn. London: New Cavendish

Bailey, H. (1995a) 'The mini-museum campaign', *Treasure Hunting*, October, 45–7

Bailey, H. (1995b) 'The mini-museum campaign', *Treasure Hunting*, November, 16

Bailey, R. (1995) 'Ten toys for a desert island', *Classic Toys*, 2(8), November/December, 28–32

Bal, M. (1994) 'Telling objects: a narrative perspective on collecting' in J. Elsner and R. Cardinal (eds) *The Cultures of Collecting*. London: Reaktion, 97–115

Balldock, D. (1995) 'The trains on the dining room carpet', *Classic Toys*, November/December, 38–42

Banfield, E.C. (1982) 'Art versus collectibles: why museums should be filled with fakes', *Harpers*, 265, August, 28–34

Banks, O. (1985) *Biographical Dictionary of British Feminists, vol. I: 1800–1930*. Brighton: Harvester

Bar-Haim, G. (1987) 'The meaning of Western commercial artefacts for Eastern European youth', *Journal of Contemporary Ethnography*, 16, July, 205–26

Bar-Haim, G. (1988) 'Actions and heroes: the meaning of Western pop information for Eastern European youth', *British Journal of Sociology*, 40(1), 22–45

Barker, P. (1996) 'Living on the edge', *Guardian (G2)*, 8 October, 1–3

Barthes, R. (1972) *Mythologies* New York: Hill and Wang

Barthes, R. (1979) *The Eiffel Tower and Other Mythologies*, trans. R. Howard. New York: Hill and Wang

Baudrillard, J. (1975) *The Mirror of Production*. St Louis: Telos Press

Baudrillard, J. (1981) *For a Critique of the Political Economy of the Sign*. St Louis: Telos Press

Baudrillard, J. (1994) 'The systems of collecting' in J. Elsner and R. Cardinal (eds) *The Cultures of Collecting*. London: Reaktion, 7–24

Beard, M. and Henderson, J. (1994) 'Please don't touch the ceiling: the culture of appropriation' in S.M. Pearce (ed.) *The Appropriation of Culture*, vol.4, *New Research in Museum Studies*. London: Athlone Press, 5–42

Beckham, S. (1987) 'Death, resurrection and transformation: the religious folklore in Elvis Presley shrines and souvenirs', *International Folklore Review*, 5, 88–95

Belk, R.W. (1987) 'Identity and the relevance of market, personal and community objects' in J. Umiker-Sebeok (ed.) *Marketing and Semiotics: New Directions in the Study of Signs for Sale*. Berlin: Mouton de Gruyter, 151–64

Belk, R.W. (1988a) 'Collectors and collecting', *Advances in Consumer Research*, 15 University of Utah, 548–53

Belk, R.W. (1988b) 'Possessions and the extended self', *Journal of Consumer Research*, 15, 139–68

Belk, R.W. (1991a) 'The ineluctable mysteries of possessions' in F.W. Rudmin (ed.) *To Have Possessions: A Handbook of Ownership and Property*, special issue of *Journal of Social Behaviour and Personality*, 6(6)

Belk, R.W. (ed.) (1991b) *Highways and Buyways: Naturalistic Research from the Consumer Behaviour Odyssey*. Provo, UT: Association for Consumer Research

Belk, R.W. (1993) 'Materialism and the making of the modern American Christmas' in D. Miller (ed.) *Unwrapping Christmas*. Oxford: Clarendon, 74–104

Belk, R.W. (1995) *Collecting in a Consumer Society*. London: Routledge

Belk, R. and Coon, G.S. (1993) 'Gift giving as agapic love: an alternative to the exchange paradigm based on dating experiences', *Journal of Consumer Research*, 20(3), December, 393–417

Belk, R.W. and Wallendorf, M. (1990) 'The sacred meanings of money', *Journal of Economic Psychology*, 11, March, 36–67

Belk, R.W. and Wallendorf, M. (1994) 'Of mice and men: gender identity in collecting' in S.M. Pearce (ed.) *Interpreting Objects and Collections*. London: Routledge, 240–53

Benjamin, W. (1982a) 'Unpacking my library' in H. Arendt (ed.) and H. Zohn (trans.), *Illusions*. London: Fontana, 59–68

Benjamin, W. (1982b) 'The work of art in the age of mechanical reproduction' in H. Arendt (ed.) *Illusions*. London: Fontana, 219–53

Bennett, T. (1988) 'Museums and the people' in R. Lumley (ed.) *The Museum Time Machine*. London: Routledge, 63–86

Bennett, T. (1994) 'The exhibitionary complex' in N. Dirks, G. Eley and S. Ortner (eds) *Culture – Power – History*. Princeton, NJ: Princeton University Press

Berger, J. (1972) *Ways of Seeing*. London: Penguin

Berkun, S. (1994) 'Agent of change', *Wired*, Premiere UK edition, March, 70–1

Best, S. (1994) 'The commodification of reality and the reality of commodification: Baudrillard, Debord and postmodern theory' in D. Kellner (ed.) *Baudrillard: A Critical Reader*. Oxford: Blackwell, 41–67

Best of British (1995) 'I'm just an old fashioned boy', September/October, 8–9

Bewley, R. (1983) 'Forward: archaeology and the public' *Archaeological Review From Cambridge*, 2(1), Spring, 3–4

Bocock, R. (1986) *Hegemony*. Chichester: Ellis Horwood

Borg, A. (1991) 'Confronting disposal', *Museums Journal*, 91(9), September, 29–31

Boston, R. (1995) 'Allusions to grandeur', *Guardian (Weekend)*, 19 August, 34–7

Bowman, G. (1993) 'How I became a collector', *Cartophilic Notes and News*, 19(177), January/February, 4950

Bridges, W. (1995) *Jobshift: How to Prosper in a Workplace without Jobs*. London: Allen and Unwin

Briggs, A. (1990) *Victorian Things*, 2nd edn. London: Penguin

Briggs, A. and Snowman, D. (eds) (1997) *Fins de Siècle: How Centuries End, 1400–2000*. London: Yale University Press

Brook, G.L.(1980) *Books and Book Collecting*. London: Andre Deutsch

Bruce, S. (1988) *The Fifties and Sixties Lunch Box*. San Francisco: Chronicle

Brunel, C. and Jackson, P.M. (1966) 'Notes on tokens as a source of information on the history of the labour and radical movement Part One', *Journal of The Society For The Study of Labour History*, 13, Autumn, 26–36

Bryant, J. (1989) 'Stamp and coin collecting' in T. Inge (ed.) *Handbook of American Popular Culture*, 2nd edn, vol. 3. New York: Greenwood Press

Buck-Morss, S. (1989) *The Dialectics of Seeing: Walter Benjamin and the Arcades Project*. Cambridge, MA: MIT Press

Butlin's Loyalty Club Newsletter (1994) London, 4, 15

Butsch, R. (1984) 'The commodification of leisure: the case of the model airplane hobby and industry', *Qualitative Sociology*, 7, Fall, 217–35

Cabanne, P. (1963) *The Great Collectors*. London: Cassell

Campbell, C. (1996) 'The meaning of objects and the meaning of actions: a critical note on the sociology of consumption and theory of clothing', *Journal of Material Culture*, 1(1), March, 93–105

Campbell, C. (1997) 'The romantic ethic and the spirit of modern consumerism: reflections on the reception of a thesis concerning the origin of the continuing desire for goods' in S.M. Pearce (ed.) *Experiencing Material Culture in the Western World*. Leicester: Leicester University Press, 36–48

Campbell, T. (1989) *One Hundred Years of Women's Banners*. Wales: Campbell

Campbell, T. and Wilson, M. (1994) *Each for All And All for Each: A Celebration of Co-operative Banners*. Manchester: CWS Press

Campen, A.D. (1992) *The First Information War: The Story of Communication, Computers and Intelligence Systems in the Persian Gulf War*. Fairfax, VA: AFCEA International Press

Cardinal, R. (1994) 'Collecting and collage making: the case of Kurt Schwitters' in J. Elsner and R. Cardinal (eds) *The Cultures of Collecting*. London: Reaktion, 68–96

Carman, J. (1996) 'Unfolding museums: storylines for the future', *Museological Review*, 2(1), 1–8

Carnegie, E. (1994) 'Challenging taboos', *Museums Journal*, 94(8), August, 29

Carrington, L. (1995a) 'Buried treasure', *Museums Journal*, 95(9), September, 33–5

Carrington, L. (1995b) 'Power to the people', *Museums Journal*, 95(11), November, 21–4

Carrington, L. (1996a) 'Metal-detecting societies may take on archaeology recording role', *Museums Journal*, 96(4), April, 10

Carrington, L. (1996b) 'Here today, gone . . .', *Museums Journal*, 96(8), August, 25

Chesshyre, T. (1995) 'The hidden lives of classified advertisements', *Independent on Sunday*, 17 September, 4–7

Chibnall, S. (in preparation) *Material Possessions: Postmodernity and the New Collecting*

Christ, E.A. (1965) 'The retired stamp collector: economic and other functions of a systematized leisure activity' in A.R. Rose and W.A. Peterson (eds) *Older People and their Social World: The Subculture of Ageing*. Philadelphia: F.A. Davies

Clarke, D. (1968) *Analytical Archaeology*. London: Methuen

Classic Toys (1995) Collectable Collectors' Workbook (advertisement), November–December, 37

Clifton, R.T. (1970) *Barbs, Prangs, Points, Prickers and Stickers: A Complete and Illustrated Catalogue of Antique Barbed Wire*. Norman, OK: University of Oklahoma Press

Cole, B. and Durack, R. (1990) *Happy as a Sandboy: Early Railway Posters*. London: HMSO

Cole, B. and Durack, R. (1992) *Railway Posters 1923–1947*. London: Lawrence King

Collect It! (1997) 1, June/July–6, December, London

Connolly, J. (1994a) 'Zow-eee! Comic prices rocket', *The Sunday Times*, 30 July, 10

Connolly, J. (1994b) 'Mad about miniatures', *The Times*, 10 September, 15

Connolly, J. (1994c) 'Mr Opie's obsession', *Sunday Telegraph Magazine*, date indeterminable, 24–8

Constantine, S. (1986) 'Bringing the empire alive: the British Empire Marketing Board and imperial propaganda 1926–1933' in J.M. MacKenzie (ed.) *Imperialism and Popular Culture*. Manchester: Manchester University Press, 192–233

Cook, E. (1995) 'M.A. dilemma', *Museums Journal*, 95(11), November, 18

Cooper, E. (1994) *People's Art*. Edinburgh: Mainstream

Coren, G. (1994) 'Calling all phone card users', *The Times*, 8 July, 16

Council for British Archaeology (1993) *Metal Detecting*. Fact Sheet 2, York

Crook, R. (1993) 'Contemporary collecting' in D. Fleming *et al.* (eds) *Social History in Museums: A Handbook for Professionals*. London: HMSO, 269–75

Croydon Libraries, Museums and Arts (1992) *Development Plan for Croydon Museum Service*

Csikszentmihalyi, I.M. and Rochberg-Halton, E. (1981) *The Meaning of Things: Domestic Symbols of the Self*. Cambridge: Cambridge University Press

Cumming, L. (1997) 'Oils in troubled waters', *Guardian* (*G2*), 6 May, 8

Currie, B. (1931) *Fishers of Books*. Boston: Little Brown & Company

Danet, B. and Katriel, T. (1989) 'No two alike: play and aesthetics in collecting' in S.M. Pearce (ed.) *Interpreting Objects and Collections*. London: Routledge, 220–39. Originally published in *Play and Culture*, 2(3), 255–71

Danet, B. and Katriel, T. (1994) 'Glorious obsessions, passionate lovers and hidden treasures: collecting, metaphor and the romantic ethic' in S.H. Riggins (ed.) *The Socialness of Things: Essays on the Socio-semiotics of Objects*. Berlin: Mouton de Gruyter, 23–61

Dannef, T. (1994) 'A fine old Beano at a Dandy price', *Daily Telegraph (Weekend)*, 30 July, 4

Dannefer, D. (1980) 'Rationality and passion in private experience: modern consciousness and the world of old-car collectors', *Social Problems*, 27(4), April, 392–412

Dannefer, D. (1981) 'Neither socialization nor recruitment: the avocational careers of old-car enthusiasts', *Social Forces*, 60, December, 395–413

Davies, M. (1994) 'Chatterley Whitfield Auction', *Museums Journal*, 94(10), October, 19

Davies, M. (1995) 'Picasso to posing pouch', *Museums Journal*, 95(7), July, 20

Davies, M. (1996) 'Mission impossible', *Museums Journal*, 96(6), June, 38

Dearsley, K. (1995) 'Behind the scenes at Corgi Toys in Northampton', *Classic Toys*, 2(8), November/December, 44–6

Debord, G. (1967/1983) *Society of the Spectacle*. Detroit: Black and Red (2nd edn 1983)

Debord, G. (1979) *Comments on the Society of the Spectacle*. London: Cromos

Digger, J. (1995) The People's Show at Walsall. Unpublished MA thesis, Department of Museum Studies, University of Leicester

Dirks, N., Eley, G., and Ortner, S. (eds) (1994) *Culture – Power – History*. Princeton, NJ: Princeton University Press

Dittmar, H. (1991) 'Meanings of material possessions as reflections of identity' in F.W. Rudmin (ed.) *To Have Possessions: A Handbook of Ownership and Property*, special issue of the *Journal of Social Behaviour and Personality*, 6(6)

Dobinson, C. and Denison, S. (1995) *Metal Detecting and Archaeology in England*. London: Council for British Archaeology/English Heritage

Dodds, C. (1994) *Robertson's Golly Handbook*. Oxford: private publication

Dodds, C. (1995) 'Golly update', *The Badger*, 98, November, 6–7

Drummond, G. (1996) 'Make the most of car boot sales', *Prima*, April, 150

Duckers, N. (1991) 'Rebirth of cool', *Guardian*, 31 August, 14

Dunkley, H. (1995) 'Fast food toys', *Classic Toys*, 2(8), November/December, 60–1

Durost, W.N. (1932) *Children's Collecting Activity Related to Social Factors*. New York: Teachers College Press

Durr, A. (1988) *Popular Art: The Emblems and Associations of Mutual Aid*. Brighton: Brighton College of Art

Eco, U. (1987) *Travels in Hyperreality*. London: Picador

Edgar, K. (1995) The Society Dilettante and Social Collecting. Unpublished MA dissertation, Department of Museum Studies, University of Leicester

Edgar, K. (1997) 'Old masters and young mistresses: the collector in popular fiction' in S.M. Pearce (ed.) *Experiencing Material Culture in the Western World*. Leicester: Leicester University Press, 80–94

Edwards, N. (1995) 'Sleuths in Sauchiehall Street', *Museums Journal*, 95(11), November, 22

Ellen, R. (1988) 'Fetishism', *Man*, 23, June, 213–35

Elsner, J. (1994) 'A collectors' model of desire: the house and museum of Sir John Soane' in J. Elsner and R. Cardinal (eds) *The Cultures of Collecting*. London: Reaktion, 155–76

Elsner, J. and Cardinal, R. (1994a) 'Unless you do these crazy things: an interview with Robert Opie' in J. Elsner and R. Cardinal (eds) *The Cultures of Collecting*. London: Reaktion, 25–48

Elsner, J. and Cardinal, R. (eds) (1994b) *The Cultures of Collecting*. London: Reaktion

Emmanuel, V. (1995) The Replica and The 'Real Thing', How Do They Compare? Unpublished MA dissertation, Department of Museum Studies, University of Leicester

Evans, A. (1995) 'Pete's passion', *Classic Toys*, 2(8), November/December, 33–5

Eyeglass: Antiques and Collectables for Everyone (1997) 1(3), April

Fanelli, G. and Godoli, E. (1987) *Art Nouveau Postcards*. Oxford: Phaidon

Fardell, R. (1995) *From Australiana to World War Memorabilia: The People's Show Festival at Harborough Museum*. Unpublished MA thesis, Department of Museum Studies, Leicester University

Fearon, D. (1986) *Victorian Souvenir Medals*. Buckinghamshire: Shire Album No. 182

Fewins, C. (1994) 'Lofty lawyer put on the map', *The Times* (date indeterminable)

mass-produced. In a consumer society, we all look for ways to alleviate the routine of the functional. In collecting, a certain depth or another dimension is found. This is expressed through swap-meets, collectors' fairs, flea-markets, car-boot sales and auctions. Nowhere, however, is it more pronounced than in the collectors' club. Only here does the collector associate socially with others of like mind. At the club meeting, collectors can relax in their role and do not have to explain, justify or defend their interests. In the club, they are amongst a chosen few. Here, the indulgences of collecting can be admitted or revelled in, notes compared and commitments for future engagements made. In other scenarios, although collectors might gather en masse, such as at swap-meets, fairs and auctions, collectors are essentially competing for acquisitions. They are acting alone, even in a group. Within the club, they are part of a cadre with whom collecting can become a shared experience. Although men's collecting is competitive, the club more often acts as an arena for mutual showmanship. This is variously expressed by the displaying of collections; allowing access to unusual varieties of the collected object owned; benefiting other members with accrued knowledge; and seasoned collectors' displaying largesse in giving duplicates away or exchanging them on very favourable terms to lesser endowed collectors. This confers status and rank within the club and is also a competitive trait. Conversely, it can be read as a male-coded example of the friendship network paradigm, more common in women's social organization.

Since the mid-nineteenth century, the collecting of things has been associated either with education or with celebration. These idioms were re-exemplified in the People's Shows of the early 1990s. These collections, shown as spectacle, sit comfortably both in the tradition of the convention of museum display and in the wider sociological arena of consumer studies. The idea of collecting as a deeper, darker and more potent expression of disquiet has yet to be explored in a museological context. For it to be so would probably require a closer relationship with and a stronger trust of collectors. The museum's experience of the collector is largely positive, as Tables 7.1–7.3, 7.4–7.8 and 7.11–7.14 indicate. Lovatt's (1995) survey of museums participating in the *People's Show Festival* of 1994 also indicates this. A local register of collectors would be a good starting-point, based on the list of contributors to People's Shows. For museums without such initial resources to draw on, the template used by participating museums could be used to attract an initial collectors' group (through the use of local advertising). If such local registers were co-ordinated nationally through bodies such as the Museums Association and the various collectors' clubs (who could be encouraged to start an umbrella group), then a very valuable knowledge-sharing forum could be established. This does, however, require museums to treat collectors and their organizations seriously rather than parochially. As a result individual collectors would be recruited into collectors' clubs and museums would be better informed about specific ranges of material. Museums would have a ready resource on which to draw for exhibitions and for contextual research information. In forming a wider and stronger front with collectors, museums could also be widening their own support base at an institutional level and as lobbying bodies.

It seems increasingly likely that new alliances will be forged in the museum sector. In recent years, museums have increasingly had to find alternative sources of funding. The National Lottery, and European and business partnership funding account for an ever-growing share of museum income whilst core funding withers away. This has happened at a time when museums have been fundamentally questioning their

future role. Objects, if current trends are anything to go by, may cease to be central to the museum's purpose. Museums may become centres or spaces in which the collections are used as props or interior decoration for wooing corporate sponsorship (see Weeks, 1997: 26–9 for the Museum Association's ethical guidelines on this issue). In order to survive, the concern about funding may override museums' social provision role and render them little more than hospitality suites for local authority receptions and self-promotional exercises in order to attract publicity or investment. In such circumstances, collectors would be a natural ally for any professional counter-offensive.

The Internet poses an interesting pointer to the future. Its proponents cite its democratic nature, first, in its ability to make images of objects universally available, and second, through its role in bringing people together with similar material interests, so that they may more usefully pursue them (McGee Wood, 1997). Its detractors cite the failure of the present generation to engage socially or to seek 'real' experiences, instead preferring to absorb simulations of them (Zinberg, 1996). In practice, there is probably more symbiotic than oppositional credibility here. However, it remains to be seen to what extent digital imagery will displace the traditional object-centred display and how the coming of digital interactive television will deter engagement with the material environment. It remains a fact that the wealth of knowledge and contacts that collectors and their organizations have are a resource museums should be actively canvassing as a means of widening cultural access. As Tables 6.4–6.6 and 6.11–6.15 indicate, collectors' clubs are proactive and industrious in pursuit of their aims, which stand in contrast to the attitude of museums, who still seem to feel that the fact that they exist is advertisement enough to draw their requirements to them. If museums are (or should be) about telling stories, opening gateways to our past, they are also commentators on our present and our future. The story of our own *fin de siècle*, however, will need to be told if we are to understand the social, economic and technological changes in our society. As things currently are, museums are going to find it difficult to do this without assistance from outside agencies. If corporate partners are important for the financial survival of museums, then collectors' organizations are important as social partners for the survival of the museum's interpretative role. Collectors' sources should also become museum sources. If the current trend and interest in objects and collecting are subconsciously motivated by a millennial apprehension, it does not mean that this impetus should be lost when such concerns subside. Museums have started to tap the resource that this offers, and are thus presented with the opportunity to produce a positive outcome from a negative experience. It would be to everyone's loss if the opportunity was not built upon.

It is likely that the collecting behaviour of the late twentieth century will survive as an historical and social record. We have the benefits of television and video which Victorian collectors did not have. The reflections in these media of the contemporary fascination with collecting should in time come to be seen in context as an aspect of the social anxiety and insecurity felt by so many at the end of the twentieth century. To deepen such understanding, oral testimonies from collectors should be collected. Reflection and thought should be encouraged in collectors on their subliminal reasons for collecting, whilst museum initiatives, building on the work of the People's Shows, should be implemented. This might include the encouragement of collectors to consider and describe what it is like to be separated from their collections; what is the difference to them between before they collected and now that they have a

Fleming, D. (1997) 'The regeneration game', *Museums Journal*, 97(4), April, 32–3

Fleming, D., Paine, C. and Rhodes, J.G. (eds) (1993) *Social History in Museums: A Handbook for Professionals*. London: HMSO

Forman, J.R. (ed.) (1993) *What's What Circlewise*, Journal of the West Anglia Toy Train Circle, 11, Summer, 1

Forrester, J. (1994) '"Mille e tre": Freud and collecting' in J. Elsner and R. Cardinal (eds) *The Cultures of Collecting*. London: Reaktion, 224–53

Franklin, M.J. (1984) *British Biscuit Tins*. London: New Cavendish, published for the Victoria and Albert Museum

Freeman, S. (1995) 'Scraping the barrel', *Museums Journal*, 95(10), October, 18

Freyer-Burk, C. (1900) 'The collecting instinct', *Pedagogical Seminary*, 7(2), 179–207

Gates, B. (1995) 'The road ahead' (extracts), *Sunday Times News Review*, 19 November, 1–2

Geary, P. (1986) 'Sacred commodities: the circulation of medieval relics' in A. Appadurai (ed.) *The Social Life of Things: Commodities in Cultural Perspective*. Cambridge: Cambridge University Press, 169–91

Gell, A. (1996) 'Vogel's net: traps as artwork, artwork as traps', *Journal of Material Culture*, 1(1), March, 15–38

Gelber, S.M. (1991) 'A job you can't lose: work and hobbies in the great depression', *Journal of Social History*, 24, Summer, 741–66

Gelber, S. M. (1992) 'Free market metaphor: the historical dynamics of stamp collecting', *Comparative Studies In Society And History*, 34, October, 742–69

Gibson, W. (1984) *Neuromancer*. London: HarperCollins

Glancy, M. (1988) 'The play world setting of the auction', *Journal of Leisure Research*, 20(2), 135–53

Gordon, B. (1986) 'The souvenir: messenger of the extraordinary', *Journal of Popular Culture*, 20(3), 135–46

Gorman, J. (1972) *Banner Bright: An Illustrated History of Trade Union Banners*. London: Scorpion

Gorman, J. (1985) *Images of Labour: Selected Memorabilia from the National Museum of Labour History*. London: Scorpion

Gottdiener, M. (1994) 'The system of objects and the commodification of everyday life' in D. Kellner (ed.) *Baudrillard: A Critical Reader*. Oxford: Blackwell, 25–40

Grant, L. (1995) 'Just say No', *Guardian*, 3 June, 12

Grant, L. (1996) 'Gurus of the third wave', *Guardian* (*Weekend*), 13 January, 18–21

Green, D. (1995) 'Just kidding', *Guardian* (*Weekend*), 25 November, 10

Green, O. (1990) *Underground Art: London Transport Posters 1908 to the Present*. London: Studio Vista

Greenhalgh, P. (1988) *Ephemeral Vistas: The Expositions Universelles, Great Exhibitions and World's Fairs 1851–1939*. Manchester: Manchester University Press

Greenhalgh, P. (1989) 'Education, entertainment and politics: lessons from the great international exhibitions' in P. Vergo (ed.) *The New Museology*. London: Reaktion, 74–98

Gregory, T. (1983) 'The impact of metal detecting on archaeology and the public', *Archaeological Review From Cambridge*, 2(1), Spring, 5–8

Gregson, N. and Crewe, L. (1994) 'Beyond the high street and the mall: car boot fairs and the new geographies of consumption in the 1990's', *Area*, 26, 261–7

Gregson, N. and Crewe, L. (1997) 'The bargain, the knowledge and the spectacle: making sense of consumption in the space of the car boot sale', *Environment and Planning D: Social Space*, 15, 87–112

Gregson, N., Crewe, L. and Longstaff, B. (1997) 'Excluded spaces of regulation: car boot sales as an enterprise culture out of control?', *Environment and Planning A*, forthcoming

Grice, E. (1995) 'Downfall of a family man: how one man's passion for beer labels led him to jail', *Sunday Telegraph Magazine*, 17 August, 22–6

Guardian (1990) 'Collectors' tickets to ride into the past', 19 February, 4

Guardian (1994) '£12,650 toy', 15 October, 5

H. D. (1995) 'Merchants of cyberspace: electronic shopping', *The Sunday Times*, 19 November, 3

Hammond, J. (1995) *Trade Union Badges*. Worthing: private publication

Hammond, P. (1988) *French Undressing: Naughty Postcards from 1900–1920*, 2nd edn. London: Bloomsbury

Hardman, D. (1981) *The History of the Holiday Fellowship, vol. 1: 1913–1940*. London: Holiday Fellowship

Harris, N. (1994) 'A poor head of steam', *Museums Journal*, 94(2), February, 52

Harrison, B. (1987) *Prudent Revolutionaries: Portraits of British Feminists Between The Wars*. Oxford: Clarendon Press

Harrison, M. (1995) *Visions of Heaven and Hell: Will Technology Deliver us a Bright New Future?* London: Channel 4 TV Publications

Henderson, S.P.A. and Henderson, A.J.W. (eds) (1994) *The Directory of British Associations and Associations in Ireland*, Edition 12: *1994–5*. Kent: CBD Research Ltd

Hermann, G.R. and Soiffer, S.M. (1984) 'For fun and profit: an analysis of the American garage sale', *Urban Life*, 12(4), January, 397–421

Herron, C. (1992) 'Cash in on new rave craze', *Brighton and Hove Leader*, 3 September

Hetherington, P. (1997) 'Beach gems power revival of jet age in Whitby', *Guardian*, 5 April, 12

Hewison, R. (1987) *The Heritage Industry: Britain in a Climate of Decline*. London: Methuen

Hides, S. (1997) 'The genealogy of material culture and cultural identity' in S.M. Pearce (ed.) *Experiencing Material Culture in the Western World*. Leicester: Leicester University Press, 11–35

Hillier, B. (1981) 'Why do we collect antiques?' in D. Lowenthal and M. Binney (eds) *Our Past Before Us Why Do We Save It?* London: Temple Smith, 70–82

Hobsbawm, E.J. (1964) *Labouring Men: Studies in the History of Labour*. London: Weidenfeld and Nicolson

Hobsbawm, E.J. (1984a) *Worlds of Labour*. London: Weidenfeld and Nicolson

Hobsbawm, E.J. (1984b) 'The transformation of labour rituals' in *Worlds of Labour*. London: Weidenfeld and Nicolson, 66–82

Hodder, I. (1987a) *Archaeology of Contextual Meanings*. Cambridge: Cambridge University Press

Hodder, I. (1987b) 'The contextual analysis of symbolic meanings' in *Archaeology of Contextual Meanings*, Cambridge: Cambridge University Press, 1

Hodder, I. (ed.) (1989) *The Meaning of Things*. London: Unwin-Hyman

Hoole, L. (1992) *Hoole's Guide to British Collecting Clubs*. Bradford: Adwalton

Holbrook, M. (1993) 'Nostalgia and consumption preferences: some emerging patterns of consumer tastes', *Journal of Consumer Research*, 20, September, 245–56

Howell, S. (1974) *The Seaside*. London: Macmillan

Hull, K. (1994) 'A way through the fog', *Museums Journal*, 94(8), August, 25–6

Hurst, R.M (1981) 'Impossible or improbable?: popular culture in a regional historical society' in F.E.H. Schroeder (ed.) *Popular Culture in Museums and Libraries*. Ohio: Bowling Green University Press

Hutton, W. (1995) *The State We're In*. London: Jonathan Cape

Independent on Sunday (1992) 'Sony's footwear posters do a walk', 30 August, 8

Inge, T. (ed.) (1989) *Handbook of American Popular Culture*, 2nd edn, vol. III. New York: Greenwood Press

Irwin, R. (1997) 'Muslim responses to the crusade', *History Today*, 47(4), April, 43–9

Jarvis, S. (1994) 'Macho man in miniature', *The Times*, 17 September

Jarvis, S. (1995) 'Always judge a book by the cover', *The Times*, 3 June, 10

Joline, A.H. (1902) *Meditations of an Autograph Collector*. New York: Harper and Brothers

Jubb, M. (1984) *Cocoa and Corsets*. London: HMSO

Katz, I. (1996) 'Trail of cyber-sex, lies and floppy discs ends in divorce court', *Guardian*, 3 February, 3

Katz, J. (1995) 'The age of Paine', *Wired*, Premiere UK edition, March, 64–9

Keene, S. (1994) 'Less Is More', *Museums Journal*, 94(11), November, 34–7

Kellner, D. (ed.) (1994) *Baudrillard: A Critical Reader*. Oxford: Blackwell

Kellner, D. (1995) *Media Culture: Cultural Studies, Identity and Politics between the Modern and Postmodern*. London: Routledge

Kenyon, J. (1992) *Collecting for the 21st Century: A Survey of Social History Collections in the Museums of Yorkshire and Humberside*. Yorkshire and Humberside Museums Council

King, E. (1985) 'The cream of the dross: saving Glasgow's present for the future', *Social History Curator's Journal*, 13, 4–11

Kroker, A. and Cook, D. (1986) *The Postmodern Scene*. New York: St Martin's Press

Labour (1937) 'The unorganised are now organised: Will Sherwood looks back over forty years of trade union service', September, 18

Lacey, B. (1994) 'Conflicting opinions', *Museums Journal*, 94(8), August, 28

Laing, D. (1985) *One Chord Wonders: Power and Meaning in Punk Rock*. Milton Keynes: Open University Press

Lajus, S. (1996) 'Debord en situation' *Télé Obs*, 140, 4 May, *Supplément A Detacher Le Nouvel Observateur*, 59

Lancaster, S. and Foddy, M. (1988) 'Self extensions: a conceptualization', *Journal for the Theory of Social Behaviour*, 18 January, 77–94

Landesman, C. (1995) 'Kitsch coup', *The Sunday Times*, 19 November

Lasch, C. (1995) *The Revolt of the Elites and the Betrayal of Democracy*. New York: Norton

Laybourne, S. (1994) 'Lost in time', *Sunday Telegraph*, 31 July, 15

Leeson, R.A. (1971) *United We Stand: An Illustrated Account of Trade Union Emblems*. Bath: Adams and Dart

Leicester Mercury (1993) 'Extra staff to deal with rush', 3 December

Lewery, T. (1986) *Gold Silk and Painted Scripture: The Art and Tradition of the Church Banner*. Cheshire Libraries and Museums

Liverpool Libraries (1971) 'The blue china craze', *Museum Piece*

Losonsky, T. and Losonsky, J. (1995) *McDonald's Happy Meals Toys around the World: A Schiffer Book for Collectors with Prices*. San Francisco: Schiffer

Lovatt, J.R. (1995) The People's Show Festival 1994. MA thesis, Department of Museum Studies, University of Leicester. Subsequently published in S.M. Pearce (ed.) *Experiencing Material Culture in the Western World*. Leicester: Leicester University Press, 196–254

Lovell, J. (1969) *Stevadores and Dockers*. London: Macmillan

Lowenthal, D. and Binney, M. (eds) (1981) *Our Past Before Us Why Do We Save It?* London: Temple Smith

Lumley, R. (ed.) (1988) *The Museum Time Machine*. London: Routledge

MacDonald, I. (1989) *Vindication: A Postcard History of the Women's Movement*. London: Bellew

MacDonald, I. (1994b) 'Postcards and politics', *History Today*, 44(1), January, 5–9

MacKenzie, J.M. (1984) *Propaganda and Empire: The Manipulation of British Public Opinion 1880–1960*. Manchester: Manchester University Press

MacKenzie, J.M. (ed.) (1986) *Imperialism and Popular Culture*. Manchester: Manchester University Press

McCann Mathew Millman (1993) *Equal Opportunities Awareness Study: Conclusions and Recommendations*. London: Museums Association

McCree, C. (1984) 'Flea markets', *Psychology Today*, 18(3), 46–53

McGee Wood, M. (1997) 'Virtual worlds, material worlds: the internet, language and reality' in S.M. Pearce (ed.) *Experiencing Material Culture in the Western World*. Leicester: Leicester University Press, 65–79

McGrandle, P. (1994) 'Fine carriages fit for little kings', *The Times*, 24 December, 16

McKenna, P. (1996) *Nightshift*. Argyll: S.T. Publishing

Maisel, R. (1974) 'The flea market as an action scene', *Urban Life and Culture*, 2(4), January, 488–505

Marquis, A.G. (1991) *The Art Biz: The Covert World of Collectors, Dealers, Auction Houses, Museums and Critics*. Chicago: Contemporary Books

Mason, R. (1994) 'Steam buff's rail against Cosson's attack', *Museums Journal*, 94(1), January, 14

Mason, R. (1996) 'A load of old balls', *Museums Journal*, 96(6), June, 21–3

Mason, R.S. (1981) *Conspicuous Consumption: A Study of Exceptional Consumer Behaviour*. Hampshire: Gower

Mayo, E. (ed.) (1984) *American Material Culture: The Shape of Things Around Us*. Ohio: Bowling Green State University Popular Press

Meglaughlin, J. (1990) *British Nursing Badges, vol. I: An Illustrated Handbook*. London: Vade Mecum

Mellor, J.M. (1988) 'Introducing badge collecting', *Antique and Collectors' Fayre*, January, 18–19

Merriman, N. (1991) *Beyond the Glass Case: The Past, the Public and the Heritage in Britain*. Leicester: Leicester University Press

Merriman, N. (1995) 'Licence to lark', *Museums Journal*, 95(9), September, 35

Millard, A. (1995) *America On Record: A History of Recorded Sound*. Cambridge: Cambridge University Press, 211

Miller, D. (1987) *Material Culture and Mass Consumption*. Oxford: Blackwell

Miller, D. (ed.) (1993) *Unwrapping Christmas*. Oxford: Clarendon Press

Miller, D. (1994) 'Things ain't what they used to be' in S.M. Pearce (ed.) *Interpreting Objects and Collections*. London: Routledge, 13–18. Originally in *Royal Anthropological Institute News (RAIN)*, 59, December 1983, 5–7

Miller, D. (1995a) 'Consumption as the vanguard of history' in D. Miller (ed.) *Acknowledging Consumption*. London: Routledge, 1–57

Miller, D. (ed.) (1995b) *Acknowledging Consumption*. London: Routledge

Miller, M. (1981) *The Bon Marché: Bourgeois Culture and the Department Store 1869–1920*. Princeton, NJ: Princeton University Press

Miller, S. (1997) 'Antiques market turns to denim', *Guardian*, 28 January, 5

Mills, J. (1997) *Doing Their Bit: Home Front Lapel Badges 1939–1945*. Kent: Wardens

Model Collector (1995) 9(11), November

Moeran, B. and Skov, L. (1993) 'Cinderella Christmas: Kitsch, Consumerism and Youth in Japan' in D. Miller (ed.) *Unwrapping Christmas*. Oxford: Clarendon Press, 105–133

Moore, K. (1994) 'Labour history in museums: development and direction' in S.M. Pearce (ed.) *The Appropriation of Culture*, vol. 4: *New Research in Museum Studies*. London: Athlone Press

Moore, K. (1997) *Museums and Popular Culture*. Leicester: Leicester University Press

Moore, K. and Tucker, D. (1994) 'Back to basics', *Museums Journal*, 94(7), July, 22

Morgan, R. (1993) *£500 a Week from Car Boot Sales*. London: Imperia

Morris, J. (1989) *Riding the Skies: Classic Posters from the Golden Age of Flying*. London: Bloomsbury

Moskoff, W. (1990) 'The undiminished magic of collecting stamps', *Chronicle of Higher Education*, 36 (25 July), B36

Moulin, R. (1987) *The French Art Market: A Sociological View*, trans. Arthur Goldhammer. New Jersey: Rutgers University

Moyes, W.A. (1974) *The Banner Book: A Study of the Banners of Lodges of the Durham Miners Association*. Newcastle-Upon-Tyne: Frank Graham

Mueller, M. (1993) 'Ward Harrison celebrity scavenger', *Empire*, November, 59–60

Muensterberger, W. (1994) *Collecting, an Unruly Passion*. Princeton, NJ: Princeton University Press

Mullen, C. (1979) *Cigarette Pack Art*. London: Hamlyn

Mullen, C. (1991) 'The People's Show', *Visual Sociology Review*, 6(1), Summer, 47–9

Museum Piece (1971) 'The blue china craze', Liverpool Libraries (1)

Museums Association (1995) *Code of Conduct*. London

Muthesius, S. (1988) 'Why do we buy old furniture? Aspects of the authentic antique in Britain 1870–1910', *Art History*, 11, June, 231–54

Nataraajan, R. and Goff, B.R. (1991) 'Compulsive buying' in F.W. Rudmin (ed.) *To Have Possessions: A Handbook of Ownership and Property*, special issue of the *Journal of Social Behaviour and Personality*, 6(6), 307–28

National Council for Metal Detecting (1992) *A Shared Heritage*, Newbury, Berks

Newark, M. and Gibson, S. (1976) *Something to Collect*. London: Pelham

O'Kelly, A. (1994) 'I love playing with my toys', *Sunday Post Magazine*, 3 April, 46

Olmsted, A.D. (1988) 'Morally controversial leisure: the social world of gun collectors', *Symbiotic Interaction*, 11, 277–87

Olmsted, A.D. (1989) 'Gun ownership as serious leisure' in R. Tonso (ed.) *Gun Culture and its Enemies*. Columbus, OH: Merill

Olmsted, A.D. (1991) 'Collecting: leisure, investment or obsession?' in F.W. Rudmin (ed.) *To Have Possessions: A Handbook of Ownership and Property*. special issue of the *Journal of Social Behaviour and Personality*, 6(6), 287–305

Opie, R. (1985) *Rule Britannia: Trading on the British Image*. Harmondsworth: Viking

Opie, R. (1987) *The Art of the Label*. New Jersey: Chartwell

Opie, R. (1988) *Sweet Memories*. London: Pavilion

Orr, D.G. and Ohno, R. (1981) 'The material culture of protest: a case study in contemporary collecting' in F.E.H. Schroeder (ed.) *Popular Culture in Museums and Libraries*. Ohio: Bowling Green University Press, 39–51

Painter, C. (1996) *At Home with Constable's Cornfield*. London: National Gallery

Paton, W.D.M. (1988) 'Bibliomania: a clinical case study, or forty years of messing around with books', *Book Collector*, 37, Summer, 207–24

Pearce, S.M. (1992) *Museums, Objects and Collections: A Cultural Study*. Leicester: Leicester University Press

Pearce, S.M. (1993) 'Making up is hard to do', *Museums Journal*, 93(12), December, 25–7

Pearce, S.M. (ed.) (1994a) *Interpreting Objects and Collections*. London: Routledge

Pearce, S.M. (ed.) (1994b) *The Appropriation of Culture*, vol. 4: *New Research in Museum Studies*. London: Athlone Press

Pearce, S.M. (1995) *On Collecting: An Investigation into Collecting in the European Tradition*. London: Routledge

Pearce, S.M. (ed.) (1997) *Experiencing Material Culture in the Western World*. Leicester: Leicester University Press

Pearce, S.M. (1998), *Collecting in Contemporary Practice*. London: Sage

Pelling, H. (1963) *A Short History of Trade Unionism*. London: Penguin

Pilkington, E. (1996) 'Working backwards', *Guardian*, 3 February, 23

Pine, N. (1986) *Goss and Other Crested China*. Buckinghamshire: Shire Album No.120

Pomian, K. (1990) *Collectors and Curiosities*. Oxford: Polity Press

Quinn, S. (1996) 'Hold the fries, it's seconds out as supermodels face "Rocky" Stallone in fast food battle', *Guardian*, 7 May, 4

Radio Times (1996) 'False economy', 4 June, 81

Raffaell, M. (1994) 'History consigned to the dustbin', *Daily Telegraph (Review)*, 20 June, 17

Rayner, J. (1993) 'The Home Guard has suburb up in arms', *Guardian (Outlook)*, 11 December

Rheims, M. (1961) *The Strange Life of Objects: 35 Centuries of Art Collecting and Collectors*, trans. David Pryce-Jones. New York: Athenium

Rheims, M. (1975) *The Glorious Obsession*. New York: St Martin's Press

Rhys, J. (1970) 'Illusion' in *The Left Bank and Other Stories*. New York: Books For Libraries Press, 29–36

Richards, T. (1991) *The Commodity Culture of Victorian England*. London: Verso

Richardson, R. and Marshall-Jones, M. (1997) 'McDonald's monthly', *Collect It!*, 6, December, 64–5

Rigby, D. and Rigby, E. (1944) *Lock, Stock and Barrel: The Story of Collecting*. Philadelphia: J.B. Lippincott

Riggins, S.H. (ed.) (1994) *The Socialness of Things: Essays on the Socio-semiotics of Objects*. Berlin: Mouton de Gruyter

Roberts, A. (1993) 'Historians agog over can labels', *The Times*, 27 May, 3

Rogan, J. (1988) *Starmakers and Svengalis: The History of British Pop Management*. London: Futura

Rose, A.R. and Peterson, W.A. (eds) (1965) *Older People and their Social World: The Subculture of Ageing*. Philadelphia: F.A. Davies

Rose, S. (1994) 'Bob Monkhouse, film collector', *Empire*, January, 40

Rudkin, O.D. (1927) *Thomas Spence and His Connections*. London: George Allen and Unwin

Rudmin, F.W. (ed.) (1991) *To Have Possessions: A Handbook on Ownership and Property*, special issue of *Journal of Social Behaviour and Personality*, 6(6)

Rush, P. (1997) 'Rupert . . . Rupert the Bear, everyone loves him!', *Collect It!*, 6, December, 8–10

Samuel, R. (1995) *Theatres of Memory*, vol. I: *Past and Present in Contemporary Culture*. London: Verso

Savage, J. (1992) *England's Dreaming: The Sex Pistols and Punk Rock*. London: Verso

Sawchuck, K. (1994) 'Semiotics, cybernetics and the ecstasy of marketing communication' in D. Kellner (ed.) *Baudrillard: A Critical Reader*. Oxford: Blackwell, 89–118

Schiffer Publications (1993) *Schiffer Publications Catalog of Books*, Fall, San Francisco

Schor, N. (1994) 'Collecting Paris' in J. Elsner and R. Cardinal (eds) *The Cultures of Collecting*. London: Reaktion, 252–74

Schroeder, F.E.H. (1981a) 'How to acquire, accession, catalog and research a popular culture collection for your museum of history, technology or art for $97 per year' in F.E.H. Schroeder (ed.) *Popular Culture in Museums and Libraries*. Ohio: Bowling Green University Press, 76–83

Schroeder, F.E.H. (ed.) (1981b) *Popular Culture in Museums and Libraries*. Ohio: Bowling Green University Press

Scott, A. (1994) 'Lines of research' (Letters page), *Museums Journal*, 94(2), February, 52–3

Seaton, B. (1986) *Justice for Mineworkers Badge Collector's Guide*. Nottingham: private publication

Senelick, L. (1975) 'Politics as entertainment: Victorian music hall songs', *Victorian Studies*, December, 149–81

Setchfield, F.R. (1986) *The Official Badge Collectors' Guide: From the 1890's to the 1980's*. London: Longman

Shanks, M. (1992) 'Craft' in *Experiencing the Past*. London: Routledge, 167–70

Sherry, J. (1990) 'A sociocultural analysis of a midwestern American flea market', *Journal of Consumer Research*, 17, 13–30

Shwartau, W. (1994) *Information Warfare: Chaos on the Electronic Super Highway*. New York: Thunder's Mouth Press

Sibley, B. (1985) *Guinness Advertising*. Harmondsworth: Guinness Superlatives

Simpson, R. (1995) 'No socks please . . .', *Guardian (Weekend)*, 2 December, 60

Smith, C.S. (1989) *Auctions: The Social Construction of Value*. Hemel Hempstead: Harvester Wheatsheaf

Soiffer, S. and Hermann, G. (1987) 'Visions of power: ideology and practice in the American garage sale', *Sociological Review*, 35, 48–83

Sorenson, C. (1989) 'Theme parks and time machines' in P. Vergo (ed.) *The New Museology*. London: Reaktion, 60–73

Spicer, L. (1997) 'Ding dong merrily on high the Christmas toys are coming', *Collect It!*, 6, December, 52–4

Starobinski, J. (1966) 'The idea of nostalgia', *Diogenes*, 54, Summer, 81–103

Steadman-Jones, G. (1974) 'Working class culture and working class politics in London 1870–1900: notes on the re-making of a working class', *Journal of Social History*, Summer, 460–509

Stebbins, R.A. (1979) *Amateurs: On the Margin between Work and Leisure*, Beverly Hills, CA: Sage

Stebbins, R.A. (1980) '"Amateur" and "hobbyist" as concepts for the study of leisure problems', *Social Problems*, 27(4), April, 413–17

Stebbins, R.A. (1982) 'Serious leisure: a conceptual statement', *Pacific Sociological Review*, 25, April, 251–72

Stewart, S. (1984) *On Longing: Narratives of the Miniature, the Gigantic, the Souvenir, the Collection.* London: Duke University Press

Stoller, M.A. (1984) 'The economics of collectible goods', *Journal of Cultural Economics*, 8, 91–104

Suggitt, M. (1990a) 'How we used to live: a travelling exhibition', *Social History Curator's Group Journal*, 17, 27–9

Suggitt, M. (1990b) 'Emissaries from the toy cupboard', *Museums Journal.* 90(12), December, 30–3

Suggitt, M. (1993) 'Collecting methods: the antique trade' in D. Fleming *et al.* (eds) *Social History in Museums: A Handbook for Professionals.* London: HMSO, 181–6

Summerfield, P. (1986) 'Patriotism and empire: music hall entertainment, 1870–1914' in J.M. MacKenzie (ed.) *Imperialism and Popular Culture.* Manchester: Manchester University Press, 17–48

Takayama, H. (1996) 'Dusting off the past', *Newsweek*, 16 September, 39

Taylor, A. (1996) 'Fenimore Cooper's America', *History Today*, 46(2), February, 21–7

Thompson, E.P. (1963) *The Making of the English Working Class.* London: Victor Gollancz

Thompson, J. (1992) *Manual of Curatorship: A Guide to Museum Practice*, 2nd edn. London: Butterworth/Heinemann

Thompson, M. (1979) *Rubbish Theory.* Oxford: Oxford University Press

Thornhill, A. (ed.) (1994) *Directory of English Bowls Club Badges.* Surrey: private publication

Tickner, L. (1987) *The Spectacle of Women: Imagery of the Suffrage Campaign 1907–1914.* London: Chatto and Windus

Tilley, C. (1989) 'Interpreting material culture' in I. Hodder (ed.) *The Meaning of Things.* London: Unwin-Hyman, 185–94

Toffler, A. (1968) *Future Shock.* London: Bodley Head

Toffler, A. (1980) *The Third Wave.* London: Collins

Tognoli, J. (1980) 'Differences in women's and men's response to domestic space', *Sex Roles*, 6(6), 833–42

Tonso, R. (ed.) (1989) *Gun Culture and its Enemies.* Columbus, OH: Merill

Tuchman, M. (1994) *Magnificent Obsessions: Twenty Remarkable Collectors in Search of their Dreams.* San Francisco: Chronicle

Tudor-Craig, P. (1996) 'Times and tides', *History Today*, 46(4), April, 8–10

Tyler, J. (1996) 'Displaying the game', *Museums Journal*, 96(6), June, 26–7

Veenis, M. (1997) 'Fantastic things' in S.M. Pearce (ed.) *Experiencing Material Culture in the Western World.* Leicester: Leicester University Press, 154–74

Vergo, P. (1989a) 'The reticent object' in P. Vergo (ed.) *The New Museology.* London: Reaktion, 41–59

Vergo, P. (ed.) (1989b) *The New Museology.* London: Reaktion

Viner, D. (1993) 'Private collectors' in D. Fleming *et al.* (eds) *Social History in Museums: A Handbook for Professionals.* London: HMSO, 352–8

Walker, J. (1997) 'Afterward: acquisition, envy and the museum visitor' in S.M. Pearce (ed.) *Experiencing Material Culture in the Western World.* Leicester: Leicester University Press, 255–63

Wallendorf, M. and Arnould, E. (1988) 'My favourite things: a cross-cultural enquiry into object attachment', *Journal of Consumer Research*, 14, 531–47

Walton, J.K. (1983a) *The English Seaside Resort: A Social History 1750–1914.* Leicester: Leicester University Press

Walton, J.K. (1983b) 'Styles of holidaymaking: conflict and resurrection' in *The English Seaside Resort: A Social History 1750–1914*. Leicester: Leicester University Press, 187–226

Walton, J.K. (1983c) 'Municipal government and the holiday industry in Blackpool: 1876–1914' in J.K. Walton and J. Walvin (eds) *Leisure in Britain 1780–1939*. Manchester: Manchester University Press, 159–86

Walton, J.K. and Walvin, J. (eds) (1983) *Leisure in Britain 1780–1939*. Manchester: Manchester University Press

Webley, P., Lea, S.E.G. and Portalska, R. (1983) 'The unacceptability of money as a gift', *Journal of Economic Psychology*, 4, 223–38

Weeks, J. (1997) 'Lights, action, cash in?', *Museums Journal*, 97(4), April, 26–9

West, B. (1988) 'The making of the English working past: a critical view of the Iron Bridge Gorge Museum' in R. Lumley (ed.) *The Museum Time Machine*. London: Routledge, 36–62

White, L. (1995) 'Net prophet', *The Sunday Times*, 12 November, 1

White, R. (1995) 'Mower the merrier', *The Sunday Times*, 12 January

Whitely, M.T. (1929) 'Children's interest in collecting', *Journal of Educational Psychology*, 20, 249–61

Whittaker, N. (1995) *Platform Souls: The Train Spotter as 20th Century Hero*. London: Gollancz

Whoolley, F. (1995) 'Room of their own', *Museums Journal*, 95(11), November, 22

Wilkinson, H. (1997a) 'A pitch in time', *Museums Journal*, 97(3), March, 19–21

Wilkinson, H. (1997b) 'Mr Cropper and Mrs Brown: good and bad collectors in the work of A.S. Byatt and other recent fiction' in S.M. Pearce (ed.) *Experiencing Material Culture in the Western World*. Leicester: Leicester University Press, 95–113

Wilkinson, K. (1990) *Association of Football Badge Collectors Badge Directory*. Liverpool: private publication

Williams, C. and Harris, P. (1994) 'Truck lift', *North-Eastern Evening Gazette*, 26 July, 5

Williams, M. (1995) *Tomart's Price Guide to McDonald's Happy Meal Collectibles*. Dayton, OH: Tomart

Williamson, J. (1997) 'The thrill of thrift', *Guardian* (*Weekend*), 10 May, 6

Windsor, R. (1994) 'Identity parades' in J. Elsner and R. Cardinal (eds) *The Cultures of Collecting*. London: Reaktion, 49–67

Wired (1995) Advertisement in the *Guardian* (*Weekend*), 22 April

Wired (1995) Advertisement in the *Guardian* (*London What's On*), 1 April, back cover

Witty, P. (1931) 'Sex differences in collecting interests', *Journal of Educational Psychology*, 22, 221–8

Wolff, I. (1993) 'Don't ask why, just put a lid on it', *Independent on Sunday*, 12 December, 24

Wright, P. (1985) *On Living in an Old Country: The National Past in Contemporary Britain*. London: Verso

Zinberg, D.S. (1996) 'Cyberspace under siege', *The Times Higher Education Supplement*, 8 March, 14

Zola, E. (1995) *The Ladies Paradise* (*Au Bonheur des Dames*) with a new translation and introduction by Brian Nelson. Oxford: Oxford University Press

Zurbrugg, N. (ed.) (1997) *Jean Baudrillard: Art and Artefact*. London: Sage

Radio

Ad Lib: Meeting the Collectors (1995) Robert Robertson, BBC Radio 4, 19 January

Anorak of Fire (1994) S. Dinsdale, BBC Radio 4 'Thirty Minute Theatre', 28 June

Carry On Collecting (1994) 'Kaleidoscope' with K. Barley, BBC Radio 4, 19 August

Finance News (1993) BBC Radio 4, 14 December

In Celebration (1994) BBC Radio 4, 'The Corby Trouser Press', April

Kaleidoscope (1994) BBC Radio 4, 13 April

Medium Wave (1994) BBC Radio 4, 20 February

Money Box (1995) BBC Radio 4, 28 May

Personal Obsessions (1994) BBC Radio 4, 24 May
PM (1994) BBC Radio 4, 10 November
Shed Culture (1995) BBC Radio 4, 25 January
Steve Wight's Talk Show (1996) Talk Radio, 2 March
You and Yours (1994) BBC Radio 4, 3 November

Television

A–B Motoring Tales (1994) BBC2
All Mod Cons (1997) BBC2, 1 September
And the Beat Goes On (1996) Channel 4
The Antiques Inspectors (1997) BBC1
The Antiques Roadshow (1993) BBC1 (children's retrospective), 13 August
The Antiques Roadshow (1993–96) BBC1
The Antiques Show (1997) BBC2, April
The Car's the Star (1997) BBC2
Changing Rooms (1997) ITV
Classic Cars (*c.* late 1990s) BBC2
Collectors' Lot (1997) Channel 4
Encounters. (1994) Channel 4, 10 October
The Exchange (1995) Carlton, 23 April
Fascism, Programme 2, 'Fascination' (1996) Channel 4, 2 October
For Love or Money (1994–95) Channel 4
Going for a Song (1996) BBC1
Going, Going, Gone (1995) BBC2
The Great Antiques Hunt (1994–95) BBC1
Heartbeat (1996) Carlton TV
The Hollow State (1996) BBC2
Home Front (1996–97) BBC2, 8 May
Hot Property (1997) Channel 5
The House Detectives (1997) BBC2
House Style (1997) ITV
The I Bomb (1995) 'Horizon', BBC2, 27 March
I'll Just See If He's In (1996) BBC2
Lovejoy (1993–95) BBC1
Mad About Machines (1997) Channel 4, April
Memories in Store (1995) Channel 4, 19 April
Modern Times (1995–97) BBC2
Moving People (1997) Channel 4
Off Your Trolley (1996) Channel 4
Our House (1996) ITV
Perpetual Motion (1994) BBC2, October–November
Peter York's Eighties (1996) BBC2, January–February
The Pitcher: A Portrait of Mick Gill-Carson (1995) Channel 4
Reduce Speed Now (1997) Carlton
Scrimpers (1994–95) Channel 4
The Secret Life Of . . . (1993–94) BBC2
Shop 'Til You Drop (1997) Channel 4
Signs of the Times (1994) BBC2
Small Objects of Desire (1993–94) BBC2
Tales of Modern Motoring (1994) BBC2, 8 April and 15 April
Time Team (1994) Channel 4
Visions of Heaven and Hell (1995) Channel 4, January/February
Working Lunch (1997) BBC2, 14 November

Index

Numbers in *italics* refer to figures, those in **bold** to tables.